iPad®
for
Digital
Photographers

iPad®
for
Digital
Photographers

Derrick Story

WILEY

iPad® for Digital Photographers

Published by
John Wiley & Sons, Inc.
10475 Crosspoint Boulevard
Indianapolis, IN 46256
www.wiley.com

Copyright © 2013 by John Wiley & Sons, Inc.

Published simultaneously in Canada

ISBN: 978-1-118-49813-2

796 6249

Manufactured in the United States of America

10 9 8 7 6 5 4 3 2 1

For general information on our other products and services or to obtain technical support, please contact our Customer Care Department within the U.S. at (877) 762-2974, outside the U.S. at (317) 572-3993 or fax (317) 572-4002.

Wiley also publishes its books in a variety of electronic formats and by print-on-demand. Some content that appears in standard print versions of this book may not be available in other formats. For more information about Wiley products, visit us at www.wiley.com.

Library of Congress Control Number: 2013932105

Trademarks: Wiley and the Wiley "wordmark" logo are trademarks or registered trademarks of John Wiley & Sons, Inc. and/or its affiliates. All other trademarks are the property of their respective owners. John Wiley & Sons, Inc. is not associated with any product or vendor mentioned in this book.

Colophon: This book was produced using the ITC Cheltenham typeface for the body text and Cronos Pro for the chapter titles, subheads, and caption text.

Credits

Acquisitions Editor
Carol Kessel

Editorial Director
Robyn Siesky

Business Manager
Amy Knies

Senior Marketing Manager
Sandy Smith

Vice President and
Executive Group Publisher
Richard Swadley

Vice President and
Executive Publisher
Barry Pruett

Editor
Carol Person, The Zango Group

Technical Editor
Lonzell Watson

Design and Layout
Galen Gruman, The Zango Group

Cover Designer
Michael E. Trent

Copy Editing, Proofreading,
and Indexing
The Zango Group

About the Author

In 2005, Derrick Story launched The Digital Story and published his first podcast. The website is a platform for his passions: writing, photography, technology, storytelling, and exploration.

There's an ongoing joke in his family that no one can easily describe what he does for a living. Maybe this will help. Derrick watches how the world is changing, then tries to explain it to others.

You can follow his progress at www.thedigitalstory.com.

GEORGE JARDINE

Dedication

To Theresa, the best writer in the family

Acknowledgments

It's incredible to think how different my life would be if Steve Jobs hadn't co-founded Apple or Galen Rowell hadn't picked up a camera. These two visionaries set forces in motion that collided and became my career. And to this day, their body of work inspires me.

I'm also grateful to the team at Lynda.com, the editors at *Macworld* magazine, the staff at Lowepro, and all the members of The Digital Story virtual camera club who have provided me with the means to make a living doing the only work I really care about.

At home, my family never knows what's going to appear on our Wi-Fi network or be strewn across the dining room table. They patiently wait for me to clean up my experiments so we can have our dinner. I'm lucky to have them. They support my wildest ideas.

Photographers need willing photo subjects. I've been fortunate to have many artists work in front of my lens to help me create engaging images. Three in particular — lovely ladyJ on the front cover, Leah Lavoneh on the back, and Alyssa Jayne on the opening page for Chapter 1 — clearly illustrate that the photographer is only half of the equation.

Carol Kessel at Wiley Publishing approached me about writing a guide that focuses on photography and tablet computing. My thanks to her, and the entire team at Wiley and The Zango Group (especially Galen Gruman and Carol Person) for publishing a book that I hope contributes to a community that has given me so much.

contents

Chapter 3: Editing Your Photos 55

Chapter 4: Transferring from the iPad to a Computer 87

▌ Chapter 9: Transporting an iPad and Camera 229

▌ Chapter 10: Tips for the Road Warrior 245

Introduction

A gentleman recently cornered me at a social gathering and huffed, "I miss the good old days of photography. All you needed then was a camera and a few rolls of film." He gulped the last of his drink, scowled, and continued (without any encouragement from me): "Now you need computers and memory cards, hard drives, ... and what the heck is the cloud anyway?"

I sympathize, but I don't agree. I remember the good days too, but differently. I had to keep an eye on expiration dates for film that required refrigerated storage. I either had to process my own black-and-white images in a jury-rigged lab at home or send out my color work to a professional outfit that charged good money for its services. I don't even want to know how much I spent over those years for processing and printing. And once I got it all back, I had to sort it, store it, and figure out how to get the best stuff in front of others.

Honestly, I don't miss those days at all.

I didn't say any of this to the nostalgic man with the now-empty drink. Instead, I found a semi-quiet table, pulled out my iPad Mini, and checked to see what my friends were publishing on Flickr. I showed a few of the best shots to a couple sitting next to me. We chatted for a minute about them, then went back to what we were doing before. If something interesting caught my eye in the room, I'd pull out my compact camera, take a photo, then upload it for someone else to enjoy.

Doesn't this sound fun?

It is.

If you're intrigued by iPads, digital cameras, image editing, cloud storage, movie making, and becoming a more nimble photographer, then this book is for you. I believe *these* are the good new days. We can be mobile, self-reliant, and have the opportunity to produce images that most photographers could only dream of a decade ago.

I want to help you experience this joy. With an iPad, a camera, and a few accessories, you can pack you own personal photo lab, art studio, publishing machine, movie theater, and personal organizer in to a small backpack or shoulder bag — and still have room for lunch.

Using these tools, I explore capturing pictures, improving them with software, and sharing them with friends — while whispering "I rock!" under my breath along the way.

Who really wants to be that cranky old guy at the cocktail party? If he had a patient somebody showing him how to use an iPad Mini with a digital camera loaded with a Toshiba FlashAir card, don't you think he'd dig it? Maybe the key to success (and enjoyment) is simply understanding how things work. If that's true, you're about to embark on a very good time.

▓ The Tools of the Trade

Here's what you're going to need to get the job done. First, you'll want an iPad. It can be a full-size model or a Mini. Photographer's choice. I have one of each, and I use them both.

Next, charge the batteries for your digital camera. Extra credit is awarded to those who have cameras that don't take up a ton of space. Yes, you could use your professional DSLR with its armada of lenses, but are you going to carry all that to the coffee shop? You don't have to. A sweet little compact or a modern smartphone will work just fine. Save the big camera for the big jobs. The rest of the time, travel light and have fun.

Preferably, you'll have a computer at home. It can be Mac or Windows; I don't care about that. But please tell me, whatever it is, that it's fewer than five years old. Mac users should be running OS X 10.7 Lion or later. And for the Windows crowd, stick with Windows 7 or 8.

Invest $29 in an iPad Camera Connection Kit so you can physically transfer pictures from a memory card to your iPad 2 or third-gen iPad. It comes with two pieces: an SD card reader and USB connector. Current iPads, including the fourth-gen iPad and the iPad Mini, use the Lightning connector. For those iPads, two pieces (the Lightning to USB Camera Adapter and the Lightning to SD Card Camera Reader) have to be purchased separately, for $29 each. For most folks, the SD card reader will do the trick.

You'll use Wi-Fi, too. It's really quite handy. If you have access to a Wi-Fi network, you can move images from device to device quickly. Many cameras now feature Wi-Fi. (This includes your smartphone, too!). You'll certainly have fun with all that.

There will be other temptations, too, to stress your credit card balance. But this list of essentials puts you in great shape for taking advantage of the techniques I describe in this book.

A Note on Conventions

Throughout this book, I use ⇨ as the separator for a menu sequence in Windows or on the Mac, so "Edit ⇨ Copy" means to choose Copy from the Edit menu.

That's not so hard, is it?

Practicing What I Preach

You might be interested to know that I wrote this introduction on an iPad using Pages software while flying from Las Vegas to San Francisco. It was automatically saved to iCloud when I landed, along with the photos I took while covering the Consumer Electronics Show.

Just sayin'.

Meet Me in the Lounge

If you think this book is the whole journey, I have great news for you: This party is just getting started.

iPad for Digital Photographers does bring together the stuff you need to know right now. But mobile photography is evolving. And I'm

going to be there as each innovation rolls out the door. Want to join me?

I've created the Mobile Photography microsite that's a part of The Digital Story: www.thedigitalstory.com/mobile-photography.

Once you've arrived, look for the area titled "Book Owners' VIP Lounge." Click on the link and enter the password **ipad2013photog** at the prompt. This is your area for further exploration and sharing. I'll post updates to the book, recap news topics, and even offer a special deal or two.

As iOS software updates are released and new hardware is introduced, I'll cover them at that microsite. I'll post news items, reviews, and plenty of how-to tips. I'll have trivia challenges, too, based on content in this book.

The Mobile Photography microsite and the Book Owners' VIP Lounge will pick up where *iPad for Digital Photographers* leaves off. (Think of it as the after-party party.) So keep this guide handy in case you have to brush up on a fundamental or two.

Chapter 1

Adding Pictures to Your iPad

The iPad may feel like a magic picture device, but you have to be the magician to get the magic. And when it comes to adding pictures, there are a number of tricks to choose from. You can simply hold up the iPad and snap a photo with its built-in camera. Or, you can really impress your audience by wirelessly sending photos from your digital camera to the tablet.

Taking Pictures with the iPad Camera

To begin, tap the Camera app icon on the iPad's Home screen to open the Camera app, and you'll either see the world before you … or your own face. That's because there are actually two cameras in the iPad. The lens on the back of the device is the high quality digital camera, and the lens on the front is the FaceTime camera, which is primarily for video conferencing (and the occasional self-portrait while lounging by the pool in Hawaii).

Basics of Handheld Photography with the iPad

Let's start by making sure you're using the right camera. The icon to switch from one camera to the other is in the lower right

FIGURE 1-1

Basic camera controls on the iPad

corner of the iPad screen. Look for the image of two arrows circling around what looks like a mini DSLR, as shown in Figure 1-1.

The specs for the back-facing camera are quite serviceable for general-purpose photography: excellent resolution with autofocus and face detection. You can tell the camera where to focus by holding your fingertip on the screen in the area of the composition that's most important. The iPad will set both focus and exposure based on this information.

When you're ready to take a picture, place your finger on the camera icon, steady the iPad, then gently pull your finger off the screen. The iPad will capture the image as your finger breaks contact

FIGURE 1-2

Taking a picture with the iPad

with the glass. If you don't see a camera icon, but rather a red dot, that means you're in video-recording mode (oops!). Switch to still photography mode using the slider icon in the lower right of the Camera app's screen, as shown in Figure 1-2.

Sometimes, new iPad users tap the glass when they want to take a picture. I don't recommend this technique because that can jar the device at the moment of exposure, causing degraded image sharpness. Just like traditional photography, you need to hold the camera as steady as possible when tripping the shutter.

Once you've captured a photo, you can review it by tapping the thumbnail icon in the lower left corner of the Camera app. That tap

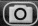
FIGURE 1-3

Using the Apple Smart Cover as a stand and the Apple ear buds to trigger the camera

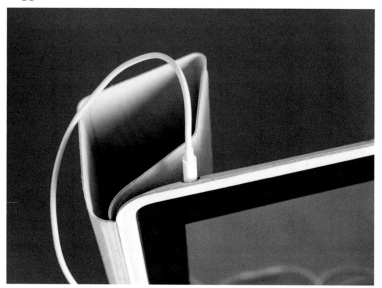

temporarily takes you to the Camera Roll where you can view the images stored on the device. If you decide you don't want to keep a picture, tap the screen once to bring up the controls, then tap the Delete button (the trash can icon) to delete the current image. Tap the blue Done button to return to picture-taking mode.

Oh, and one other little goodie to explore: The Options button (lower left corner) in the Camera app allows you to turn off and on a grid overlay. This is helpful for keeping horizon lines level and buildings straight.

Steadying the Camera for Higher Quality

You might be surprised at how good your images look when recorded with the iPad's built-in camera, especially when employing good shooting technique. If you're willing to spend a little extra time setting up the shot, you can further improve the quality. The trick is to stabilize the device when taking the picture using a variety of tools.

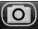

FIGURE 1-4

The Makayama Movie Mount for securing the iPad to a tripod

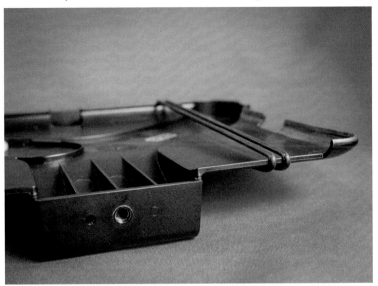

Apple's iPad Smart Case and Smart Cover can serve as a temporary stand, as can third-party covers. By keeping the iPad motionless when the shutter clicks, you'll get even sharper images.

But how do you keep from jarring the device when tripping the shutter? Lifting your finger off the glass might not work as well for a propped-up iPad as it does when you're holding it. Here's a nifty trick that you might like: Plug your Apple ear buds into the audio jack as shown in Figure 1-3, launch the camera, prop up the iPad, then … squeeze the Volume Up button (the + icon) on the volume control of the Apple ear buds. Your iPad will take a picture. That's right, you'll hear that familiar click-click. The beauty of this technique is that your ear buds are serving as a cable release, preventing accidental shaking of the iPad at exposure. If you don't have your ear buds with you, you can use the Volume Up button on the iPad itself instead.

In the language of photography, nothing says "serious" more clearly than breaking out a tripod to hold the camera steady such as for a long exposure. Using one is fairly simple for traditional photography: You just screw the connecting bolt into the threaded socket recessed in the bottom of your camera. Last time I checked,

however, there wasn't a socket on the side of my iPad. So, how do you go about mounting an iPad on to a tripod?

The $100 Makayama Movie Mount (www.hdhat.com) for the iPad includes a wide-angle lens. But the really important part is that you can secure your iPad in the Makayama using two stretchy bands. Then you can attach the entire unit to a tripod via the mount on the bottom of the holder, as shown in Figure 1-4. In short, secure the iPad to the Makayama, and then connect the entire bundle to the tripod. And as a bonus, there's even a "cold shoe" on top that allows you to mount a mic or small LCD light. Woohoo!

I've used the Makayama to record time-lapse movies with a third-generation iPad, and the unit worked great. Plus it's a great way to make new friends: I guarantee some passers-by won't be able to resist stopping and inquiring about your unusual-looking rig. It's almost as irresistible as taking a puppy to the park — almost.

Software with a Bit More Control

The iPad's included Camera app does a great job of easily capturing photos. But if you need a little more control, you might want to look to a third-party app, such as the $2.99 ProCamera HD available in the iTunes App Store. This tool allows more precise control of focus, exposure, and white balance than the built-in Camera app does. Its best feature is the ability to separate the focus and exposure targets and have them work independently. Other goodies include a built-in self-timer, digital level, image stabilization for still photos, burst mode, and advanced geotagging.

The trick to getting the most out of ProCamera is to use Expert Mode. Enable this option by tapping the Menu button and then tapping Expert Mode in the menu that appears. This allows you to unlock the two targets that are used for focusing and exposure, as shown in Figure 1-5. You can now focus on one part of the composition (using the square target), and base the exposure on a different area using the round target. This one feature alone will increase your picture-taking prowess.

Be sure to explore some of the other menu items, such as the self-timer.

Another popular picture-taking app is the $0.99 Camera+, which features a nifty magnification slider that allows you to zoom in as

FIGURE 1-5

ProCamera HD in shooting mode showing two separate targets

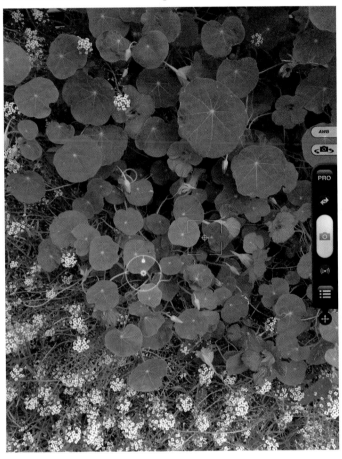

much as 6×. Camera+ includes four basic shooting modes: Normal, Stabilizer, Timer, and Burst. Tap the Menu button in the lower right corner to reveal nine additional controls, including Geotagging, iCloud Sync, and Grid Overlay. Camera+ is well designed and easy to use.

By taking advantage of these apps, or those like them, you might discover that you're taking pictures more often with the iPad itself. Having that large, high-resolution screen creates an immersive experience when composing shots. After photographing with the iPad, you may have a hard time returning to what seems like a tiny 3-inch LCD on the back of your traditional camera.

FIGURE 1-6

The Camera Connection Kit for iPads with a Dock connector

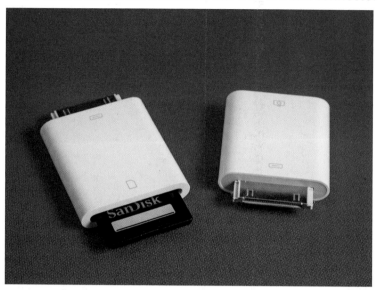

FIGURE 1-7

Importing pictures using the Photos app on the iPad

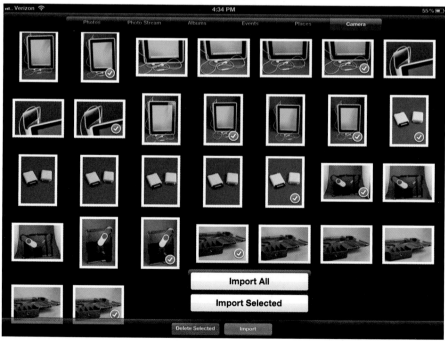

Importing with the Camera Connection Kit or Lightning Camera Adapters

Apple's $29 iPad Camera Connection Kit for the first three generations of iPads' Dock connector includes two adapters that plug into the Dock connector, as shown in Figure 1-6. One adapter has a slot for an SD card, and the other has a USB port to accommodate the cable that comes with your camera. Both adapters work equally well. Having the pair is just a matter of convenience for you.

iPad Mini owners and those with a fourth-generation or newer iPad will need the $29 Lightning to SD Card Camera Reader or the $29 Lightning to USB Camera Adapter for direct picture uploading. These connectors work the same as their Dock counterparts, but they are sold separately rather than as a pair. I'm currently using the SD Card Camera Reader for my iPad Mini. It works great.

When you connect either SD card adapter to an iPad with a memory card full of pictures, the Photos app launches automatically and creates a new album pane labeled Camera. At the same time, the screen fills with thumbnails representing the photos residing on the camera's memory card.

You can import all the images on the memory card by tapping the blue Import All button. If you want to select specific pictures to import, tap the images you want, and the iPad marks them with a blue check mark. The Import All button then changes to simply Import. When you're ready to initiate the process, tap the Import button and you're offered a couple of choices: Import All or Import Selected, as shown in Figure 1-7. Chances are, if you've gone to the trouble of marking specific images, you'll choose Import Selected.

Once you tap Import Selected, the iPad begins the copying process. Notice that I said "copying." Your pictures remain on the memory card. A second set of the images now resides on the iPad. This is a good thing: You've just created a backup of your favorite photos from the memory card.

As each image is copied to the device, the check marks change from blue to green. Once all images have been copied, you'll see the message "Would you like to delete imported photos from the attached camera?" I highly recommend that you select Keep. For the time being, your memory card also serves as an archive. When I'm

on the road, I reformat memory cards only if I have to. I like having two sets of pictures.

At this point, it's safe to disconnect the adapter from the iPad. The Camera album tab will disappear, and the iPad will display your new photos in an album titled Last Import.

Basic Maneuvers in the Photos App

You're now looking at a screen full of photos. What's the next step? I'll go over a few of the basics now, just to keep things moving along. Then, in Chapter 2, I dig deeper into organization. But since you're all dressed up right now, we should at least have one dance.

Tap any thumbnail to enlarge the image; double-tap to zoom to 100 percent; double-tap again to zoom back out. Use the finger-and-thumb expand gesture to zoom out to a desired size; use the finger-and-thumb pinch to zoom in. At any time, you can tap the iPad

FIGURE 1-8

Tapping the Share button reveals a pop-over with a sizable list of options

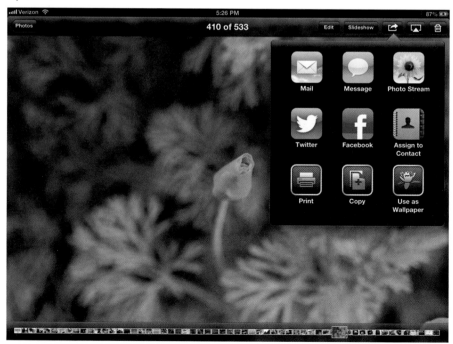

screen once to display the Camera app's navigation and thumbnail bar.

While you're looking at a single photo (instead of the thumbnails in the album), the top navigation bar displays some buttons.

Moving from left to right, the first button is the return-to-thumbnails button, which is labeled Photos, Album, or wherever you came from. Use it to navigate back through your album hierarchy.

Next is the Edit button. Tap Edit to reveal four controls at the bottom of the screen: Rotate, Enhance, Red-Eye, and Crop. I explain these in Chapter 3. These controls are straightforward and easy to use.

To the right of the Edit button is the Slideshow button. Using Slideshow is a fun way to view freshly loaded pictures. The iPad does all the work for you, and even adds music if you want.

The next button to the right is Share. Its pop-over, shown in Figure 1-8, has several options:

- Email Photos
- Message
- Photo Stream
- Twitter
- Facebook
- Assign to Contact
- Print
- Copy Photo
- Use as Wallpaper

If you have an AirPlay device available, such as an Apple TV, you'll also see the AirPlay button (the icon of a triangle in a TV screen) next to the Share button. Use it to stream your photos to a TV connected to an Apple TV.

And in the far-right corner is the Delete button (the trash can icon) for use if you decide that you don't want to keep an uploaded picture after all.

OK, the dance is over. There are a few other things that I need to describe. For now, however, at least you know your way around the ballroom.

How the iPad Handles JPEG and RAW Files

My inquisitive mind thinks it's worth understanding how the iPad handles the files you've just imported. You, however, may not care about RAW files and such. If this is the case, feel free to jump to the next section. Skipping this section would be especially appropriate if you've never shot in RAW mode, or even know what RAW means. For those of you who do work with RAW, read on.

To explain the difference between RAW and JPEG, I like to use the classic cooking show as an example. We all know that it's not good television to watch bread bake (or paint dry, grass grow, … you get the idea). That's why cooking show hosts have a finished loaf in the oven as they show you how to knead dough. Once they've explained the preparation, like magic, they can display the finished product.

In terms of bread-making, JPEGs are the finished product and RAW files are the dough. The camera "bakes" your photos for you, including compressing them when creating JPEGs. If you were to switch to RAW mode, however, the camera simply places all the ingredients in a container for you, and you have to do the "baking" yourself later with a computer. The advantage is that you get to bake photos exactly the way you want, and with no loss of quality.

Most DSLRs offer both a JPEG and a RAW option. JPEGs are the default because they are smaller in size and easier to consume. Photographers sometimes switch to RAW when they want to extract every ounce of quality from the picture.

If you've captured in RAW with your digital camera and uploaded the files via the iPad Camera Connection Kit or the equivalent Lightning adapter, the iPad will display a JPEG version of the RAW file on the screen. How does it do that? Here's where my cooking-show metaphor goes up in smoke. The camera creates a small JPEG and embeds it in every RAW file. It's like there's a baby loaf of baked bread in the batter. Yuck!

The iPad has access to this embedded JPEG, and in fact would rather use it than the RAW file. Who wouldn't prefer baked bread to batter?

But you can force the iPad to work with the RAW file. For example, if you e-mail that RAW file from the Photos app (without

doing any editing), the iPad attaches the RAW file. However, it does rename it "Photo."

Let's review: You upload a RAW file to the iPad. The iPad displays it as a JPEG. If you send a copy of the file without editing it, the iPad attaches the original RAW file.

But things change if you edit the image. Let's say that you apply a crop to the image in the Photos app, then e-mail the photo. In this case, the iPad sends the edited JPEG, not the original RAW file. Don't worry! Your original RAW file is still on the iPad. And there are ways to move it off the device and on to your computer, which I cover in Chapter 4. The most important thing right now is to know that if you upload a RAW file to the iPad, you can also copy it from the iPad at a later time, even after editing the file.

Review: Once you edit the RAW file on the iPad, the default mode of sharing it is JPEG.

Interestingly enough, the iPad handles JPEGs in a similar manner. You can send the original image if you don't edit it first. But the minute you crop or enhance the photo, the iPad creates a new JPEG and sends the new image. And once again, there is a way to export the original JPEG even after you've edited it.

Let's review: The same basic rules apply to original versus edited JPEGs as with RAW files.

Photographers capturing photos using RAW+JPEG (yes, you can do that), should know that the iPad works with the JPEG when possible. Once again, baked bread. So if you e-mail a photo that was uploaded as RAW+JPEG, the iPad sends the JPEG. Fortunately, you can use tools to export both files, and once again, those tools are covered in Chapter 4.

Final review on this topic: RAW+JPEG use more space on your iPad because two files are uploaded for every picture. And the iPad defaults to using the JPEG anyway.

Even though this description reads like a cup of technical molasses, there's a reason for understanding how the iPad handles these files. If, for example, you go to all the trouble to capture in RAW, you'll want to know that you can get that RAW file out of the iPad. And don't you feel better knowing that the answer is "Yes you can!"?

Wireless Transfer from Camera to iPad via Eye-Fi

OK, let's take a break from bread and batter metaphors and move to something a bit sweeter. Instead of using hardware to copy your photos from a digital camera to the iPad, you can send them through the air. Yes, wireless communication!

The most established way to accomplish this feat is to use an Eye-Fi SD memory card and the free Eye-Fi app for the iPad. But things have evolved in this space. For example, a newer, less cumbersome wireless option is the Toshiba FlashAir card. I'll describe the Eye-Fi card first. Then I'll explore other options.

An Eye-Fi card looks like a regular SD memory card. But in addition to storing pictures, it can also transmit them via Wi-Fi. Both the Eye-Fi and iPad must be connected to the same Wi-Fi network for you to be able to transfer files between them.

Once the Eye-Fi card is configured and placed in your traditional camera's SD card slot, you take a photo with that camera and then send a copy to your iPad. If the iPad isn't turned on, the Eye-Fi card waits until the iPad is active, then sends the photos from the previous session.

FIGURE 1-9

The Eye-Fi Center application on a computer

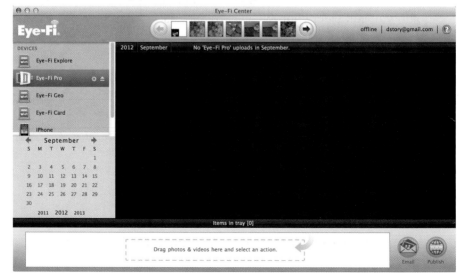

Initially, you need your computer to configure the Eye-Fi card. Start by downloading the Eye-Fi Center application from the www. eye.fi website. After you launch the application, you need to set up an account. Remember the account's username and password — you'll need them later.

Next, connect the Eye-Fi card to your computer via the card reader included in the package. Once the computer acknowledges the card, it appears in the left column of the Eye-Fi Center's window. Click the Preferences button (the gear icon) next to the card to display the Preferences settings, as shown in Figure 1-9.

Icons for eight buttons display across the top of the screen: Networks, Photos, RAW, Videos, Eye-Fi View, Notifications, Geotagging, and Transfer Mode. Click any button to reveal its settings. Initially, you only need to set up Networks and Transfer Mode. Once you get the controls running smoothly, you can fine-tune your experience using the other settings.

Click the Networks button to set up a private network. The application will find your local Wi-Fi network, ask for the password, and allow you to add access to the network to the card. When you complete the network name and password correctly, a blue button labeled Add Network to Card lights up. Click it to complete this step.

Return your attention to the top row of icons and click Transfer Mode to open a menu. Next, choose Selective Transfer, which is the option at the bottom of the list. By doing this, only images that you mark with the Protect button in the camera are uploaded. At this point, you can eject your Eye-Fi card and insert it in the camera.

The final stage of setup must take place on the iPad. Download the free Eye-Fi app. Launch the app, which will ask you to sign in. Enter your e-mail address (username) and password and tap the Login button. Once your credentials have been verified, you see the Card Pairing screen. Here's where you let the iPad know that you want to receive images from the card you configured. Once that's completed, tap the Done button. You're now ready for some fun.

Take a few pictures with your camera. Review them and decide which ones you'd like to transfer. Press the Protect button on your camera to protect the image you want to upload. If you can't find this control, refer to your owner's manual. Once you protect an image, you'll see a key icon in the corner of the picture.

After a minute or so, the camera will send the photo to your iPad, and it will appear in the Photos app's screen. Go back to your camera and protect another image or two. They will also transfer to your device. If you have any problems, visit the support section of the Eye-Fi website, which does a great job explaining how to troubleshoot your card.

Here's the bottom line: For pure speed and convenience, it's hard to beat Apple's Camera Connection Kit or Lightning adapters. But if you're willing to spend a little "trial and error" time, Eye-Fi cards present a geeky alternative.

■ Wireless Transfer via the Toshiba FlashAir Card

By no means is Eye-Fi the only player in the wireless space. Others now have begun to step in, such as the Toshiba FlashAir.

FIGURE 1-10

Choosing the FlashAir card from the list of available Wi-Fi networks on an iPad

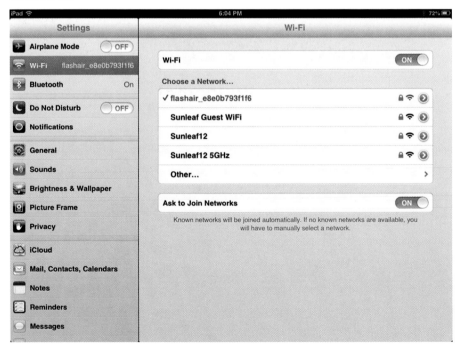

Toshiba created a more streamlined setup process than Eye-Fi by including a Wi-Fi access point in the SD card itself. When you turn on the camera, the card begins broadcasting, just like the Wi-Fi router many of us use for our home networks. The beauty of this approach is that you don't need any special software to access your pictures. You can use the browser on a computer, smartphone, or iPad to see and download photos. And there's additional software in the iTunes App Store that provides a customized interface. I'll show you one such app in just a few moments.

But first, let's give the FlashAir card a spin. Insert FlashAir in your camera's SD card slot and power up the camera. Then go to the Settings app on your iPad. Tap Wi-Fi, and choose the FlashAir card from the list of networks, as shown in Figure 1-10. Your iPad will ask for a password. Type **12345678**; it should connect. If it doesn't, try again, or refer to the documentation that came with your FlashAir card.

FIGURE 1-11

The FlashAir Welcome screen on an iPad

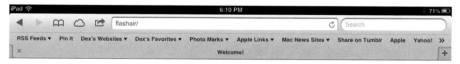

FIGURE 1-12

Olympus Image Share displaying thumbnails from the Toshiba FlashAir card

Now all you have to do is launch the Safari web browser on the iPad and go to http://flashair. After a few seconds, you should see the Welcome screen, as shown in Figure 1-11. Tap the arrow icon to personalize the network name (SSID) and add an eight-character password for your card. You only have to do this once. If you succeed, you're instructed to rejoin the network with the new name and password. Now you've created a secure connection between your camera and the iPad (or other device).

Next, relaunch the web browser and enter the FlashAir URL again. You can browse all the photos on your memory card right there in the browser. You can also use one of the FlashAir compatible apps from the iTunes App Store to manage your pictures, such as the free Olympus Image Share, as shown in Figure 1-12.

If you use Olympus Image Share, tap the thumbnail of a photo you want to copy, and the iPad will download it from the camera. Then tap the Share button in the upper right corner of Image Share,

and choose Save to Camera Roll from the Share pop-over that appears. The photo will be copied to your iPad.

The Olympus Image Share app is limited to grabbing just JPEGs off your memory card. If you shoot RAWs, go back to the Safari web browser, and go to http://flashair to display all the images on the card. Tap the thumbnail of the RAW file you want to download. Once the image is copied from the card, the browser asks you what app you want to use to open the RAW file. In my case, I use Photogene for processing RAW files on the iPad. Make your selection, and the RAW file you copied from the camera opens in the selected application on the iPad for editing.

Personally, I try to avoid RAW files on the iPad. They're so big! And that avoidance leads to a tip that I'll pass along from personal experience: The smaller the files, the faster the transfer. To keep things moving along, I set my camera to RAW+JPEG when using the FlashAir card and choose Small for JPEG size, which is 1,280 pixels on the longest side for my Olympus OM-D. This resolution is fine for most web publishing. I then use Olympus Image Share to manage the JPEGs on the iPad. (You can use any brand of camera with the Toshiba FlashAir card and Olympus Image Share app.)

Then later, when I get home, I copy the RAW files from the FlashAir card to my computer using a standard USB card reader. This approach gives me the best of both worlds: speed and flexibility when working with the iPad on the go, and the quality of RAW files at home when editing on my computer.

Bottom line: Small JPEGs are much more manageable with this workflow.

Cameras with Built-in Wi-Fi

Wi-Fi is being added to many compact cameras, so you don't need a Wi-Fi-enabled SD card. A great example of the new breed of compact cameras with Wi-Fi is the Canon PowerShot N. When you press a button on the side of the camera, the PowerShot N can set up a private Wi-Fi network that wirelessly sends images to an iPad or iPhone running Canon's CameraWindow app. By making wireless transfer easy, Canon has created a camera that complements the mobile devices we're using daily.

FIGURE 1-13

The Share screen in iPhoto on an iPhone

We'll continue to see more cameras and mobile devices easily communicating with each other this way. Wireless transfer is a rapidly evolving technology, so if any of these examples have piqued your interest, keep your eyes open and follow the news. Who knows how you'll be uploading your pictures a year from now.

Sending Images from iPhone to iPad

To change gears for a minute, I want to ask you this: Have you ever felt a little self-conscious holding up your iPad in a crowded room to take a picture? Yeah, me too. But that, most likely, isn't the case with an iPhone.

And as you might suspect, Apple has a solution to move images from its phones to its tablets. I'll start with the most basic methods: connecting your iPhone directly to the iPad.

You need the iPad Camera Connection Kit or Lightning to USB Camera Adapter for a hard-wired upload. Insert the USB adapter into the Dock connector or Lightning port on the iPad and plug the USB cable that came with your iPhone into the adapter. The iPad will display thumbnails of all the pictures in your Camera Roll. If your iPhone is locked, you'll get a message to unlock it to proceed.

Now, simply select and import as you would normally with any other camera. You'll have full resolution images from your iPhone to work with. After the pictures have been copied to the iPad, a

message will appear: "Would you like to delete the imported photos from your iPhone?" I recommend you tap the Keep button, not the Delete button, at least until you read Chapter 5 on backup strategies.

Beaming Pictures via iPhoto

The $5 iPhoto for iOS has many nifty features, including the ability to "beam" pictures from one iOS device, such as your iPhone, to another, like your iPad. What separates iPhoto from many other apps is that you don't need a Wi-Fi network to make this happen (although Wi-Fi works great). The photos can be beamed using Bluetooth, which is built in to both devices, but rarely accessible by applications for such direct transfer.

First, make sure Bluetooth is enabled on both devices. In the Settings app, go to the Bluetooth pane and set the Bluetooth switch to On.

Then launch iPhoto on both devices (if they use the same Apple ID for the iTunes Store, you can install it on both devices, rather than buy separate copies for each).

To beam a picture, open the Camera Roll album in iPhoto on your iPhone, find an image you like, and tap the Share button at the top of the screen. In the Share screen that appears (see Figure 1-13), you're presented with several options, including Beam. Tap the Beam button, then tap Selected on the next screen; your iPhone will send the image to iPhoto on the iPad. The iPad will ask if it's OK to accept the image. If you tap Yes, the image appears in iPhoto's Photos screen in a new album titled Beamed.

This technique is particularly useful when you don't have a network or USB connection available. The transfer speeds are not as fast as the other approaches, but you can copy the photos that you absolutely have to work on.

Choose the Approach That's Right for You

I covered a lot of ground in this chapter, from taking pictures with the iPad itself to sending photos wirelessly from a camera to the tablet. Even though I've tested all these methods, I use only a few of them.

Generally speaking, I transfer photos from my camera using the Lightning to SD Card Camera Reader or the Toshiba FlashAir card. The method I choose depends on my needs at the moment.

I recommend that you experiment with the techniques that resonate the most for you. Once you find something you like, practice it. You can always add other approaches later. But first, develop your "go to" system for moving pictures from the camera to the iPad. Then, when you need to work quickly, you'll have your act together.

Chapter 2

Organizing Your Photos

When you first start using the iPad, organization might not seem like a big deal. Everything is fresh and new and clean. It's like when you first open the door to a luxury hotel room.

Then you settle in. Activity leads to clutter. And suddenly things don't feel quite so orderly. Unlike that once-pristine hotel room, there's no housekeeping to come in and clean up the mess.

Fortunately, the iPad supports excellent photo-organization tools. Maybe they're not as convenient as a housekeeping service, but they certainly will help you keep things tidy. I'm going to start with the built-in Photos app, then switch to iPhoto for iOS. I also show you an excellent third-party application, Photo Shack HD.

Using these applications, you can build a workflow designed for the way that you want to integrate the iPad into your approach for picture organization. And as your needs change, these applications should be able to adapt to them.

Organizing Photos in the Photos App

The Photos app that comes loaded on the iPad is designed to house and share all the pictures on your device. Because image libraries can get quite large, there are helpers in the application to assist your organizational efforts.

These tools are positioned at the top of the Photos app, displayed as a row of tabs, as shown in Figure 2-1. If your iPad is

FIGURE 2-1

The Photos pane in the Photos app

new, you may only see a couple tabs, such as Photos and Events. As you continue to work with the device, more tabs will likely appear, such as Photo Stream, Albums, Faces, and Places. Each opens a pane when tapped. I cover them all here, so you'll be prepared as they appear.

The Photos pane (yes, there's a Photos pane inside the Photos app) is your "every image on the iPad" display. At the top of the pane is the oldest photo. As you scroll down, you see the newer images, with the most recent at the bottom. You don't have any organizational control here. Images just appear as you take pictures or add them via upload. But they're here.

If available, the next pane is Photo Stream — Apple's term for the storage and sharing of pictures through its iCloud service. If you've enabled Photo Stream on your devices, such as an iPhone, the images you take with that camera flow into this pane, as shown in Figure 2-2. You'll need to enable it, however. To do so, go to the Settings app, tap iCloud, and then turn on Photo Stream. (The

FIGURE 2-2

The Photo Stream pane in the Photos app

iCloud system preference on a Mac or the iCloud control panel on a Windows PC to enable Photo Stream on those devices.)

There are two types of streams that can appear in this area. The first is your overall Photo Stream, labeled My Photo Stream. Tap it to see all the images you have stored in iCloud.

If you've established any Shared Photo Streams, they also appear in this pane. I cover both types of Photo Streams in more detail in Chapter 6.

The next pane, Albums, is a powerful housekeeping tool where you can manage various subcollections: those created by the iPad, and others you've made. Both types allow you to view your photo library in smaller groupings. You can create your own albums using any topic you want, drawing from the images in your Camera Roll. I describe how to do that in just a minute. Keep reading.

The iPad creates some albums for you, automatically, including Camera Roll, Last Import, and All Imported, as shown in Figure 2-3. So, for example, if you want to view only the pictures you just

FIGURE 2-3

The Albums pane in the Photos app

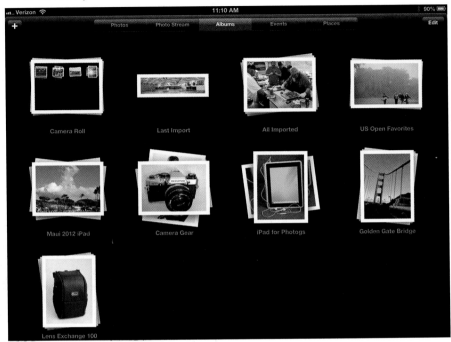

uploaded to the iPad, you can tap the Last Import album and see those without the distraction of the other images on your device.

In the Events pane, your photo collection is divided into time-based groupings, with one event group for each day, as shown in Figure 2-4. The iPad uses the timestamp on the photo to determine the date for the event.

The Faces pane is for those who use the face detection and recognition capability in iPhoto or Aperture to find and collect photos of specific people in their library. You can copy your Faces collection to the iPad in its entirety or person by person, as shown in Figure 2-5. Copying is handled via iTunes on your computer, as I describe later in this chapter.

As you may have guessed by the name, Places draws together images from a specific location. For this to work, your pictures must contain location metadata, also called *geotags*. Metadata can be applied automatically by pictures captured with an iPhone or iPad,

FIGURE 2-4

The Events pane in the Photos app

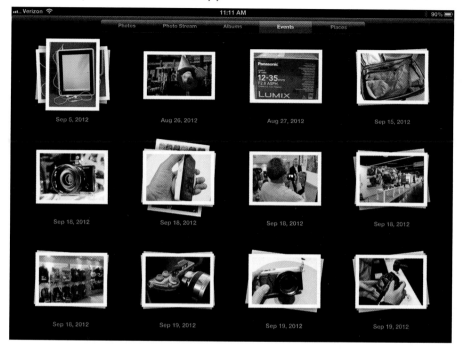

a camera that has geotagging capability, or added in postproduction with an application that enables you to geotag your images.

Photos that contain location data are plotted on a world map with red pins, as displayed in Figure 2-6. Tap a pin to see all the pictures captured at that location.

Once you're familiar with the different types of collections, your iPad image library should feel more manageable. To find a photo among thousands, you only have to remember one of these things: when you took it (Events), the person in the picture (Faces), or where you captured the shot (Places). Or maybe you created a custom album for that shot. As mentioned earlier, it's not the housekeeping crew per se, but they did leave you their cart full of tools.

FIGURE 2-5

The Faces pane in the Photos app

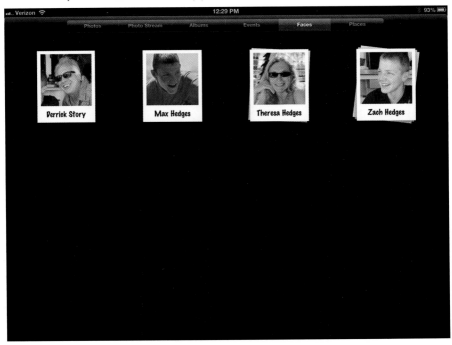

Creating your own albums in the Photos app

So let's put some of those tools to use. Creating your own album is one of the most powerful tools of the bunch. Start by tapping the Photos pane in the Photos app to display all the images on your iPad. Tap the Edit button in the upper right corner. Tap once on the image thumbnails that you want to organize into an album. As you do so, they are marked with a blue check mark.

Tap the Add To button in the upper right corner. You're presented with two options: Add to Existing Album (if you've previously created an album) or Add to New Album, as shown in Figure 2-7. This time around, tap Add to New Album. Give your album a name, and tap Save. Your pictures are collected into an album with the name you applied and placed in the Albums pane.

Use the Add to Existing Album option to move selected images to a previously created album; you get a list of such albums to choose from.

FIGURE 2-6

The Places pane in the Photos app

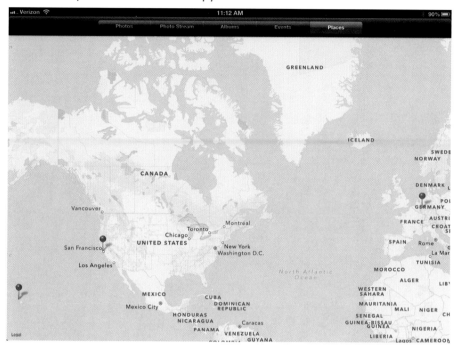

📷 **Tip**

To select multiple images quickly, tap a thumbnail with two fingers, hold for a second, and drag your two fingers across the other images you want to include. As your drag, blue check marks are applied to those shots. (This is the iPad's version of the marquee drag-select feature in OS X or Windows. It requires that your iPad runs iOS 6 or later.)

One of my favorite uses of albums is to pull together a collection of shots for a slideshow. In the album, you can reorder the images and create a storyboard. To reorder the images:

1. Open an album you've created (not Last Import or All Imported).
2. Tap the Edit button.
3. Tap and drag a thumbnail to move it to a new position.
4. Tap Done once you have everything in place.

You can see your presentation come to life by tapping the Slideshow button. Choose your transitions and music in the pop-up

FIGURE 2-7

Adding images to an album in the Photos app

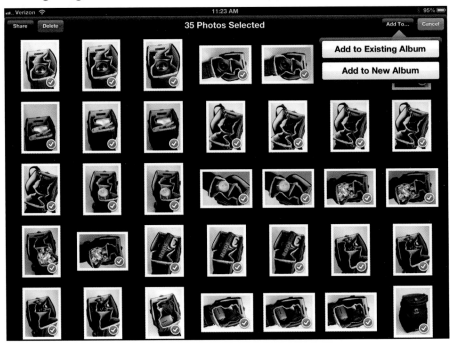

menu that appears, and tap Start Slideshow. You've just authored a multimedia presentation! (I describe more options for building presentations in Chapter 7.)

Deleting albums and photos in the Photos app

OK, it's true, not every picture we capture turns out great. In fact, sometimes the entire collection of shots fall short. So why not get them off your iPad before someone sees them?

You can easily delete an album:

1. Go to the Albums pane
2. Tap the Edit button.
3. Tap the Close button (the X icon) that appears in the upper left corner of the album. The iPad will delete the album, but not the photos in it. You've merely uncollected your collection.

To delete the pictures themselves:

1. Go back to the Photos pane.
2. Tap Edit.
3. Tap the image you want to trash (putting a blue check mark on it). You can select as many photos as you want to delete them all at once.
4. Tap the red Delete button in the upper left corner. The pictures are removed from your iPad.

Keep in mind that the pictures displayed in the Photos pane comprise the master library on your iPad. These are the same shots that other photo applications use for editing and organization. So when you remove a picture from the Photos pane, it's gone.

Adding Faces collections to the Photos app

As mentioned earlier, you can share your Faces collections, assembled in iPhoto or Aperture on the Mac, with your iPad. The conduit for the communication is iTunes. This is one of those scenarios where your computer and iPad work together. Also, this is a Mac-only workflow because Aperture and iPhoto don't run on Windows computers. The steps are as follows:

1. Open iTunes on your Mac.
2. Connect your iPad to iTunes via its USB cable or Wi-Fi.
3. Near the upper right corner in iTunes, click the Devices button and click your iPad's name in the pop-over that appears.
4. Once iTunes establishes communication with the iPad, click the Photos pane in the iTunes window.
5. Check the Sync Photos From option and choose either Aperture or iPhoto, depending on which you use (see Figure 2-8).
6. Select the Selected Albums, Events, and Faces radio button.
7. Scroll down the page to the Faces Selection section and select the check boxes next to the people you want to appear on your iPad, as shown in Figure 2-9.
8. Click the Apply button.

Once the sync has finished, go to the Photos app on your iPad. You'll see that Faces has been added to the tabs at the top of the screen.

The Photos app has an impressive array of organizing tools, especially considering it's so simple to use. But we still have more

FIGURE 2-8

Syncing your photos from iPhoto or Aperture via iTunes

FIGURE 2-9

Choosing people to add to the iPad via iTunes

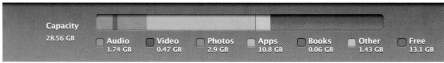

housekeeping options available. The next level is iPhoto for iOS. And it's a blast.

Organizing with iPhoto for iOS

iPhoto for iOS is available in the iTunes App Store for $4.99. For less than what you'd pay for a Subway sandwich, you can substantially bolster the image-handling capabilities of your iPad. For the moment, I'll focus on iPhoto's organizational tools. Its ability to tag, filter, and collect pictures will help you maintain control of your picture library.

Marking your photos in iPhoto

iPhoto provides three basic ways to mark your images: flags, favorites, and tags. Reveal these options by browsing a photo and tapping the Edit button in the upper right corner. A toolbar appears at the bottom.

Using flags

In the middle of the toolbar, you see the flag icon. A flagged image can be anything you want. You could use flags to mark photos for potential inclusion in a slideshow or as a way to pull together a quick presentation. Because flags are easy to apply and to remove, they're often used as temporary markers.

Tap once on the Flag button (the flag icon) to mark the currently selected photo. Its icon appears on the thumbnail for that shot. Tap the Flag button again to remove the flag. Tap and hold the Flag button to reveal a menu with additional options, as shown in Figure 2-10, including Flag All, Unflag All, Last 24 Hours, Last 7 Days, and Choose Photos.

Let's say that you're working with a large collection of images in iPhoto for iOS. You can flag them all at once with just a single tap. Or you could mark the shots in the last day, or week, with a tap.

If you wanted to choose a handful of pictures quickly, choose Choose Photos from the Flag menu and tap the thumbnails you want flagged. To select continuous thumbnails, tap the Range button (which appears after you tap the first photo in the sequence), then

FIGURE 2-10

Applying flags in iPhoto for iOS

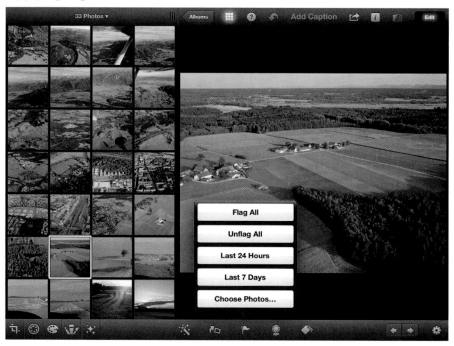

tap the last image. Everything in between is flagged. Tap the Done button when finished.

Using favorites

To the right of the Flag button on the toolbar is the Favorites button, represented by an award ribbon. The marking process is very straightforward: Tap the button to mark an image as a favorite, then again to unmark it.

Because favorites aren't as versatile as flags, they are used more sparingly, such as for your best "portfolio" images and other scenarios where you're not likely to change your mind very often.

Using tags

In iPhoto 1.1, Apple introduced tags, an easy way to add descriptive metadata to your images. You can create tags for activity, color, location, or anything your mind can conceive.

FIGURE 2-11

Applying tags in iPhoto for iOS

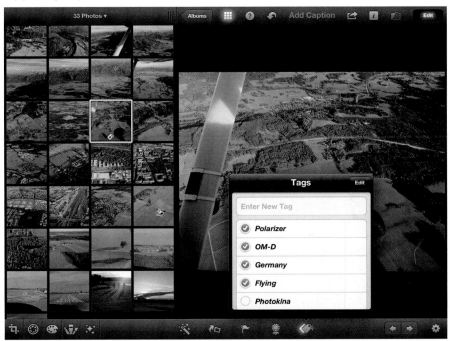

To tag an image, tap the Tag button (the sales-tag icon) next to Favorites on the toolbar, as shown in Figure 2-11, to open the Tags pop-over. If you already have tags in the list, you can apply any tag by tapping its name, which checks that tag and applies it to the selected photos. You can apply multiple tags by checking each one desired. To create a new tag, type descriptive text in the Enter New Tag field. Tap the Tags button when done.

Often, you want to tag multiple images at once. To do so:

1. Tap the More button (the gear icon) in the lower right corner of iPhoto.
2. Choose Select Multiple from the menu that appears.
3. Tap the Range button that appears at the top of the screen.
4. From the thumbnail display on the side, choose the first image in the sequence, then the last image, and they — plus everything in between — is checked.
5. Tap the Done button at the upper right.

You can display up to four columns of thumbnails when working in Edit mode. This makes tagging and flagging easier. Look for the divider line in the header at the top of the thumbnails. Tap and drag the line to reveal more columns. You can reduce the number of columns by dragged back toward the edge of the screen.

Now, tap the Tag button and select the tags that you want applied to the selected images. You'll see the tag icon placed on all the shots in the set. Tap the Tags button again when finished.

These tags help you organize your images on the iPad, and as standardized IPTC data they travel with your image and can be read by other photo-management applications, such as Aperture and Photoshop.

Using filters to organize your images in iPhoto

The time you invested in marking your photos is about to pay off: The filters built in to iPhoto for iOS can help you isolate the shots you're looking for.

Let's begin in the Albums pane in iPhoto; get to it from the row of tabs at the top of the main iPhoto screen. You'll see a set of tiles for existing albums; this screen is called the Library shelf. The blue albums are the Photos app's standard ones, the gray albums ones you created in Photos. Other apps' albums are typically white, while the gold Edited album holds photos you edited in iPhoto.

Open an album by tapping it once. Tapping that label reveals You'll see the first photo in the album taking up the screen, plus a row of buttons at the top. To see all the photos in that album, tap the Grid button (a set of nine squares); a panel of thumbnail images opens on the side of the screen. Above those thumbnails is the X Photos label, where X is replaced by the number of photos. Tap that label to reveal a pop-over with a handful of filters, as shown in Figure 2-12.

You can sort the thumbnails by Oldest First or Newest First. Other options include All Items, Flagged Items, Movies, and any tags you've applied to your pictures. (You see only filters for what you have, so if you have no movies in an album, you won't see the

FIGURE 2-12

Filters in iPhoto for iOS

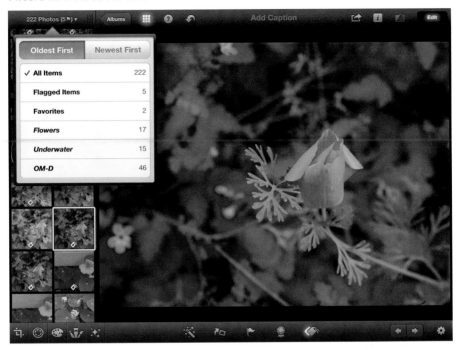

Movies filter. Likewise, if no photos are tagged or flagged, you won't see those options.)

Play with the different options to get a feel for the filters. Then explore the filters for other albums you've created. For example, if you've edited images in iPhoto, the filter Edited Items appears in the list. After applying a filter, you can always return to the full contents of the album by tapping All Items in the pop-over.

Using smart albums in iPhoto

Applying tags to your images also helps you organize at the album level because iPhoto creates *smart albums* based on the tags you've created. These are not really albums but automatically assembled aliases to your photos based on attributes, similar to smart mailboxes in OS X's Mail application and smart folders in the Mac's Finder windows. They appear on the Library shelf as manila envelopes with a cute tag paper-clipped on the side and the name you've created, as shown in Figure 2-13.

FIGURE 2-13

Smart albums in iPhoto for iOS based on tags

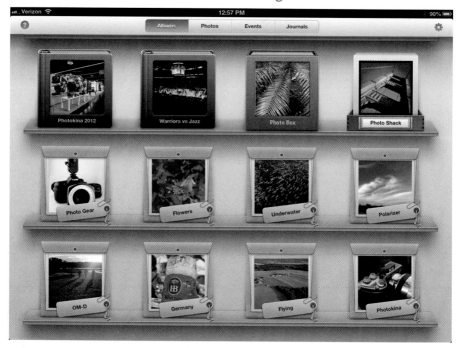

Tap any smart album to reveal all the images using that tag. As of version 1.1 of iPhoto, this is the only way you can create a custom album in the application.

iPhoto: More than a pretty interface

iPhoto for iOS provides a handy complement of organizational tools. Combined with its image editing prowess, which I cover in Chapter 3, I consider it a leading contender to serve as the primary image-management app on the iPad.

But there are others. So if for some reason iPhoto doesn't strike your fancy, take a look at Photo Shack HD.

Photo Shack HD

Photo Shack HD is a $14.99 image organizer available in the App Store. Its top selling point for me, over the many other excellent organizers, is that it uses your iPad photo library as its source and

FIGURE 2-14

Photo Shack HD provides a clean viewing interface plus plenty of organizational tools. The Photo view shown here provides information about the image.

doesn't duplicate images, so you conserve valuable storage space on your iPad, yet gain management tools.

Photo Shack HD is particularly helpful for those who like to use star ratings for their images. Plus, it can sort by various filters, show EXIF data, accept personal metadata, and transfer images to computers. Because it can read albums that you create in the Photos app, Photo Shack shouldn't disrupt your existing workflow. When you want to look at your images in a different environment, switch to Photo Shack HD, shown in Figure 2-14.

It integrates particularly well with iPhoto for iOS. When you export an image from Photo Shack to iPhoto, it's added to a Photo Shack album and catalogued in iPhoto's library.

Photo Shack HD has a batch feature that allows you to add your author name, copyright, location, keywords, ratings, and other

information to entire albums of photos at once. This data persists for JPEGs and PNGs when synced to your computer via iTunes.

Setting up a library in Photo Shack HD

When you first open Photo Shack, you see an empty My Album, and not much else. I recommend that you establish your own library with a descriptive name. You can have multiple libraries if you want.

Tap the Add button (the + icon) in the upper right corner of the Photo Shack HD screen and choose Create New Library from the menu that appears, as shown in Figure 2-15. Give it a name, and tap Apply. Once you're in your new library, you can point Photo Shack to images on your iPad. Mirroring the album structure you established in the Photos app is a great starting point.

Tap Add again, and this time choose Import iPad Albums. The albums you created in the Photos app appear. (If you haven't created any yet, tap the Events pane and start with those instead.)

FIGURE 2-15

Creating a new library in Photo Shack HD

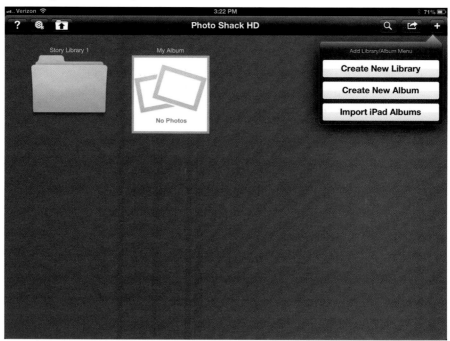

FIGURE 2-16

When you select an album to add to Photo Shack HD, it turns blue.

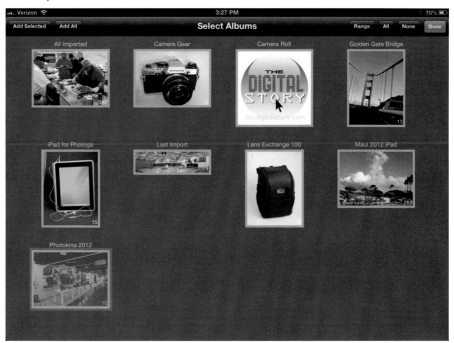

Now tap the Share button (the icon of an arrow emerging from a rectangle) in the upper right corner of the screen. Tap once on the albums you want to import; they turn blue when selected, as shown in Figure 2-16. Tap the Add Selected button. If you want to select all the albums, tap the Add All button. You've successfully imported a group of photos into Photo Shack HD.

Viewing images in Photo Shack HD

Tap once on an album to open it. You have the option of viewing large or small thumbnails via the selection buttons at the top of the screen. Look for the small and large square icons in the top right corner to choose the desired thumbnail size. Personally, I like the big thumbnails! Tap any thumbnail to open it in full screen. Zoom in to or out of an image using the standard iOS zoom gestures. The zooming feature in Photo Shack is very good, making it an excellent choice for looking at the fine detail in your pictures. Double-tap to return to full-screen view.

FIGURE 2-17

Photo Shack HD supports AirPlay, allowing you to view your work on a TV via an Apple TV.

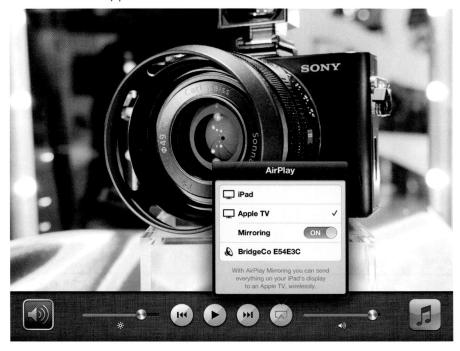

Tap once on the image to reveal toolbars at the top and bottom of the screen. There are plenty of goodies here, including the Metadata pop-over with extensive EXIF info and the Photo Info pop-over that lets you add title, byline, description, location, country, copyright, and keywords. Use the standard iOS Share pop-over for basic e-mailing or to open the image in another iPad app. Other tools lets you set up slideshows, map locations where photos were taken, and – via the Studio pop-over – provide a handful of basic effects (monochrome, auto-optimize, and so on) and frames.

If you have an Apple TV, you can mirror the photos to your TV. Double-press the Home button on the iPad, scroll the icons to the right in the multitasking bar that appears at bottom until you see the AirPlay button at left, then tap the AirPlay button, as shown in Figure 2-17. If your Apple TV and your TV are both on, the first image should immediately appear on the TV screen.

To return to the thumbnails, tap the button with the album name in the upper left corner in Photo Shack HD. You can then return to the library by tapping the button with its name in the same location.

Sorting images in a Photo Shack HD album

Photo Shack HD has eight filters for sorting in the album: date, comment, title, filename, rating, location, country, and keyword. To apply any of these filters, open the album, and tap the Sort button in the upper left corner. Apply the filters you want and tap the blue button. Your thumbnails are reorganized accordingly.

Applying personal metadata in Photo Shack HD

To add a photo title, byline, copyright, and more, tap a thumbnail to open the image, and tap the Photo Info button. Type the information you want to add and tap the green Save button.

You can use the Batch function to add data to an entire set of photos. In thumbnails view, tap the Share button, and then tap All. Tap the Batch button and type the information you want added to all the images. When finished, tap Apply. The batch function is particularly handy for bylines and copyrights.

📷 Tip

Using the Batch function is convenient for adding your author's name and copyright to photos. But check your camera, too. Many current models allow you to add copyright info when you take the picture. That's even better!

Adding star ratings in Photo Shack HD

Applying star ratings is a fast way to rank your images. In an album that's open, begin by tapping once on a thumbnail to enlarge it to full view. Tap the screen to reveal the Settings button in the bottom toolbar. In the Settings pop-over, slide the Display On-Screen Star Ratings switch to On and tap Apply.

Five empty stars initially appear in the upper right corner of the image frame. To rate the picture, just tap the desired star, as shown

FIGURE 2-18

Working with star ratings in Photo Shack HD

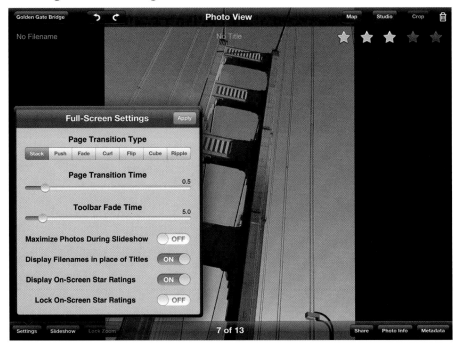

in Figure 2-18. One star is a low rating, and five stars qualify as your best. Swipe to the next image, and rate it. Before you know it, the entire album is rated.

If for some reason the onscreen stars don't appear (that happened to me once), you can access them by tapping the Photo Info button in the lower left corner of the screen; the star rating is displayed in the Photo Info pop-over.

If you want to sort your album according to the ratings, return to the thumbnail view. Tap the Sort button and in the pop-over that appears, choose Rating ⇨ Descending. Then tap the blue button to complete the sort. You'll now have your best images at the top of the album, descending to the lower-rated photos.

Exporting images to your computer from Photo Shack HD

You can send full-resolution JPEG images, complete with metadata such as star ratings, to your computer directly from Photo Shack HD. In thumbnail view, tap the Share button, choose the images you want to send by tapping them, and tap the Export button in the top left toolbar.

The Photo Sharing pop-over has five options:

- The Use Titles for Filenames on Export switch.
- The Prefix Sequence Numbers to Filenames switch: This maintains the sort order on the computer.
- The Use Full Resolution button: This retains user-modified metadata in the exported JPEG or PNG file, but does not retain any changes to the resolution or file size made in Photo Shack HD.
- The Original Photo Images button: This maintains the original image and metadata in the file transferred to your computer, not any changes made in Photo Shack HD.
- The Photos Library Version button: This retains in the exported file any modifications to the photo as well as any metadata you added in Photo Shack HD.

Generally, I tap the Full Resolution button and export the most recent metadata with my images, as shown in Figure 2-19.

Once you've made your decisions, tap the Export button.

Once the export is finished:

1. Connect your iPad to your computer.
2. Open iTunes.
3. Click the Devices button and click the name of your iPad in the pop-over that appears.
4. Go to the Apps pane, scroll to the bottom of the screen, and look for the File Sharing section.
5. Click Photo Shack in the apps listing; you'll see the files you exported in the Photo Shack Documents window.
6. Choose the files to transfer and click the Save To button. The files and their metadata are transferred to your computer.

Open the transferred images in Photoshop, iPhoto, Lightroom, or Aperture, and you'll see the metadata you wrote to the files on the iPad, as well as the star ratings. You can accomplish most of

FIGURE 2-19

Choosing the Use Full Resolution option for exporting images from
Photo Shack HD

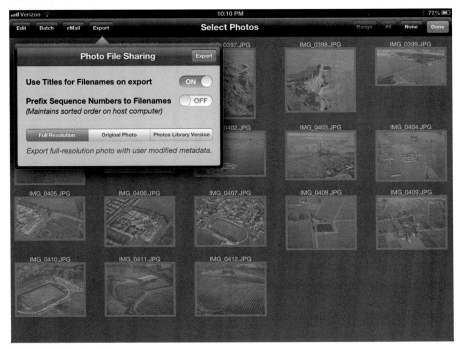

your photo organizational work on the iPad, maybe during the flight
home, and have the info transferred to your computer after your
return.

> **◎ Note**
>
> The iTunes transfer does work for RAW files, but the metadata you added
> does not accompany the files. RAW files, by nature, do not typically accept
> edits from outside the camera that created them.

▓ Sample Workflows for Organizing

Here are a couple sample workflows that take advantage of the
three organizational applications described in this chapter: Photos
app, iPhoto for iOS, and Photo Shack HD. The steps are basic, and
you'll probably need to customize any example workflow to meet

your needs. But I want to get your wheels turning so you can figure out a process that makes sense to you.

Workflow 1: Organize on the iPad, edit on the computer

This sequence is primarily for those who want to organize their photos on the iPad, but save the image editing for the computer. The applications used are Photos app and Photo Shack HD.

1. Launch Photo Shack HD, open your library, and delete the Last Import album. (Tap the Share button, tap the Last Import album, tap Edit, and then tap Delete.) Tap the Done button.

2. Connect the memory card to the iPad using the iPad Camera Connection Kit or the Lightning to SD Card Camera Reader.

3. When the memory card's contents appear in the Photos App, select the images you want to copy from the card by tapping them, then tap Import Selected. You can quickly select a sequence of thumbnails by holding two fingers on an image and dragging across multiple thumbnails.

4. Once the import is complete, switch to the Photo Shack HD to add these recently uploaded images. To do so, tap the Add button (the + icon), choose Import iPad Albums, tap the Share button in the upper right corner, tap the album labeled Last Import, and then tap the Add Selected button in the upper left corner. Photo Shack HD now has these images.

5. Rename the album by tapping and holding on it to display a menu with the Rename option. Choose Rename and provide a descriptive name.

6. Open the album by tapping it once.

7. View each image and apply a star rating.

8. Return to thumbnail view.

9. Tap the Share button in the upper right corner, tap the All button, and then tap the Export button. You'll probably want to tap the Use Full Resolution button so your new metadata is included with the pictures.

10. Send your files to iTunes by tapping the Export button.

FIGURE 2-20

iPhoto's Share pop-over provides you with a host of sharing options.

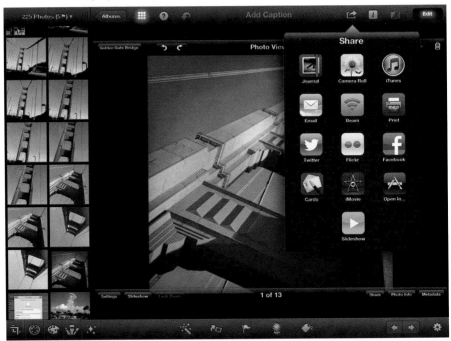

Workflow 2: Organize and edit on iPad

This sequence is primarily for those who want to organize, image-edit, and share from the iPad. The applications used are Photos app and iPhoto for iOS.

1. Connect the memory card to the iPad using the Camera Connection Kit or the Lightning to SD Card Camera Reader.
2. When its contents appear in the Photos app, select the images you want to upload by tapping them and then tapping Import Selected.
3. Open iPhoto and tap the blue Last Import album.
4. Flag the images you think are keepers and want to edit and share.
5. Once you've finish marking those keepers, apply the Flag filter to the thumbnails so you are only looking at your favorite shots.
6. If you want, add tags and edit the images.

7. Tap the Share button to open the Share pop-over, where you can copy your best shots to Facebook, Twitter, Flickr, and a host of other options, as shown in Figure 2-20.

Putting It All Together

The organizing workflow options in this chapter only use three applications: Photos, iPhoto for iOS, and Photo Shack HD. And because they interact with one another so well, at any time you can focus on just one or use them in combination.

The Photos app is your core repository of images and the best way to create albums on the iPad that can be viewed in other applications.

Photo Shack HD adds the star rating capability, easy organization, excellent viewing, and the ability to add personal metadata. It is especially effective for JPEGs because the metadata you add stays with the pictures.

iPhoto for iOS has an excellent library system, easy tagging, and a handy set of sorting filters. Plus iPhoto lets you edit images and share in the same environment. More about that in coming chapters.

The total investment for this software is less than $25. For most folks, that's less than an hour's worth of their time at work. By using these tools, however, you'll gain many hours in efficiency.

Chapter 3

Editing Your Photos

I know, I know: You've been dying to get to this chapter. I realize that earlier information about organizing your photos isn't as sexy as making them pop off the screen with image adjustments.

But organization is an important step before image editing. Why? Because you should only spend time image-editing your best photographs. I'm going to say that one more time, because it's super-important: Image-edit only your best work. Don't dilute your creativity and waste your time by messing with subpar photographs. Instead, use organizational markers such as iPhoto for iOS's Flags and Favorites to identify your best work. Then apply your brilliance to the marked pictures.

But now that you know how to organize your photos on the iPad, we can get to the fun stuff. Consider Chapter 2 the "eating your vegetables first" part of the book. That is, unless you're a vegetarian. Hmmm. Well, anyway, let's get on with it.

Image editing has always been an important part of photography. Artists such as Ansel Adams and W. Eugene Smith were as proficient in the darkroom as they were behind the camera. Today, digital photography makes fine-tuning our pictures even easier. And no place is that more evident than on an iPad.

Once an image appears on the device, you can literally interact with it using your fingertips. (I'll resist any childhood finger painting analogies, but we both know we're thinking it.) Touch one area to make it brighter, another to add more color. I've noticed that the

photos I edit on the iPad become unique images. Even when I try to replicate what I've done on a traditional computer, they somehow look different. For me, the iPad encourages experimentation, risk-taking, and creativity.

In this chapter, I begin by showing you the most basic editing tools included on every iPad. I then describe some of my favorite applications that allow you to adjust exposure, correct color, and experiment with effects. The goal is to find the art in your photograph. At this point, you may be thinking, "This certainly looks like fun. But the photos can't look as good compared to editing them on my regular computer, right?" Wrong.

Accomplishing Basic Editing in the Photos App

In Chapters 1 and 2, I described using the Photos app for viewing and organizing your pictures into albums. But it also contains a handful of editing tools, as shown in Figure 3-1. These adjustments are convenient if you need to crop an image, for example, because you don't have to jump to different software.

To reveal these adjustments, open a picture and tap the Edit button in the top toolbar. If you don't see it, tap once on the photo to make it appear. Four tools appear at the bottom of your picture: Rotate, Enhance, Red-Eye, and Crop.

📷 Note

All four tools are nondestructive, meaning your original photo is not replaced; instead, any adjustments are made to a copy of the image. Thus, even after you've saved the new version of the picture, you can change your mind and revert to the original or try a different look. Also, after editing an image, you can tap the Revert to Original button to remove all the edits you've performed on this image. You can remove just the current correction by tapping Undo or Cancel in the upper left corner.

FIGURE 3-1

The editing environment in the Photos app

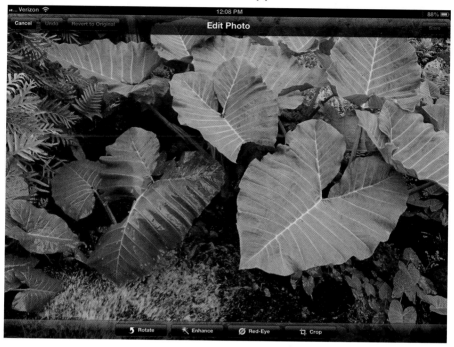

The Rotate tool

When a picture displays with the wrong orientation, you can fix it using the Rotate tool. Tap the Rotate button until the photo is shown correctly. If that's all you need to do, then tap Save in the upper right corner.

The Enhance tool

The Enhance tool strives to improve the color, contrast, and brightness of a photo by assessing the image's balance and calculating a better one. Tap the Enhance button once to apply the adjustment, and tap again to remove the adjustment. It works better on images that are low contrast and need a little brightening up.

FIGURE 3-2

The Crop tool in the Photos app

The Crop tool

Cropping is your most powerful ally in the quest to discover the art in your photos. It's also the best tool in the Photos app.

Tap the Crop button to summon the grid with four handles, one at each corner, as shown in Figure 3-2. You can tap and drag any corner to adjust the grid. Once you have the composition to your liking, tap the yellow Crop button in the upper right corner. The adjusted image appears without the grid.

You can also enlarge or shrink the image within the grid to crop it. Just use the standard iOS expand and pinch gestures to enlarge and shrink the image within the grid, and drag the image to crop it within the grid. The grid can't move, but the image can.

If you like what you see, tap the yellow Save button.

To experiment, tap the Edit button, then tap Crop again. You'll see the familiar grid, but you'll also notice that the rest of the image is still there.

FIGURE 3-3

The Crop tool's Constrain pop-over has nine options.

Crop tool's Another feature in the Crop tool is the Constrain pop-over, shown in Figure 3-3. To open it, tap the Constrain button that appears on the bottom of the frame when the cropping grid is visible. The pop-over provides nine constrained proportions: Original, Square, 3 × 2, 3 × 5, 4 × 3, 4 × 6, 5 × 7, 8 × 10, and 16 × 9. These settings allow you to consistently crop your pictures for printing or slideshow presentation. If you decide not to constrain your picture, tap anywhere on the image to hide the pop-over.

> **Tip**
>
> If you're planning to print images from your iPad library, use the Constrain pop-over to crop the pictures to the proportions of the printing paper. For example, choose the 4 × 6 constraint for postcard-size prints. That way, what you see on the iPad screen is what will emerge from the printer.

A third capability in the Photos app is straightening your image. That grid that displays when the Crop tool is active is a guide for aligning the image. Use the standard two-finger rotate gesture in iOS to rotate the picture in Photos, until it's straightened or at least aligned to your liking.

The Red-Eye tool

Red eye is caused by reflection from a flash pointed directly at a subject in a dimly lit environment. If this devil appears in your portraits, tap the Red-Eye button, then tap each eye. The iPad will do its best to remove the unwanted color.

▉ Editing in iPhoto for iOS

The editing tools in the Photos app are terrific for drive-by adjustments. But more horsepower is available, too, in the form of iPhoto for iOS. Your image will improve as you work your way through the tools from left to right in its Color toolbar.

You may be wondering if there's a methodical approach to image editing. There is! Have you heard the term "workflow"? Dull word, I must say, but an important concept. One of the challenges we face when working on an image is deciding what to do first, then once that's done, what to do next. Having a workflow in mind before you open the picture can simplify this process. It's like having a travel itinerary for your image editing. And that's how I approach iPhoto and any other editing app that I recommend.

My process has five steps that address composition, exposure, color, localized adjustments, and effects — in that order. And iPhoto supports the full workflow. I won't describe every editing nuance in iPhoto. But I do provide you a roadmap for success.

Step 1: Improve the composition

When you compose an image with a camera, you're trying to frame the elements of the scene in an interesting manner. Sometimes you're more successful than others. Fortunately, you get another chance when you view the image on the iPad. And in some ways, it's easier the second time around.

FIGURE 3-4

Straightening in iPhoto for iOS

Your most powerful ally to improve the composition is with the straightening and cropping tool in Photos or iPhoto. Often there's an interesting shot hiding in a mediocre one. You just have to find it.

Let's say that you have a horizon line that isn't quite horizontal. Begin by tapping the thumbnail of the image you want to improve to display a larger version. Then tap the Edit button in the upper right corner. At the far left of the bottom toolbar that appears is the Crop & Straighten button (the icon of two overlapping right angles). Tap it to reveal the straightening dial in the center of the toolbar, as shown in Figure 3-4. There are three ways to fix the photo:

- Tap and rotate the dial until the horizon line is straight. Use the grid to help you get a good alignment.
- Tap the dial once to activate the glowing blue outline to enable the built-in gyroscope. Next, rotate the iPad until you get the desired result and tap the dial again.
- Tap and hold two fingers on the image, and rotate them to move the photo in the desired direction.

FIGURE 3-5

Cropping in iPhoto for iOS

Notice that iPhoto crops and aligns at the same time.

Once the horizontal lines are correct, study the image to see if you can improve it further with cropping, as shown in Figure 3-5. Tap and drag anywhere on the edge of the picture to move the borders inward. When you lift your finger, iPhoto crops the image accordingly.

You can adjust two sides of the image at once by tapping a corner and dragging. To constrain the crop to a particular proportion, tap the More button (the gear icon) to reveal a selection of sizes, including 3 × 2 and 16 × 9, as shown in Figure 3-6. The red Reset Crop & Straighten button is there too if you decide you want to start over.

To check your progress, tap the Show Original button (the icon of a sheet of paper being pulled back) next to the Edit button. You can judge any composition improvements you've made (or mishaps you've created). Tap the Crop & Straighten button again when you've

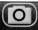

FIGURE 3-6

Constrain options in iPhoto for iOS

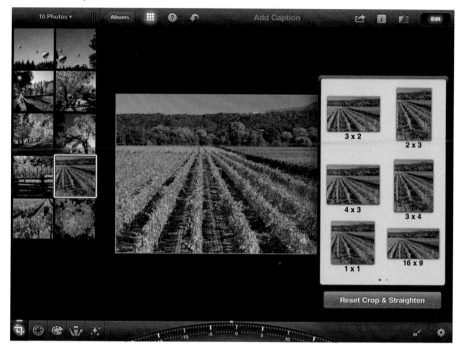

finished; you'll see a glowing blue bar above its icon, which means you've applied a crop or straighten adjustment to the photo.

My guess is that the picture is already looking better, just by cropping it. See what you think in Figure 3-7. Do you like it better than the original composition in Figure 3-4?

If you decide, however, to continue working on the composition, iPhoto is a nondestructive editor. You can return to the Crop & Straighten tool any time you want. The original image information will be waiting for you.

If cropping is all you need to do, then tap the Edit button to exit editing mode. But I'm guessing that you'll want to keep going. Will it help if I tell you the next step is really fun?

Step 2: Adjust the exposure

Adjusting the light, dark, and middle tones is now the business at hand. Tap the Exposure button to the right of the Crop & Straighten

FIGURE 3-7

The improved picture after straightening and cropping

tool. Its icon looks like the aperture blades in a camera lens. An adjustment slider with five icons appears at the bottom of the frame. To see what they are, tap the Help button (the ? icon) at the top of the picture. Labels appear for the active controls, as shown in Figure 3-8.

From left to right, the slider's controls are:

- Adjust Shadows, which lets you adjust the dark tones in the image.
- Contrast, which lets you adjust the contrast of the dark tones.
- Brightness, which lets you adjust the midtones. (Yes, you're right, "brightness" seems like an odd term for what are really the midtones. Believe it or not, this term is widespread.)
- Contrast, which lets you adjust the contrast of the light tones
- Adjust Highlights, which lets you adjust the light tones in the image.

Using these controls is easy once you know what's going on. The trick is to pay attention to each of the two thin vertical lines just

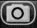

FIGURE 3-8

The exposure tools in iPhoto for iOS

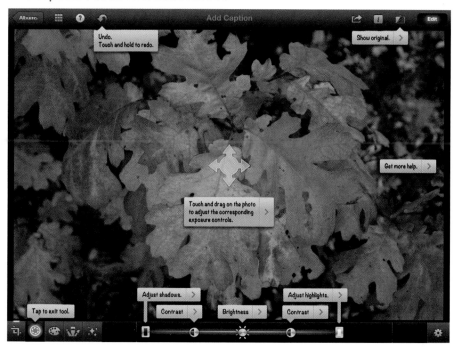

outside the Adjust Highlights and Adjust Shadows markers. They represent the full tonal range of your photo. When the Highlights and Shadows markers are touching each of the vertical lines, you have a good rendering of darks and lights. If you move the markers outside the lines, clipping occurs. That means you begin to lose detail in the dark and bright areas of the image. Let's see how that works.

Adjusting exposure on an image

Notice that for this shot of autumn leaves, the markers are well inside the vertical lines, especially for the highlights, as shown in Figure 3-9. This results in a "flat" photo that has plenty of information in the midtones, but not enough oomph at the edges of the tonal range.

By moving the Adjust Shadows and Adjust Highlights markers to the edge of each vertical line, I've improved the tonality of the

FIGURE 3-9

The image appears flat, with shadows and highlights well within the vertical marker bars

picture. For the final touch, I moved the Brightness marker a little to the left to adjust the midtones.

These minor exposure adjustments make a big difference in the appearance of the photograph, as shown in Figure 3-10.

You can check your work by tapping the Show Original button to see where you started.

For most images, adjusting shadows, highlights, and brightness is all you need to do to improve exposure.

◉ Tip

You can use a different technique for exposure adjustments by placing your finger on an area of the image and dragging up or down, or right and left. Dragging up and down adjusts the exposure in that area, and dragging right and left changes the contrast. The sliders move automatically, letting you know what you've done. You've got to try this: It's quite fun. And I think it's faster, too.

FIGURE 3-10

An improved rendering of the photo with just minor exposure adjustments

Copying and pasting exposure adjustments

Once you have the image exposed the way you want, you can copy those settings and apply them to other images that need similar corrections.

While still in Edit mode with the Exposure tool active, tap the More button (the gear icon) and choose Copy Exposure, as shown in Figure 3-11. Leave Edit mode, go to another photo, enter Edit mode and tap the Exposure button. Tap the More button and choose Paste Exposure. The settings from the previous image are applied to the new one. You can modify it as needed afterward.

Tap the Exposure button after you've finished with this step. As before, a glowing blue line remains above the icon to let you know that you've made an exposure adjustment.

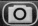
FIGURE 3-11

You copy exposure adjustments via the More menu.

Step 3: Fine-tune the color

Once you have a properly exposed image, it's easier to evaluate its color. You may not have to make any adjustments at all. But it's worth taking a minute to be sure.

There are two basic types of color adjustments to consider:

- **Enhancement.** You like the colors the way they are; you just want them more intense.
- **Correction.** In these images, the colors look "off" and you want to fix them.

Take a moment to decide which color adjustment is appropriate for the photo you're working on.

Enhancing the color

Let's start with enhancement. In Edit mode, tap the Color button (the icon of an artist's palette) to the right of Exposure. Four sliders appear in the bottom toolbar (from left to right): Saturation, Blue

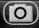

FIGURE 3-12

The color controls in iPhoto for iOS

Skies, Greenery, and Warmth, as shown in Figure 3-12. All are for enhancing your image.

As I look at Figure 3-13, I like the overall color; I just want more of it. So I start by moving the Saturation slider to the right to intensify the overall color in the scene. The look appeals to me, but I'm going to keep experimenting. For this shot, adding overall saturation might be a little too heavy-handed. So I tap the More button and choose Reset Color in the menu that appears so I can try different adjustments.

 Tip

If you want to hide the thumbnails so the image occupies the full screen, as in Figure 3-13, tap the Thumbnail Grid button in the top toolbar. Its icon is a set of nine boxes arranged in a square.

FIGURE 3-13

Adding a large dose of saturation in iPhoto for iOS might be a bit too heavy-handed for this image.

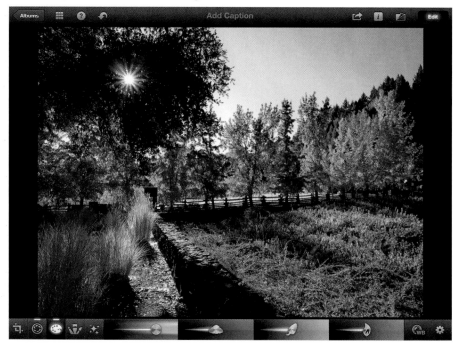

How about just working on the sky? I move the Blue Skies slider to the left to deepen the blues in the sky. That looks good. I'll leave it for now.

There are a lot of greens in this image, so I move the Greenery slider to the right to bring them to life. That also looks pretty good. I've improved the color of the photograph, as shown in Figure 3-14, and it looks more natural than the heavy saturation adjustment I tried first.

But I'm not done. I move to the Warmth slider on the right side of the Color toolbar. I consider this to be a magic slider. You might think your image looks good as is, but then you add a little warmth and it suddenly looks even better. That's the case with my leaves shot, too. I very much like how the Warmth slider enhances the image. Now I think I've really got it.

FIGURE 3-14

Working with the individual color sliders in iPhoto for iOS renders a more pleasing image to my eye.

I can check my work by tapping the Show Original button (next to Edit). Wow! What a difference. And I thought the image was good before. But it has more life now.

If you prefer to be more fingers-on with the adjustments, you can tap the image itself to reveal a color guide. Drag your finger in the direction indicated by the arrows to increase or decrease color for that particular area.

You can copy your color corrections and apply them to similar photographs by tapping the More button and choosing Copy Color in the More menu that appears. Then go to the next image and choose Paste Color from the same menu.

You can also enhance the color of a scene without over-juicing people who are part of the picture by turning on the Preserve Skin Tones switch in the More menu. By doing so, the colors in the environment are increased more than the skin tones of the subjects. You might want glowing trees, but not necessarily glowing people.

> **◎ Tip**
>
> You can create a black-and-white image by moving the Saturation slider all the way to the left. Then use the Blue Skies and Greenery sliders to fine-tune your monochrome image. Some shots look great in monochrome.

Correcting color

You typically run into colorcast problems when capturing images in artificial light. Cameras do a decent job of correcting for tungsten or fluorescent lighting on the spot, but there's usually room for improvement. The White Balance tool in iPhoto for iOS can help you fine-tune the color in these types of photographs.

When you tap the White Balance button (the WB icon) in the Color toolbar, a menu of icon buttons appears with six presets and two custom options, as shown in Figure 3-15. The presets (from

FIGURE 3-15

The White Balance controls in iPhoto for iOS

left to right) are Sun, Cloudy, Flash, Shade, Incandescent, and Fluorescent. These are similar to the presets in the white-balance menu on your camera.

Cloudy and Shade add warmth. Sun and Flash optimize your image for shooting outdoors and with a flash, respectively. Incandescent and Fluorescent adjust the colorcast to compensate for artificial lighting situations. You can try these settings by simply tapping each. You might get a quick fix right off the bat.

For even more control, tap the Custom Scene Balance button (the icon of a square in a tray) at the far right of the White Balance menu. The Loupe tool appears, which you can drag to an area of the image that should be white or gray, as shown in Figure 3-16. iPhoto then takes that information and makes a custom correction for you. Custom is often the most sure-fire way to correct color — that is, if you have a white or gray area in the image. If you don't, you'll have to use the other alternatives.

FIGURE 3-16

Working with the Custom Scene Balance tool in iPhoto for iOS

The Custom Face Balance tool (the icon of a silhouette in a tray), to the left of Custom Scene Balance, operates in a similar manner as Custom Scene Balance, except it works for skin tones.

Once you've finished correcting the white balance, tap the Color button to exit that adjustment tool.

Removing colorcasts with the White Balance tool usually brings your images to life. To be honest, it just makes them look better.

📷 Tip

Want to see the original image without any adjustments? Just make sure that no tools are selected when you tap the Show Original button.

Step 4: Make local adjustments

Have you ever looked at an image you've been adjusting and said to yourself, "Looks pretty good. Now, if I could only fix that one little

FIGURE 3-17

The brush options in iPhoto for iOS

thing"? iPhoto has a set of eight brushes to do exactly that. Each brush turns your fingertip into a localized editing tool to work on specific areas of the photograph.

Tap the Brushes button (its icon is three brushes) to display the available brushes: from left to right, Repair, Red Eye, Saturate, Desaturate, Lighten, Darken, Sharpen, and Soften, as shown in Figure 3-17.

As I look at this image, there are two local adjustments I want to make. First, I want to brighten the fish in the center of the composition. Second, there are two blemishes in the white background I want to remove. Let's start with the fish.

I tap the Saturate brush. I know it's selected because it has a blue glow around it, as shown in Figure 3-18. I then use my finger and paint on the fish, which applies additional saturation to those areas. To erase my strokes or adjust the amount of saturation applied to the image, I can tap the More button to reveal additional controls.

FIGURE 3-18

Working with the Saturation brush in iPhoto for iOS

Once I've finished, I tap the Brushes button again to deselect the brush and further examine my image.

I notice there are a couple blemishes in the background that I want to eliminate. I can take a closer look by tapping and holding on the photo with two fingers to reveal the magnifying loupe, as shown in Figure 3-19. There's a spot on the right side and some shading in the upper right corner that I don't like. So I tap the image to turn off the loupe, then tap the Brushes button to select the Repair brush.

The minute I choose Repair, the image seems to revert back to its original state. But I'm not worried: The Repair brush is a processor-intensive process, so iPhoto conserves its resources by working on the original image stored in memory. Once I finish the repair, iPhoto will apply it to my nicer-looking adjusted photo.

With the Repair brush selected, all I have to do is finger-paint on the blemishes. Boom! They disappear. If I make a mistake, I can tap the More button and choose Clear Repair Strokes from the menu that appears to erase the repair strokes. Once I'm finished, I tap the

FIGURE 3-19

Checking for blemishes with the magnifying loupe in iPhoto for iOS

Brushes button to apply the repairs to the current photo. Now that looks good!

I use this same procedure for the other brushes in the palette. Brushes encourage creativity. Have fun with these. And if you don't like what you did, use the More menu to clear your current brush strokes or, using the Erase All Strokes option, all your brush adjustments.

Step 5: Apply effects

By the time you've applied brushwork to your photograph, it's probably ready for prime time. But if you want to see what else you can do with your picture, take a look at iPhoto's effects. They encourage fun and experimentation.

When you tap the Effects button (its icon is a set of five stars), directly to the right of brushes, seven effects fan open across the screen: Artistic, Vintage, Aura, Black & White, Duotone, Warm & Cool, and Ink Effects, as shown in Figure 3-20.

FIGURE 3-20

The effects in iPhoto for iOS

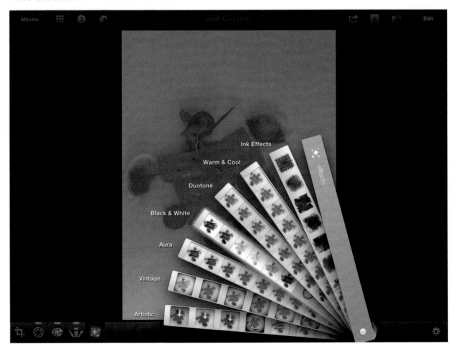

To my mind, the most useful tools are in the Artistic swatch, which has three gradient adjustments (Dark, Warm, and Cool Gradient) plus four additional tools: Vignette, Tilt-Shift, Oil Paint, and Watercolor. Gradient filters can be very useful for landscapes when you have bright skies that need to be tonally aligned with the foreground. The other four tools are great for trying new looks. Once you've experimented, use the More menu to remove the effect — that is, unless you discover something you truly like and want to keep applied.

Editing in Photogene for iPad

I consider Photogene a terrific bargain at $2.99. There's also the Pro version available for $7.99, but most photographers won't need the upgrade. Here, I'm working with the standard version.

Photogene works directly with your existing iPad image library and albums. It doesn't require importing a duplicate file. It's a nondestructive editor, so the original image information is always preserved, and you can undo any work that you've done in Photogene. And best of all, it accommodates the five-step workflow I described for iPhoto.

Setting up Photogene

To access the application settings, tap the Settings button (the *i* icon) in the upper left corner of the screen, next to the Photogene logo. The Settings pop-over appears. Tap the Application Settings button to reveal its options. One option in particular that I recommend is switching to the Black Theme. It's more modern and frames your images beautifully. Tap the Back button when you've made your selections, then tap the Close button to exit the Settings pop-over.

Editing an image

The default view in Photogene displays your existing albums and events from your iPad's library. Choose an image to work on by tapping its thumbnail. The top toolbar displays basic controls, as shown in Figure 3-21, such as Undo, Redo, Revert to Original, left/

FIGURE 3-21

Photogene's tools

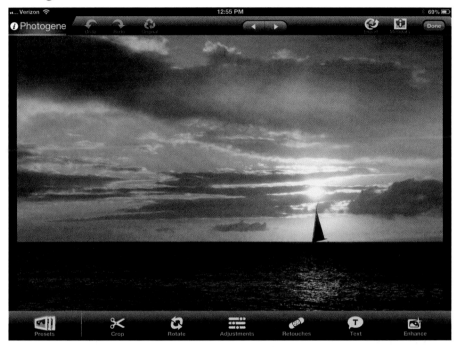

right navigation arrows, Export, Metadata, and Done. The bottom toolbar contains the editing tools, as Figure 3-21 also shows.

In the left corner is the Presets button (the icon of a side view of three photos). The filters in the panel that appears when you tap Presets are good for one-stop editing. Choose a filter that looks good, such as Drama, tap it, and you're done. If you don't like what you selected, tap another filter; it will replace the previous effect. You can tap and hold on the Compare button (the A|B icon) next to the Presets button to see your original version. Tap the Original button (the recycling icon) on the top toolbar if you decide you don't want to apply any of the effects. To exit the Presets area, tap the Close button (the X icon) on the right side above the thumbnails.

◯ Tip

There are dozens of filters in the Presets area. They are handy for testing different looks for an image. This is particularly useful when you want to try something different, but you're not sure what.

FIGURE 3-22

Photogene has a histogram to help you judge exposure.

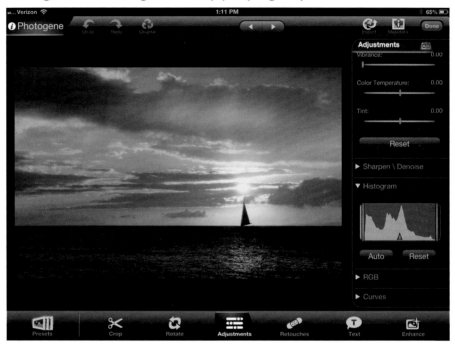

As I mentioned earlier, Photogene accommodates the five-step workflow. Start with the Crop button for Step 1. Then tap the Adjustments button for Steps 2 and 3 to open its panel of controls. (You can see both buttons in Figure 3-22.) One tool I really like in the Adjustments panel is the histogram that shows you a graphical representation of all the tones in your image, with standard levels controls for adjusting the tones.

You can find the localized adjustments for Step 4 in the Retouches panel, whose button is directly to the right of Adjustments. Not only do you have the Heal tool for repairing blemishes, there are seven other brushes, including Dodge and Burn. Very handy!

The Enhance button is in the far right of the bottom toolbar, and its panel contains tools to finish your work of art. Here you'll find Vignette, Center Focus, and an array of handy gradients.

To save your work, tap the Done button in the top toolbar. The thumbnail in Photogene updates to reflect your edits and include

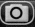

FIGURE 3-23

The export options in Photogene

a "scissors" badge in the lower right corner. (The original image in the Photos app remains unchanged.) To save the edited version to your master iPad library, tap the Export button (the icon of an arrow emerging from a circle) in the top toolbar and make your choice from its pop-over, as shown in Figure 3-23. You have plenty of options available, even the resolution you want for the exported image.

Photogene is a good choice for people who are comfortable with computer-based image editors such as Lightroom, iPhoto, and Aperture. It has an excellent complement of tools, and an intuitive user interface.

Editing in Snapseed

For those who want something a little more hands on than Photogene, take a look at Snapseed, created by Nik Software.

Snapseed has been honored as the iPad App of the Year in 2011, and for good reason: Every pixel feels as though it were designed

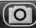
FIGURE 3-24

Snapseed's options for bringing an image into the application

just for tablet photography. And even though it might not look like it on first view, Snapseed works great with the five-step workflow.

Bring a picture into Snapseed by tapping the Image Source button (the camera icon) in the upper left corner, as shown in Figure 3-24. You have the option to take a picture, grab one from your Photos library, or paste an image from the Clipboard (iOS's temporary memory storage area for the last cut or copied object).

First, tap the Crop tool or the Straighten & Rotate tool to get your composition in shape. These basic adjustments are displayed as tile-size buttons on the left side of the screen, as shown in Figure 3-25. Figure 3-26 shows one adjustment in progress (a crop). Apply the desired adjustments, then when the image looks good tap the Apply button (the triangle icon) in the bottom toolbar.

For the workflow's Steps 2 and 3, tap the Tune Image button. This tool allows you to adjust brightness, ambiance, contrast, saturation, and white balance. How do you apply those controls? Tap the image, and then drag your fingertip up or down. Doing so reveals

FIGURE 3-25

The buttons for Snapseed's basic adjustments are shown on the left side of the screen.

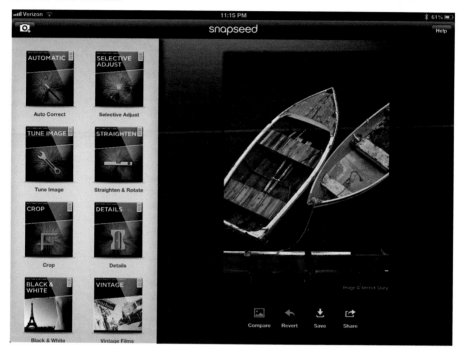

a menu with the five controls, as shown in Figure 3-27. Choose the one you want. Then tap again, but this time drag your finger left and right to set the amount for the control. You can always see the unedited version by tapping the Compare button (the picture icon) in the bottom toolbar. Tap the Apply button when you have the exposure and color to your liking.

For Step 4, localized adjustments, tap the Selective Adjust button on the left side of the screen. Tap the Add button to activate a control point, then tap the area of the image you want to work on. You can make the affected area smaller or larger by using the standard iOS pinch and expand gestures, respectively.

Now tap in the affected area and drag your fingertip up or down. Three options appear in a menu: Brightness, Contrast, and Saturation. Choose the one you want. Then tap and drag left and right to set the amount. You can add multiple control points to one image. Tap Apply when you're finished.

FIGURE 3-26

Applying a crop in Snapseed

For the finishing touches of Step 5, Snapseed provides a whole range of effects — including Black & White, Drama, Grunge, and Tilt-Shift — via the Creative Adjustments button on the left side of the screen.

Once you're finished working, you can add the edited image to your Camera Roll by tapping the Save button in the bottom toolbar. Snapseed also provides export options in the Share pop-over, including Email, Facebook, Twitter, and Instagram.

FIGURE 3-27

Displaying the Fine Tune adjustments by tapping the image and dragging your finger up and down.

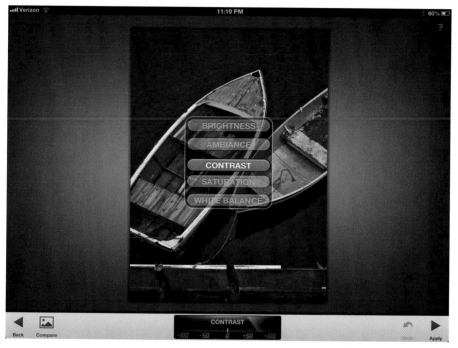

Don't let its simple user interface fool you: Snapseed is a powerful image editor that totally embraces the iPad experience.

Chapter 4

Transferring from the iPad to a Computer

The iPad can do a lot with photos, as Chapters 1 through 3 have shown. The iPad, however, has limited storage. At some point, you need to move your pictures off the tablet to another location.

As you approach this need, think of your iPad as a memory card residing in a digital camera. It's temporary storage for your photographs — just like that SD card you bought at the camera store. In fact, they both may have about the same capacity.

Thinking along these lines, don't expect every picture you take to stay in your camera forever. The same goes for the iPad. You can take pictures with its built-in camera, or you can copy images from your camera memory cards to the device. But the pictures stay there only for the time you need them. Depending on how many photos you shoot, the bulk of those images have to move off the iPad and live somewhere else. And more often than not, that new residence is your computer.

With the idea in mind that the iPad is a memory card, think about what happens when you plug your camera into a computer: You're usually offered a choice or two of what to do next. You have similar choices when you connect your tablet, too.

> 📷 **Note**
>
> When you connect an iPad to your Windows PC or Mac, iTunes may launch because it detects an iPad. If that happens, go ahead and minimize it. You're not ready for iTunes yet.

Transferring from an iPad to a Windows PC

Apple's iPad communicates just fine with Windows PCs. Turn on the iPad and connect it to the PC via its USB cord. A dialog box should appear in Windows asking if you want to import pictures, because Windows sees your device as a camera. (See, it's not just me!) There might be a delay if Windows needs to install a device driver before the options appear. Once everything gets sorted out, go ahead and choose Import Pictures and Videos using Windows Live Photo Gallery, as shown in Figure 4-1.

Windows reads all the pictures on your Camera Roll and presents two options (as shown in Figure 4-2): One option is Review, Organize, and Group Items to Import, and the other is Import All New Items Now. I highly recommend the first option unless you want to make a full dump of your iPad to your computer.

FIGURE 4-1

On a Windows PC, after connecting the iPad, choose Import Pictures and Videos using the Windows Live Photo Gallery option (the third option from the top).

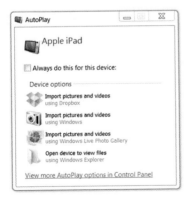

FIGURE 4-2

Windows provides an option to download all images or just a few images from your iPad.

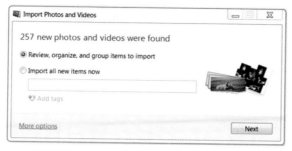

In the next window, your iPad images are presented as groups, as shown in Figure 4-3. Groups are similar to events on a Mac. Photos taken in a certain period are clustered together. You can change the period using the Adjust Groups slider in the lower right corner.

Select the groups you want to import via the check box next to each group, then give your group a name, such as "Photo Booth Portraits" as I did in Figure 4-3. You can add tags, too. The tags are viewed as keywords in many photo-management applications,

FIGURE 4-3

Working with groups for image transfer to Windows from the iPad

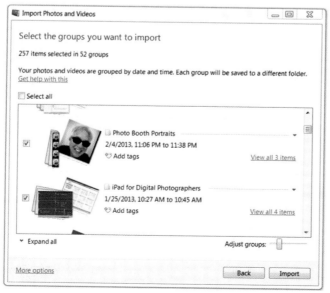

FIGURE 4-4

Organizing imported photos into their own subfolders makes finding them later easier.

including Adobe Lightroom. Once you're ready, click the Import button, and the images are transferred to the designated location on your computer.

I recommend creating an import folder in your Pictures folder. My folder is named "From iPad." Windows creates subfolders for each group I imported, and places them in From iPad. You set up this import folder by clicking the More Options link in the Import Photos and Videos dialog box. You should consider setting up subfolders for different shoots or projects, as shown in Figure 4-4, to make it easier to find relevant photos later.

Once the imported images are organized in your Pictures folder by folder, you can view them in Live Photo Gallery, which comes with Windows. The application also lets you perform basic image editing and apply effects.

Another option is to point to a photo-management application, such as Adobe Lightroom, to your neatly organized picture folders. I'll get into that in a bit.

The real goal is to move only the shots you want from the iPad to the computer. And during the process, to create an organizational structure that will serve you well regardless of the application you use to manage and edit your pictures.

I don't know about you, but I'm feeling more comfortable already.

Transferring from an iPad to a Mac

Let's switch platforms and see how things play out on the Mac, which has a couple of options for simple import.

Importing with Image Capture

In the Mac's Applications folder is an unheralded program named Image Capture. It's part of the standard feature set of the Mac's OS X operating system. And it works very well with iOS devices.

Start by turning on your iPad and connecting it to the Mac via its USB cable. Then launch Image Capture. You're greeted with a window that identifies your iPad, plus any network devices in the vicinity, as shown in Figure 4-5. If it's not selected already, click the iPad's icon in the left column. Any pictures on the Camera Roll appear in the browser window on the right. The images may be presented in list view or thumbnail view. You can switch from one to the other via the two view options buttons (the grid for thumbnail view and the set of lines for list view) in the bottom toolbar — these are the same buttons you see in Finder windows and other Mac apps.

Before you put any wheels into motion, decide where you want to store the images you're about to import. I recommend setting up a folder in your Pictures folder. Use the Import To pop-up menu at the bottom of the window to establish the location for your images. In Figure 4-5, I've created a folder called "iPad mini Photos."

📷 Tip

If you have more than one iPad, set up an import folder for each device in your Pictures folder to help you keep track of which images came from where.

FIGURE 4-5

Importing images into a Mac from the iPad via Image Capture

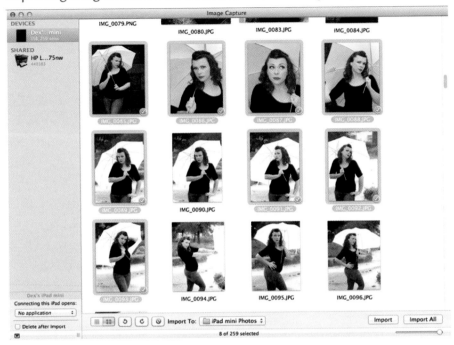

If you want to import everything on the iPad, just click the Import All button. You can also select specific images by pressing and holding the ⌘ key and then clicking on each thumbnail whose image you want to copy. Release the ⌘ key, then click the Import button in the lower right corner of the Image Capture window. Once images are copied to the Mac, they are marked with a green check mark, as shown in Figure 4-5.

Once the images have been imported, double-click any of the thumbnails in either view, and Image Capture opens a larger version of the photo in Preview.

Image Capture has one other trick up its sleeve: By clicking the List View button to the left of the Import To pop-up menu, you can switch to list view and see the EXIF data for your photographs, including ISO, shutter speed, and even focal length if this data were recorded, as shown in Figure 4-6.

FIGURE 4-6

Viewing EXIF data in Image Capture

Importing with Preview

The Preview app can also directly import images from a connected iPad. The procedure is similar to that in Image Capture: Connect the iPad via USB and launch Preview. (It's in your Applications folder.) In the File menu, you should see the name of your iPad near the bottom of the list in one of the Import From menu options. For example, I would choose File ⇨ Import from Derrick's iPad, then be greeted with the familiar import window in thumbnail view.

This time around, you'll make your selections first, then will be asked where you want to put the files. After import, the images will be displayed in Preview with thumbnails on the left and a browser window on the right, as shown in Figure 4-7.

A big difference with Preview, compared to Image Capture, it that once the images are transferred, you can immediately work on them using the tools in the application. To get started, select an image by clicking its thumbnail. Then choose Tools ⇨ Adjust Color. A panel

FIGURE 4-7

Browsing images in Preview

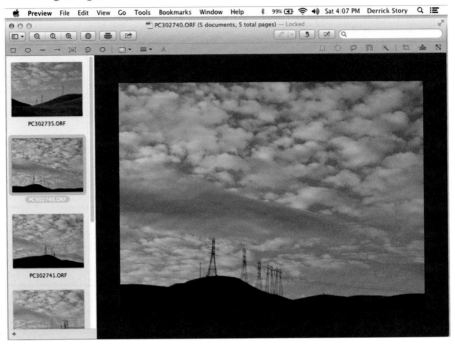

appears, as shown in Figure 4-8, with terrific adjustment sliders, including Exposure, Highlights, Shadows, Sharpness, and even the Eyedropper tool to automatically correct colorcasts.

I don't recommend doing too much image correction work in Preview because it's a destructive editor. In other words, once you save your image with the adjustments, the original on your Mac (but not your iPad) is overwritten — there's no going back. But it's useful for quick touchups right after import.

Tip

If you plan on making image adjustments in Preview, create a copy of the picture first. In Preview, with the original photo open, choose File ⇨ Duplicate to create a working version. Then, when you close the image, Preview asks you to name the picture. You may want to add "edited" to the duplicate's filename so you know it's been adjusted.

FIGURE 4-8

Image adjustments in Preview

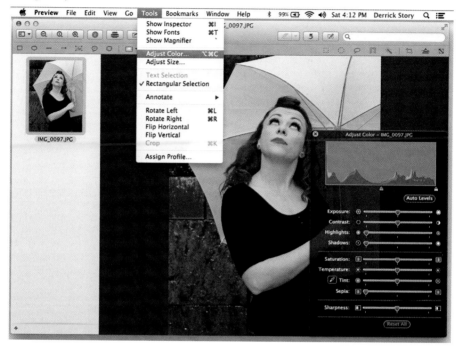

Transferring from an iPad via iTunes

One way to preserve the highest image quality, even after editing the picture on your iPad, is to export the finished product to iTunes.

You can always import photos already transferred to your computer — Windows or Mac — into iTunes by choosing File ⇨ Add to Library, selecting the photos, and then clicking the Open button.

But iPhoto for iOS lets you export images on your iPad directly to iTunes on your computer. (The steps are the same whether you have a Mac or a Windows PC.)

In iPhoto for iOS, select the images you want to copy to the computer from the album storing them. Then tap the Share button in the top toolbar (its icon is a tray with an arrow emerging). In the Share pop-over that appears (see Figure 4-9), tap iTunes. You may be asked whether to share the images' location data along with the images; choose Don't Allow or Allow iPhoto as desired.

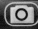

FIGURE 4-9

Sharing to iTunes from iPhoto for iOS

After you tap iTunes in the Share pop-over, the pop-over asks you what images to transfer: Selected, Flagged, All, or Choose Photos.

If you hadn't already selected the photos to transfer and now want to select them from the current album, tap Choose Photos. Tap the thumbnails you want to copy to your computer. A white check mark indicates a selected image. Once you're finished, tap the Next button in the upper right corner of the screen.

Otherwise, tap Selected to transfer the already-selected photos, Flagged to select photos you previously flagged (see Chapter 2), or All to dump all the iPad's photos into iTunes.

iPhoto prepares the images and gives you two choices: Export and Cancel. Tap Export to send the photos to iTunes.

Now go to iTunes on your computer. Your iPad should be connected to your computer via the USB cable or via Wi-Fi — check the Devices pop-over in iTunes to see if the iPad is listed; if so, you're connected. (Connect the iPad via the USB cable if it's not listed in the

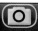

FIGURE 4-10

Shared images from your iPad appearing in iTunes on your computer

Devices pop-over, then to enable Wi-Fi connections in the future, go to the Summary pane for that iPad and be sure the Sync This iPad over Wi-Fi option is selected.)

Select your iPad in the Devices pop-over to open a window with several panes of options. Go to the Apps pane, then scroll down to the File Sharing section and click iPhoto in the list. In the pane at right, your shared folders should be listed, as shown in Figure 4-10.

Select the folder you want to import from the iPad, then click the Save To button in the lower right corner of the right pane. (If you have lots of apps listed, you may have to scroll down to the bottom of the apps list to see the Save To button.) A dialog box appears; in it, navigate to your Pictures folder, or wherever you're placing your images, and click the Open button. The pictures then copy from the iPad to the computer. If you get an error message, chances are your iPad went to sleep. Awaken it, try again, and everything should be fine.

If you want to delete the transferred folder on your iPad, select that folder in iTunes again, then press the Delete or Backspace key on your computer. Just make sure on your computer that the transferred folder and its images are all there first!

Transferring from an iPad to Adobe Lightroom

You can also import images from the iPad directly to your photo-management software, such as Adobe Lightroom.

Begin by launching Lightroom on your Mac or Windows PC and connecting the iPad to the computer via its USB cable. On a PC, once the computer recognizes the iPad, the AutoPlay window may pop up asking what you want to do with the iPad; it's not relevant to this import, so close it.

In Lightroom, click the Import button in the lower left corner of the Lightroom window. Lightroom opens the Import dialog box and displays thumbnails for all the images in the iPad's Camera Roll, as shown in Figure 4-11.

If you click Import immediately, all the photos in the Camera Roll are copied to the computer. If you want just some images copies, click Uncheck All, then select the ones you want. If they're in a sequence, select the first image, press and hold the Shift key, and click the last image you want in the sequence. Click the check box of any selected image in the sequence to mark them all with check marks (that is, to mark them for import).

You can add metadata to the pictures via the Apply During Import section in the panel on the right side of the Lightroom window. But more important in that panel is the Destination section where you can set up the folder structure for your imported images. If you set up specific import folders as I recommended earlier in this chapter, be sure to save your images to the appropriate folders.

For example, Figure 4-11 shows that I am using the subfolder 2012-08-Maui for the photos I'm importing. To do that, I first chose the From iPad as my destination, then selected the Into Subfolder option and chose the Into One Folder from the Organize pop-up menu, then in the Into Subfolder text field I typed in the name of the folder I wanted the images copied to (2012-08-Maui, in this case).

FIGURE 4-11

Importing from the iPad to Lightroom (in Windows 7)

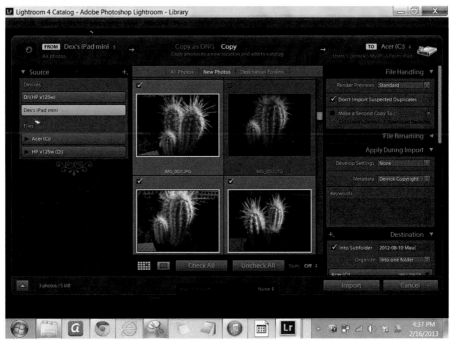

Once everything is set, click the Import button to copy the selected images from the iPad to the desired folder on the computer. Once Lightroom finishes the import, the copied images' thumbnails appear in its library.

Transferring from an iPad to iPhoto or Aperture on a Mac

This probably won't surprise you, but the iPad and iPhoto on the Mac get along quite well. The transferring process is simpler than with Lightroom because you don't have to deal with directory structures and nested folders — iPhoto handles all the organization for you. So does Apple's more powerful image editor, Aperture.

After connecting the iPad to the Mac, Aperture users click the Import button (the down-arrow icon) in the upper left corner of the app window. Then select the iPad from the list of import sources.

From this point, the process is the same as importing in Lightroom, as just described.

Users of iPhoto for OS X should launch iPhoto and connect the iPad via its USB cable. (iPhoto may ask "Do you want to use iPhoto when you connect your digital camera?" Click Decide Later.) If you've brought pictures from the device to iPhoto before, you'll see an area at the top of the screen titled Already Imported. Below that is the New Photos area displaying the thumbnails from the iPad's Camera Roll.

You can import all the new pictures by clicking the Import X Photos button in the upper right corner (X is replaced with the actual number of images available for downloading), as shown in Figure 4-12. If you want to import just a few images, select them by pressing and holding the ⌘ key, then clicking each desired image (a yellow border appears around each selection). You can instead choose a sequence of images by selecting the first photo, pressing and holding the Shift key,

FIGURE 4-12

Importing images into iPhoto on a Mac

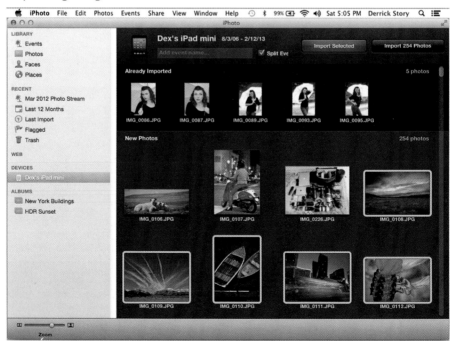

and then clicking the last image in the sequence. Release the ⌘ or Shift key and click the Import Selected button.

Whether you import all or some images, iPhoto copies them from the iPad and organizes them as events (like the Photos app does on the iPad, as Chapter 2 explains). You can give the event a name by typing in the text box in the upper left. You can separate images captured over a long time into separate events by selecting the Split Events option.

📷 **Tip**

You set the duration for events in iPhoto's Preferences dialog box (choose iPhoto ➪ Preferences). Your choices are 1 Week, 1 Day, 2-Hour Gap, and 8-Hour Gap.

Once the import is completed, iPhoto asks whether you want to keep or delete the photos on the iPad. I recommend you choose

FIGURE 4-13

Events displayed in iPhoto for the Mac

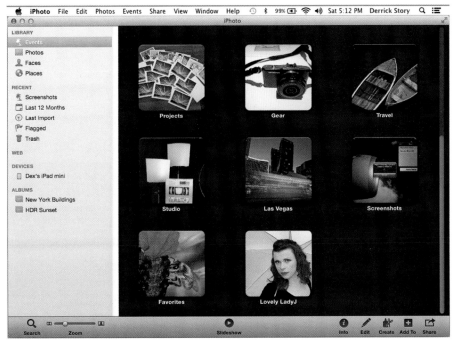

Keep Photos, just in case the transfer was unsuccessful. You can always clean up the photos on your iPad later.

You can see your new images neatly organized in iPhoto by clicking Events in the Sidebar's Library section, which displays the Events library view, as shown in Figure 4-13. If you're iPad is still connected to the Mac, you also see the iPad's name listed in the Devices section.

> **Tip**
>
> iPhoto and Aperture share the same library container, usually located in the Pictures folder on your Mac. You can open your iPhoto library in Aperture by pressing and holding the Option key when you launch Aperture, and then selecting the library name from the dialog box that appears. Any changes you make to an image in Aperture are visible in iPhoto.

Transferring from an iPad via PhotoSync

An excellent file-sharing app that works with both Mac and Windows is Touchbyte's $1.99 PhotoSync. The required PhotoSync Companion software for your Mac or Windows PC is available free on the PhotoSync website (www.photosync-app.com). I use PhotoSync with both platforms, and it works great.

This software is particularly useful when you want to move an image or two from one device to another. PhotoSync not only works from iPad to computer, but also to any other iOS device that is running the app. You can go from iPhone to iPad, iPad to iPad, computer to iPhone, iPad to computer, and so on.

Another PhotoSync strength is that it doesn't mess with the files in any way. What you send from one device is what you receive on the other. You don't have to worry about a reduction in quality as you move files around.

After you've downloaded and installed PhotoSync Companion for Windows or for Mac, I recommend pinning it to the taskbar (in Windows) or adding it to the Dock (on the Mac) so it's easy to access. Launch the application; an instruction sheet should greet you explaining its basic operations. A "drag and drop" box also appears for sending files, as shown in Figure 4-14.

FIGURE 4-14

Images copied to a Windows PC via PhotoSync from an iPad

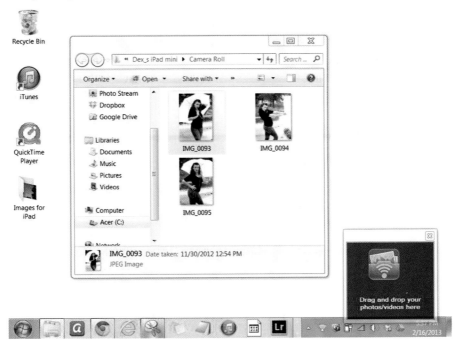

On the iPad, launch PhotoSync. It will display thumbnails from your Camera Roll that you can tap to select. Select one or more images, then tap the red Sync button in the upper right corner of the screen. PhotoSync asks if you want to sync the selected images or all the images. Choose Sync Selected. In the menu of destinations that appears, choose the name of your computer, as Figure 4-15 shows. (The computer must have the PhotoSync Companion app running and be on the same Wi-Fi network as your iPad.)

After you select the computer to transfer the files to, PhotoSync begins the transfer. When it's done, PhotoSync Companion on your computer opens a window displaying your files. The default location for the photos is \Pictures\PhotoSync\Camera Roll unless you've set up a different destination in PhotoSync Companion's preferences. From this point, you can view the photographs, move them to another location, or store them in your photo management software.

The Mac version also has the option of sending images directly to iPhoto or Aperture. In PhotoSync Companion's Preferences

FIGURE 4-15

Choosing the computer to send your files to using PhotoSync on an iPad

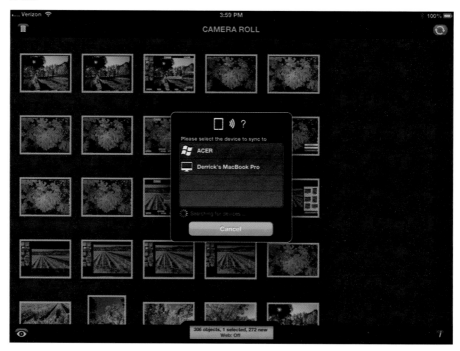

dialog box, go to the Receive pane and select your desired photo-management software, as shown in Figure 4-16. Now when you send the images, they will go to the photo management app instead of directly to the Pictures folder. You can always change the preference again if you want your images to go to another folder.

Once you're familiar with PhotoSync transfers, you can branch out and use it to send files from the computer to iOS devices or from your iPad to Dropbox and other online storage services. You can even post from it to a Flickr, Picasa, or Facebook account. It is the Swiss army knife of photo transfer for iPad users.

Transferring from an iPad via Photo Transfer

Another super-handy file sharing app for the iPad is ERCLabs' $2.99 Photo Transfer app. It features much of the same functionality

FIGURE 4-16

PhotoSync Companion's preferences on a Mac (at right)

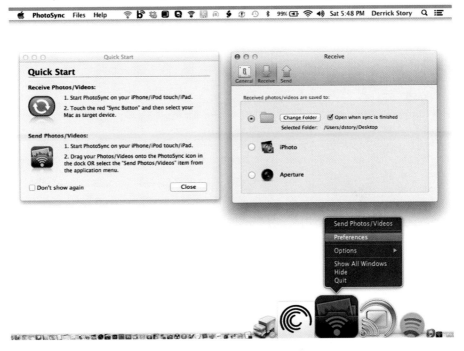

as PhotoSync, but has a gorgeous interface. Photo Transfer is particularly good for sending pictures from the iPad to any Windows PC or Mac. It isn't as adept, however, at sending images from computers to iOS devices. For that work, I prefer PhotoSync.

The most straightforward way to use Photo Transfer for copying pictures from your iPad to a computer is via its web interface. Begin by launching Photo Transfer on your iPad. Then tap the Send button. The application presents options for communicating with a Mac or Windows PC or another iOS device. Select the type of device you want to send images to.

In the next screen, select the images you want to send. You'll also see a web address to type in the browser's URL field on your computer, as shown in Figure 4-17. Make your photo selections on the iPad. Then enter the web address in the browser on your computer and press the Return or Enter key to begin the transfer.

The Photo Transfer then opens a web page on your computer with the selected photos. From this web page, you can download

FIGURE 4-17

Setting up photo sharing in Photo Transfer for the iPad

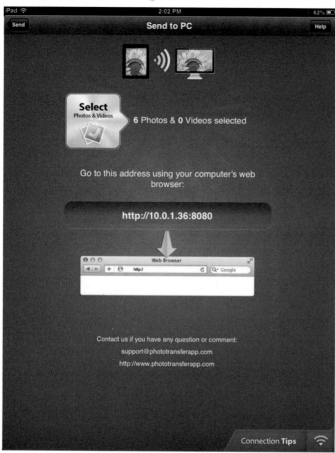

the images to your computer. The advantage to this approach is that you don't need a companion program to communicate with the iPad. If you're visiting friends, for example, you can share full-resolution images right on the spot. And the notion that your iPad is building and serving up a web page is kind of cool.

Photo Transfer does have an optional companion app for the Mac if you don't prefer sharing via the web browser. The choice is yours. Either way, this handy utility helps you copy your iPad photographs to other devices.

FIGURE 4-18

Tap the red Delete button once you've selected the images you want to remove from your iPad.

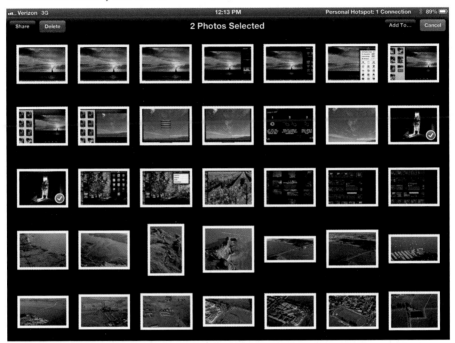

Cleaning Up Transferred Images

All the techniques in this chapter are for copying your images from the iPad to the computer, so your pictures remain on your tablet. You should tidy up regularly, removing the shots from the iPad that you have copied elsewhere — as you would with a camera's SD card. After all, the iPad has limited space.

A simple way to delete images is to use the Photos app on your iPad. Go to the Photos pane, then tap the Edit button in the upper right corner. Tap the images you want to remove, then tap the red Delete button in the upper left corner, as shown in Figure 4-18. Your photos are removed from the iPad, freeing precious memory for new pictures.

Tip

If you need to remove pictures from a sequence, tap the first thumbnail with two fingers, then drag both fingers across the other thumbnails. As you drag, the familiar blue check mark is applied to them, indicating they are selected. (Your iPad needs to run iOS 6 or later for this technique to work.)

Chapter 5

Transferring from the iPad to the Cloud

Have you ever noticed that when you get a paper cut, it suddenly feels like you use that finger for everything? You might even say to yourself, "Wow, I never realized that pinkie was so important." Our personal data is like that too. E-mail, contacts, calendar appointments, and, yes, especially our pictures can be taken for granted ... until suddenly they're gone.

In my experience, the best backup plan is the one that's easiest to implement. If you don't have to do anything other than set it up, it's probably effective. At the other end of the spectrum is manual backup. Not only do you have to remember to do it. But you have to make it happen — time after time after time.

The best easy backup strategy involves the use of the cloud. Ideally, you'll embrace the cloud backup option as your safety net, and possibly investigate more complicated manual sharing for specific purposes.

As you read, I ask that you pick one of these approaches for your iPad workflow and implement it right away. You can always change your mind later. But while you contemplate the best service for you, I want your data safe.

What Is the Cloud?

In essence, the cloud is a computer with lots of storage residing at a different location from the device you're holding in your hand. Communication between the two locations takes place through

the Internet. By taking advantage of the cloud's great capacity and availability, you can store lots of data without filling up your personal device.

Cloud storage is a perfect match for the iPad. Even though iPads are available with as much as 128GB of storage, they're expensive. Most people I talk to have 32GB iPads. Without cloud services, that space would be quickly consumed with pictures, movies, and music.

Through Apple's iCloud service, for example, I have additional gigabytes of online storage that I can use for backups and sharing. And most of the time, that sharing is with myself. "That sounds crazy," you think. It isn't. Here's why.

My entire music collection would not fit on an iPad. In fact, it wouldn't fit on five iPads. Yet I want all my music available to me via my mobile devices. Through iTunes Match, the music storage service that's part of iCloud, I can store all my iTunes-purchased

FIGURE 5-1

Songs stored on the cloud using iTunes Match. The cloud symbols indicate that the songs themselves do not reside on the computer, yet they are available for streaming.

songs remotely, yet have them available for my computer and mobile devices, as shown in Figure 5-1. (For $25 per year, I can store all my music, whether purchased from iTunes or not.) With an Internet connection I can stream my music from the cloud to my device. Or, I can temporarily download specific songs from iCloud to my iPad for those times I know I won't have Internet connectivity.

What works for music is available for pictures, too. Apple also stores 1,000 of my photos via Photo Stream, which is the part of iCloud that's dedicated to images. So every picture I take with my iPhone or iPad is automatically saved to the cloud. Not only does this provide me automatic back up, it makes it easy to share those images among my devices. I don't have to "send" my iPhone pictures to my iPad. They just show up in the Photo Stream pane of my Photos app, as shown in Figure 5-2.

I take this a step further by having all those images flow from iCloud into my iPhoto application on the Mac. They are both protected and accessible there. (I of course back up my Mac

FIGURE 5-2

The Photo Stream pane on an iPad

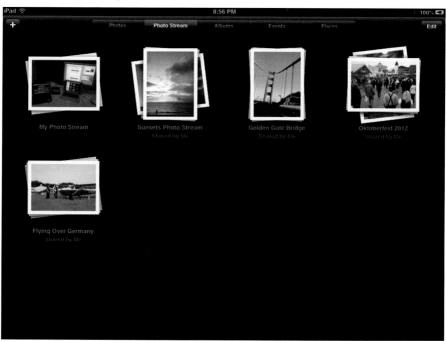

automatically using the Time Machine software that comes with OS X; all I had to supply was the external backup drive.)

Because the iPad is a mobile device, the odds of losing it are greater than for your computer sitting on a desk at home. If you embrace the ideas in this chapter, however, you should never lose any important information. By having your data backed up and stored in multiple locations, you can enjoy the benefits of mobility without putting your data at risk. Let's take a closer look at how these technologies work.

Using Apple's iCloud

iCloud is best for Apple-centric workflows, but it does work for Windows too.

By virtue of owning an iPad, you can set up an iCloud account for free with 5GB of storage for files. You also can save the 1,000 most recent images in Photo Stream — it doesn't count against that free

FIGURE 5-3

iCloud settings on an iPad

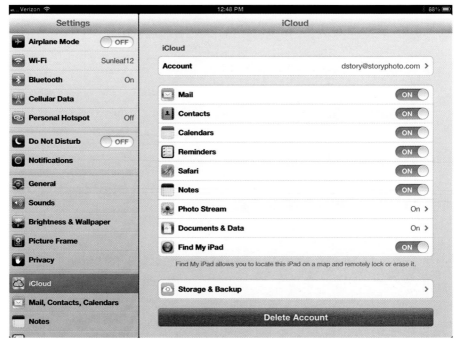

5GB allocation. Neither does iTunes Match music. If you already have an iCloud account, it's simple to enable it.

On the iPad, go to the iCloud pane in the Settings app. At the top of the iCloud pane is the Account option where you can set up a new account or sign in to an existing account, as shown in Figure 5-3. You can also enable the iCloud features listed below the Account option. You have control over the type of data shared on the cloud. Those options include:

- **Mail:** iCloud includes an e-mail account.
- **Contacts:** Your database of people and their contact info.
- **Calendars:** Your appointments calendar.
- **Reminders:** Your to-do lists.
- **Safari:** Your bookmarks.
- **Notes:** Your notes; it's like an electronic notebook you can always access.
- **Photo Stream:** Photos captured by your iOS devices.

FIGURE 5-4

The Storage & Backup pane in the iCloud settings for the iPad

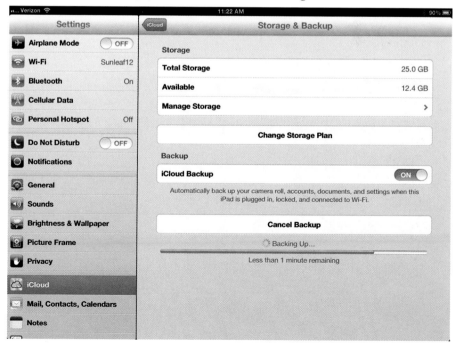

- **Documents and Data:** Pages, Keynote, and other document files in apps that support iCloud Documents.
- **Find My iPad:** A utility that helps you locate a missing iPad.

I use all these functions. You might not think you need your contacts on the iPad until you have to look up one.

Once you have iCloud enabled on the iPad, make sure you've activated the same account on any other iOS devices you have, such as an iPhone. The data should start to sync across your devices in a short period of time — it does require a Wi-Fi or cellular connection. Typically, it's not instantaneous right after setup. But it should be all wired up in an hour or so, and after that data will be shared very quickly. Then, for example, when you add new people to your contacts on the iPhone, they will also appear in your contacts on the iPad. It's the dream of single-entry data.

Backing Up via iCloud

The last basic feature in the iCloud pane is Storage & Backup, listed at the bottom of the iCloud pane. Tap it to reveal a second screen that lists your total storage and how much you have remaining, as shown in Figure 5-4. I'll come back to managing storage in a minute. First, I want you to set up your automated backup.

Also in this pane is iCloud Backup. I recommend that you turn it on. This automatically saves data from your Camera Roll, account settings, and documents when your iPad is connected to a Wi-Fi network. This is the "easy" solution I described at the beginning of the chapter. You have 5GB of storage available initially, and you can purchase more depending on your needs. I have a total of 25GB for my two iPads, iPhone, and Mac. I also recommend enabling iCloud Backup on any other iOS devices you have.

Once all your backups have been enabled, you can check your work by tapping Manage Storage in the iCloud settings in the iPad's Settings app. You are presented a list of devices and documents that are currently being backed up, as shown in Figure 5-5. Doesn't that feel good!

Now tap the Storage & Backup button at the top of the screen to go back to the Storage & Backup pane. You'll see that you can initiate a manual backup by tapping Back Up Now at the bottom of the pane.

FIGURE 5-5

The Manage Storage pane in the iCloud settings on the iPad

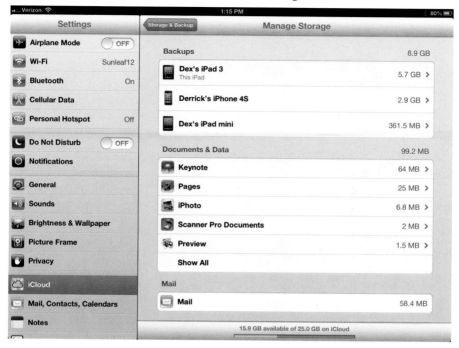

The iPad will go through the entire backup sequence and give you a refreshed date for last backup.

This approach — using iCloud — is the definition of easy. Now that you have everything set up, you are protected. Yes, you can use other backup methods concurrently with iCloud. But for now, the big safety net is in place.

Using Photo Stream

The pictures management aspect of iCloud is called Photo Stream. Once you've enabled it in the iCloud settings, every picture you take with an iOS device is saved to Photo Stream and made available on your computer, iPad, and iPhone. Photo Stream stores as many as 1,000 photos. After you reach 1,000 photos, the older images are removed from Photo Stream (but not from your iOS devices or computers) as new ones are added. So it's worth thinking about how to save some or all your pictures floating through iCloud.

The logical home base is your Mac or Windows PC. Not only do these devices have more storage capacity, they also receive the full-

FIGURE 5-6

Photo Stream enabled in iPhoto on a Mac

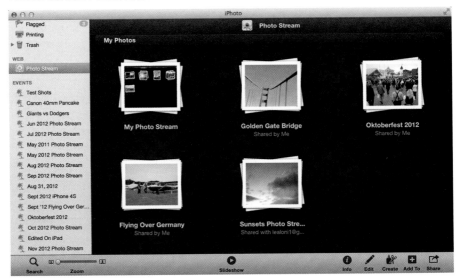

FIGURE 5-7

A full-resolution iPhone 4S picture displayed in iPhoto on the Mac

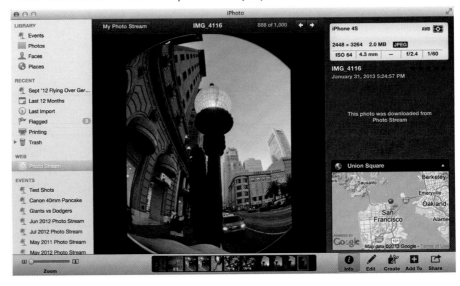

FIGURE 5-8

A photo displayed at lower resolution on an iPad

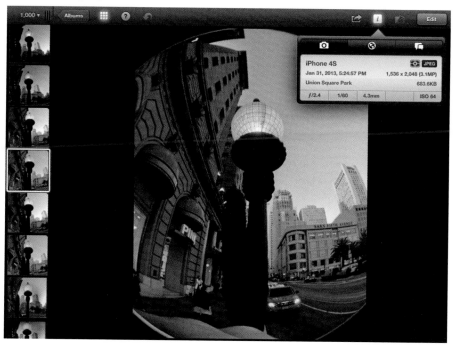

resolution versions of the Photo Stream pictures. So what exactly does that mean?

For example, I take a picture with my iPhone 4S that measures 2,448 × 3,264 pixels (an 8-megapixel image) with a file size of 2MB. Because I have iCloud enabled on my iPhone, the image is saved to my Photo Stream. I then enable Photo Stream on my Mac via iPhoto, as shown in Figure 5-6. (Using iPhoto or Aperture on a Mac is the easiest way to manage your Photo Stream.) The picture appears in iPhoto at 2,448 × 3,264 pixels and 2MB, as shown in Figure 5-7. That's the full resolution of what I originally captured.

All right, so you may be thinking, "That's nice, Derrick. The image transferred is virtually the same size as the image you captured. That's not really big news." You wouldn't think so, until you explore the next scenario.

On my iPad, that same picture appears via Photo Stream at 1,536 × 2,048 pixels (3.1 megapixels) with a file size of 683.6KB, as

shown in Figure 5-8. That's a lower-resolution version. Images on iCloud are served differently to different devices. Ha!

It actually makes sense. Each photo is sized to look good on the device it's served to. But in terms of archiving, going from iCloud to your computer makes the most sense for two reasons:

- First, your computer gets the highest resolution version of the image possible.
- Second, your computer has more storage capacity to deal with these bigger pictures.

This scenario is a perfect example of the basic philosophy of this book: Your iPad is a mobile device with limited storage capacity, and the computer is the home base for all your content. Every ship needs its harbor.

Taking Control of Your Photo Stream

Just because all your images are flowing into the Photo Stream doesn't mean that everything has to stay there. You do have choices on how you manage your Photo Stream. Let's take a closer look.

Saving pictures from your Photo Stream to your iPad

Images that appear in your iPad's Photo Stream but that originated on another device, such as an iPhone, can be saved to your iPad's Camera Roll. This moves the picture from iCloud to the storage in the iPad.

There are a couple reasons why you might want to move pictures from iCloud to your device. One scenario is that you might want to edit an image that's residing in your Photo Stream. Another is that you might want to manually delete an image from the Photo Stream, thereby removing it from all devices that haven't copied it locally such as to, you guessed it, the Camera Roll. (I explain how to do that in the next section.) So, if you want to have that picture stay on your iPad, you should copy it to the Camera Roll.

Regardless of why you want to save a picture from your Photo Stream to the iPad, here's how you do it:

1. Open the Photos app.

FIGURE 5-9

Saving a single image from your Photo Stream to the iPad

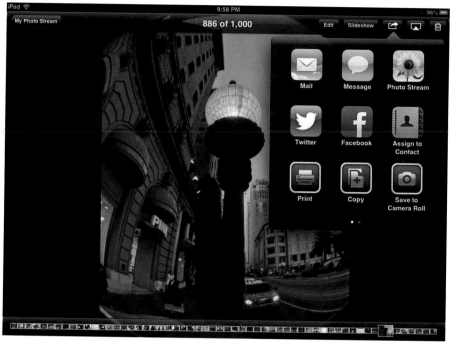

2. Go to the Photo Stream pane and tap the image you want to save.

3. Tap the Share button in the upper right corner of the screen.

4. Choose the Save to Camera Roll option in the menu that appears, as shown in Figure 5-9.

To check that it is saved on the iPad, navigate to the Photos pane in the Photos app and make sure the picture is there. It is now saved. Even if you delete it from the Photo Stream, a copy resides on the iPad.

If you want to save multiple pictures to your Camera Roll, then use this method:

1. Go to the Photo Stream pane.

2. Tap the My Photo Stream album to reveal the thumbnails of the photos stored in iCloud.

3. Tap the Edit button in the upper right corner.

4. Choose the pictures you want to copy from your Photo Stream by individually tapping each one, or by tapping and

FIGURE 5-10

Copying multiple images from your Photo Stream to the iPad

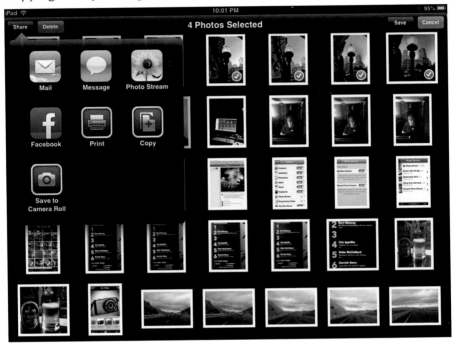

holding with two fingers and dragging across the thumbnails to select a range. Check marks appear next to each selected image.

5. Tap the Share button in the upper left corner.

6. Choose the Save to Camera Roll option in the menu that appears, as shown in Figure 5-10.

7. All selected images are copied to your iPad's local storage (here, the Camera Roll).

Deleting images from your Photo Stream

We all take photos that we don't like. And sometimes we really don't like them. So the thought of ugly shots being pushed automatically to every device we own isn't a pleasant one.

Fortunately, you have veto power over your Photo Stream. You can delete an image, or an entire raft of bad shots, from all your iOS devices.

To delete images, go to the Photos app, then follow these steps:

FIGURE 5-11

Deleting images from Photo Stream

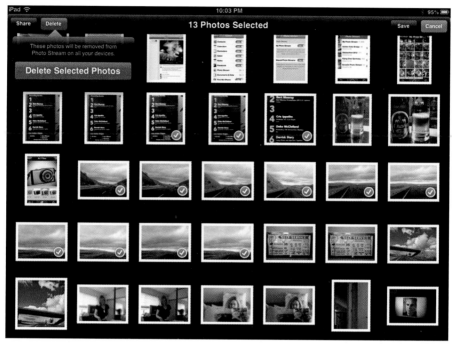

1. Open the Photo Stream pane.
2. Tap My Photo Stream
3. Tap the Edit button in the upper right corner.
4. Choose the pictures you want to copy from your Photo Stream by individually tapping each of them, or by tapping and holding with two fingers and dragging across the thumbnails to select a range. Check marks appear next to each selected image.
5. Tap the red Delete button in the upper left corner of the screen. This warning will appear: "These photos will be removed from Photo Stream on all of your devices," as shown in Figure 5-11. Yes! Vaporize them!
6. Tap the Delete Selected Photos button that appears below the warning.

The images are removed from the Photo Stream pane on your iPad, and from any other Photo Stream-enabled devices. Just remember: If you copied an image to local storage, such as the

Camera Roll or other album on an iOS device or to a folder on your computer, that image will not be deleted even though its original is deleted from Photo Stream.

Using Shared Photo Streams

If you have a collection of images that you want to publish to their own Photo Stream, you can set up a Shared Photo Stream. The access to this collection can be limited to just you, so it can appear on your devices and nowhere else. Or you could invite other people to view them on their devices or via the web.

A typical scenario would be to show off a collection of vacation photos you're proud of, but you don't want people to see the goofy images your family took of each other at the burger bar. The selected images would be in the Shared Photo Stream, while all the vacation shots, including those from the burger bar, would be in the master (private) Photo Stream.

FIGURE 5-12

Choosing photos for a Shared Photo Stream

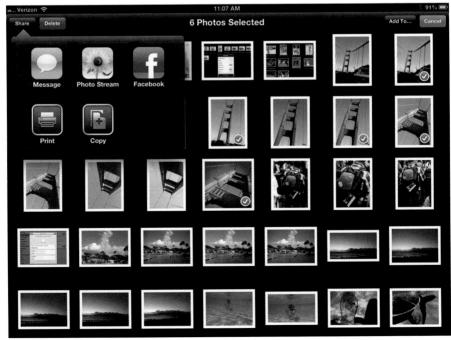

The initial steps for setting up this collection are similar to what I showed you earlier in this chapter. Open the Photos app, go to the Photos pane to display images' thumbnails, tap the Edit button in the upper right corner, and select the images you want to appear in the Shared Photo Stream (shown in Figure 5-12). Then tap the Share button in the upper left corner of the screen. Finally, choose New Photo Stream in the dialog box that appears, as shown in Figure 5-13. (If you choose an existing Shared Photo Stream, the selected images are added to it.)

In the dialog box that appears, you have the opportunity to share this Shared Photo Stream with other people. If they have iCloud accounts, enter the e-mails they use for iCloud access in the To field. If the Shared Photo Stream is just for you and your devices, leave this area blank.

Then, give your new Shared Stream a name. I've selected Golden Gate Bridge, as shown in Figure 5-14. And finally, if you want this stream to go public and appear on iCloud.com, set the Public

FIGURE 5-13

The New Photo Stream option

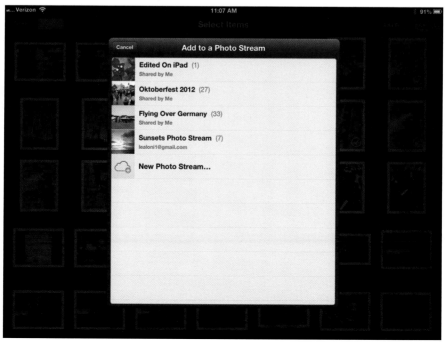

FIGURE 5-14

Giving the Shared Photo Stream a name

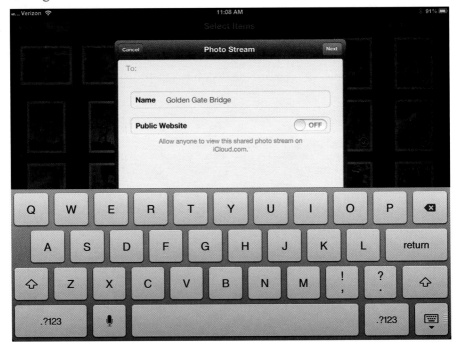

Website switch to On. This is useful for folks you want to share the images with but who don't have an iCloud account. Otherwise, leave it off. Then tap Next.

In the last dialog box, you can enter a comment about the photos, as shown in Figure 5-15. Comments are useful for viewers to know the context of the series. (They can add their own comments, by the way.) Then tap Post.

Your new Shared Photo Stream appears on all your iCloud-enabled devices in the Photos app's Photo Stream pane. It also shows in the Photo Stream section of iPhoto or Aperture on the Mac.

If you decide that you no longer want to share that stream, you can delete it. To remove a Shared Photo Stream, go to the Photo Stream pane in the Photos app. Tap the Edit button in the upper right corner. An X appears in the corner of each Shared Photo Stream album. Tap the X to delete that Shared Photo Stream from all devices. Tap the blue Done button when you're finished.

Adding a comment about the Shared Photo Stream

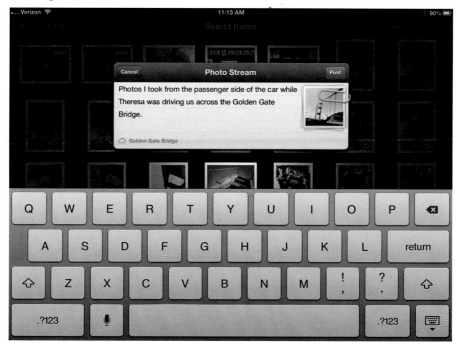

Connecting Photo Stream to a Windows PC

Photo Stream connects reasonably well with a Windows 7 or Windows 8 PC, although not as smoothly as with a Mac. The first step is to download the iCloud control panel for Windows (http://support.apple.com/kb/DL1455) and install it. Once you do so, you can enable Photo Stream by clicking the Options button and checking the boxes next to My Photo Stream and Shared Photo Streams, as shown in Figure 5-16, in that control panel.

The location for your Photo Stream folders will also be listed. The default residence is the folder Photo Stream inside your Pictures folder. If you've enabled all the features, you'll have three new folders in your Photo Stream folder: My Photo Stream, Shared, and Uploads.

The Photo Stream folder is the reservoir for your master Photo Stream, Shared contains your Shared Photo Streams, and Uploads is used to drop images from the Windows PC to be added to the Photo Stream.

FIGURE 5-16

Setting up Photo Stream on a Windows 7 or 8 PC

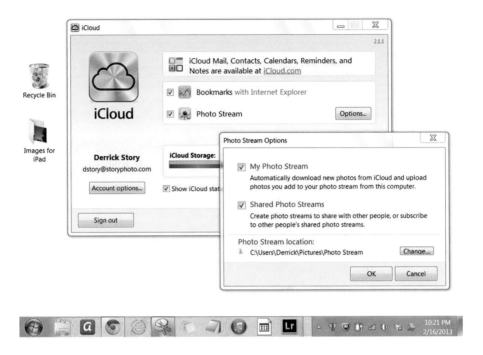

In theory, this all should "just work." I say "in theory" because, initially, I had problems nudging my Windows PC to interact with my Photo Stream, even after I had checked all the options in the iCloud control panel. I did have some luck after signing out of iCloud, then signing back in, to refresh the connection. Once iCloud and the PC started talking, the updates to Photo Stream flowed into my PC's Pictures library in a timely manner.

After you install the iCloud control panel, Photo Stream is added to the Favorites column in Windows Explorer (called File Explorer in Windows 8), as shown in Figure 5-17. When you click the Photo Stream favorite, your main Photo Stream and the Shared Photo Streams are displayed in an Explorer window. It's a handy time-saver for viewing your online images.

 Tip

If you've used an old MobileMe account with your PC, you may first be prompted to sign out of your MobileMe account before signing in to iCloud.

FIGURE 5-17

Photo Stream added to the favorites in Windows Explorer

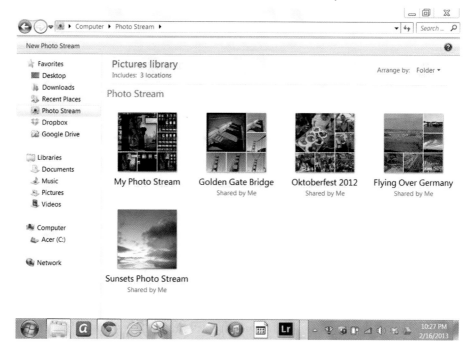

The Windows experience for Photo Stream isn't as seamless as its integration with the Mac's OS X. But it does work, and that's good news for folks who use multiple computing platforms.

Connecting Photo Stream to a Mac

iCloud life gets considerably easier when you connect via a Mac running OS X 10.8 Mountain Lion or later. In this configuration, iCloud is integrated in the operating system. Plus, you have your choice of two photo management applications — the $15 iPhoto (which is a free Mac App Store download as part of the iLife suite if you buy a new Mac) or the $80 Aperture — to streamline the workflow even further. Once configured, your pictures automatically appear in the application of your choice and are copied to the Mac's hard drive. This is an ideal scenario for backing up the images from your mobile devices.

Setting up Photo Stream on your Mac is basically a two-step process.

Step 1 is to enable Photo Stream on your Mac by launching System Preferences, double-clicking the iCloud button to open the iCloud system preference, and checking the box next to Photo

FIGURE 5-18

The Photo Stream option in the iCloud system preference on a Mac

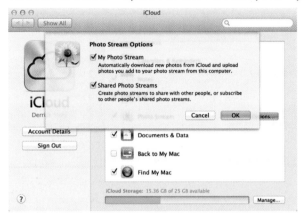

FIGURE 5-19

Setting up Photo Stream Preferences in iPhoto on a Mac

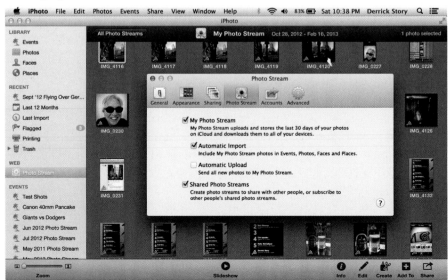

Stream. Then click the Options button, and check the boxes next to My Photo Stream and Shared Photo Streams, as shown in Figure 5-18.

Step 2 is to open iPhoto or Aperture on the Mac and perform a similar process. Open the Preferences dialog box (choose iPhoto ➪ Preferences or Aperture ➪ Preferences) and go to the Photo Stream pane, then check all the boxes except Automatic Upload, as shown in Figure 5-19. This sets up a one-way flow to the Mac from Photo Stream, but it won't send images that you work on in iPhoto or Aperture to the Photo Stream.

With this configuration, all the images you save to Photo Stream from your iPhone and iPad will flow to iPhoto on your Mac and be stored there for safekeeping.

Using Other Cloud Services

Photo Stream isn't the only cloud in the sky when it comes to storing and sharing your images online. There are a handful of excellent services as well. They come in particularly handy if you work in a Windows environment or a mixed-platform environment, where you don't have iPhoto or Aperture on every computer,

Using Dropbox

Even though it's primarily a file-synchronization service, Dropbox includes the Camera Upload feature that allows you to automatically save any picture you capture with your iPhone or iPad to a folder in your Dropbox. Much like Photo Stream, Camera Upload is automatic once enabled. I think it's particularly attractive for Windows users because Dropbox works better on Windows than Photo Stream does.

When you sign up for Dropbox (www.dropbox.com), you're provided 2GB of space at no charge. You can purchase additional storage, or "earn" more through incentive programs such as referring other users to the service. (I currently have 3.2GB of free storage.) Just remember that uploading photos to Dropbox counts against your Dropbox storage limit — unlike how iCloud gives you free storage for 1,000 Photo Stream photos.

Dropbox is easiest to use when installed as an application on your iOS device or computer. You can also access your files through

FIGURE 5-20

Viewing images in the Dropbox app for the iPad

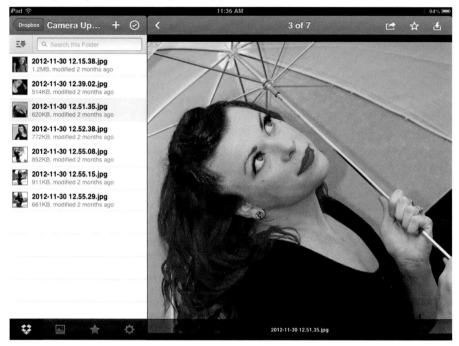

a secure web interface at www.dropbox.com. You can enable Camera Upload on all your iOS devices, or just those you select. (I have it turned on for my iPhone only.) Any file saved to the Camera Roll on my iPhone goes to the Camera Uploads folder on Dropbox and is available via the Dropbox app on all my devices, as shown in Figure 5-20.

Dropbox's image sharing and storage aren't limited to the Camera Upload feature. Many iOS applications can save directly to Dropbox, allowing it to serve as a backup for your edited images and other documents, too. (I've set up a Dropbox folder called iPad Share that I use to save images from Photogene, Snapseed, and iPhoto for iOS.)

In Photogene, I can save directly to Dropbox, as shown in Figure 5-21. With Snapseed and iPhoto, I tap the Share button, tap Open In in the Share pop-over that appears, and then choose Open in Dropbox from the menu that appears. On my computer, I drag the

FIGURE 5-21

Copying an edited image from Photogene to Dropbox on an iPad

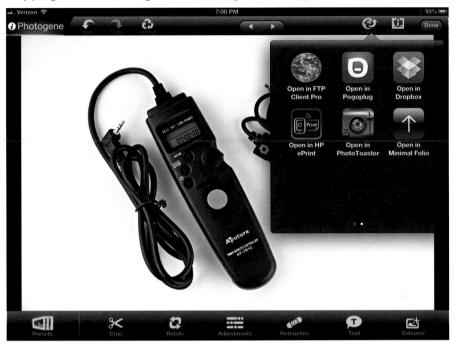

photos from Dropbox to my computer's hard drive. This is an easy way to move my edited photographs from the iPad to my computer.

Because Dropbox is so fluid, you can use it in different ways. Here are a few of my favorite scenarios:

Automatic backup and sharing of iPhone pictures: Enabling Dropbox's Camera Uploads on your iPhone ensures that your mobile photos will be safe, even if you misplace your iPhone. This is also a viable method for sharing your iPhone pictures with the iPad.

Saving and copying edited photos to a computer: Once you've edited a picture on the iPad, it stays there unless you copy it to another location. By sharing the image to a folder in Dropbox, you've made a copy that's located off your device. Not only have you safeguarded the image, but also the work you've done to it.

Sharing your work with coworkers, friends, and family: Dropbox allows you to create shared folders with controlled access. You can create a shared folder for work, family, or friends. Access is provided by invitation. And because Dropbox works on practically

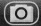

any device or platform, odds are good that you can design a system that meets everyone's needs.

Using Google Drive

You can also share files in the cloud via Google Drive, which provides 5GB of free storage (and you can buy more, of course!). Like Dropbox, Google Drive apps are available for Windows, Mac, and iOS devices.

The strength of Google Drive is the speed at which it synchronizes. It's quite fast, with images available quickly on all shared devices. On the downside, the user interface isn't as friendly as Dropbox's.

You can create folders on Google Drive for specific purposes. For example, I have a Photo Share directory that stores images from my iPhone and iPad. But I have to place the items there manually.

I can save edited images from my iPad's photo apps to Google Drive by using the Open In option in the Share pop-over, as shown in

FIGURE 5-22

Copying images to Google Drive from iPhoto for iOS on an iPad

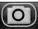

Figure 5-22. The picture is placed in the My Drive directory, which is basically at the top level of your Google Drive.

It's hard to argue with 5GB of free online storage. And over time Google Drive is bound to evolve. But for ease of use, I currently prefer Dropbox or Photo Stream.

Creating your own cloud with Pogoplug

To this point, everything I've described involves using services created and maintained by others. What if you want more control over your data? One option is to set up your own cloud storage where you're sending information to your hard drives. This can be done — and without too much fuss.

Lots of options are available, but the one I currently recommend is Pogoplug (http://pogoplug.com/devices). The system is easy to implement: You purchase a hardware device that lets you connect a hard drive to your Internet router at home (or any location that you have access to). Then you install the Pogoplug app on your iPad,

FIGURE 5-23

Viewing the contents of a Pogoplug drive remotely from an iPad

iPhone, and your computer. Pogoplug asks you to create an account and sign in. Once everything is set up, you can connect your mobile devices and computer to the networked hard drive. You can read data from this drive and write to it as well. With Pogoplug, it doesn't really matter where you are: The networked drive is visible to a local area network, such as your Wi-Fi at home, as well as over the Internet, as shown in Figure 5-23.

I've downloaded stored images from my Pogoplug drive while traveling hundreds of miles from home. It's a great feeling being able to use the iPad to talk to your hardware back home.

Chapter 6

Presenting Your Mobile Portfolio

Do you remember the first time you saw a photograph on an iPad? I do. I was captivated. My mind instantly started weighing all the possibilities of this magical device. The fact of the matter is, the iPad is one of the best tools ever for sharing your work. I feel I'm a better photographer when I look at my images on that beautiful backlit screen.

Now here's how to dampen that magical moment: Make someone stand there for a few minutes while you fish around on your iPad looking for a few good photos to show them. There's a lot to be said for deciding ahead of time which pictures deserve the spotlight.

Here lies the value of curation. In the digital age, we tend to amass hundreds, even thousands of images. By taking the time to select a few dozen favorites allows us, and others, to celebrate our abilities as artists rather than be remembered as disorganized snap shooters. Creating a portfolio says that you have reached a certain point in your photography. It makes the statement "Not only do I know how to take a photograph, I know how to present it as well."

I recommend that you build a basic portfolio right away, live with it for a while, and then decide how to proceed from there. And don't be shy! Share your work with others and listen to their comments. For example, as shown in Figure 6-1, "Do you like twilight shots? What do you think of my Las Vegas night scene?" This part of the photography process is as important to your craft as learning the controls on your camera.

FIGURE 6-1

Many images, such as this Las Vegas twilight scene, just sparkle on the iPad's backlit display.

Basic Portfolio Guidelines

Just as with a print portfolio, there are a few guidelines to keep in mind during the curation process:

- **Don't add too many images.** Discipline yourself to keep your main portfolio limited to 12 to 24 photos. Viewers will appreciate seeing only your best work, and not everything you've captured during the past year.
- **When in doubt, leave it out.** If you're wondering whether to include a certain image, you probably shouldn't.
- **Avoid pointing out things about an image that you don't like.** Let the viewer experience your work untainted. Once you point out a flaw, that's all they will see.
- **Hand the iPad to the viewer and let that person navigate.** This allows people to enjoy your work at their own pace.
- **Listen to what viewers say.** Every time someone comments about your picture, that's a gift, regardless of whether it's a

complement or a suggestion. Accept these gifts with an open mind. Your photography will improve as a result.

Building a Basic Portfolio

You have all the tools you need on your iPad right now to assemble your first portfolio. The only missing ingredients are your pictures.

To get started, launch the Photos app on the iPad. If you go to the Photos pane, you'll see all the pictures residing on the device, as shown in Figure 6-2. iCloud users can also go to the Photo Stream pane to view images available for copying to the iPad from the cloud. Finally, go to the Albums pane where your portfolio will reside.

Now that you have the lay of the land, go back to the Photos pane. Tap the Edit button in the upper right corner (it becomes the Cancel button). Tap the thumbnails of the images you want to add

FIGURE 6-2

You can build your first portfolio by working with the existing images in the Photos app.

FIGURE 6-3

Selecting images to curate for your first portfolio

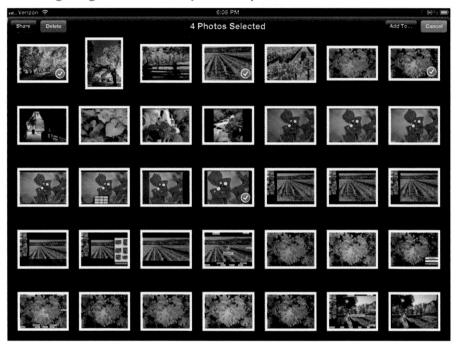

to your initial portfolio; the iPad places a blue check mark on the images you select, as shown in Figure 6-3.

Once you've chosen a handful of shots, tap the Add To button to the left of the Cancel button. You're presented with two choices: Add to Existing Album or Add to New Album, as shown in Figure 6-4. This time around, choose Add to New Album. The iPad prompts you to give the album a name. Type in **Portfolio**. Tap the Save button.

The iPad takes you directly to the Albums pane, where you can view your new collection. Tap the Portfolio album to open it.

It's now time to arrange the images you've curated. Tap the Edit button. Tap and hold your finger on a thumbnail, then drag it to the position you want. Play with the arrangement until you have the flow that feels good, then tap the blue Done button.

> **📷 Tip**
>
> If you have a specific image you want to serve as the album cover for your portfolio, drag it to the first position. You've just made an album cover!

FIGURE 6-4

Creating a new album

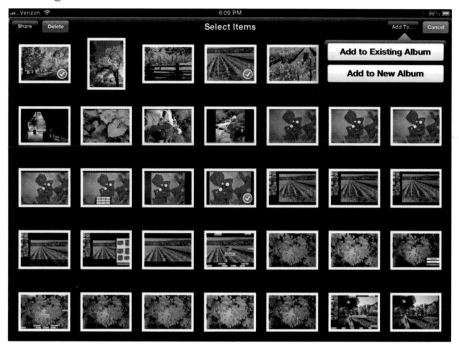

OK, back to the collection itself. On my first time through, I usually add more pictures to the portfolio than I should. But that's OK because I then view the pictures as a slideshow. And the ones that shouldn't be there jump right out.

To view the pictures as a slideshow, tap the Slideshow button to open the Slideshow Options pop-over, then tap the Start Slideshow button, as shown in Figure 6-5.

Enjoy your work for a few minutes. Once the presentation is over, you'll probably want to delete a few shots. When you're ready to do so, tap the Edit button while in the thumbnail view. Tap the pictures you want to remove from the portfolio to select them. Then tap the red Remove button. The iPad notifies you that the photos will be removed from this album (remember that they will remain in your Camera Roll and other albums they may be in, as shown in Figure 6-6). Tap the red Remove from Album button. Good-bye, photos!

Play your slideshow again. How does it look? Should you move a few pictures? Maybe delete a couple more? Make the adjustments

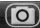
FIGURE 6-5

Initiating a slideshow in the Photos app

as I previously described. Once you have the presentation to your liking, pat yourself on the back. You've just created your first portfolio. It will be proudly displayed on the Albums page among your other collections, as shown in Figure 6-7.

I currently have 20 images in a portfolio album that plays with a moving piano piece (never underestimate the power of great music to make you photos look better). The presentation runs about a minute and 20 seconds. I know that doesn't sound very long, but it's actually just right. Viewers get a good look at my work in a time span that keeps their attention. It's rare that I present a slideshow that lasts more than two minutes.

📷 Tip

Work with the number of images in your slideshow so that the pictures end with the music you've selected. It's more satisfying to have the visual and audio in sync for these presentations.

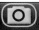

FIGURE 6-6

Removing pictures from the current album, but not from the iPad itself

Now it's time to share your photos with someone. You could play the collection as a slideshow for your audience. And sometimes I do that, especially if I have a big screen available (more on that soon). For one-on-one presentations, however, it's fun to hand the iPad to the viewer and let him or her swipe through the presentation at his or her own pace.

Set the stage by tapping the first thumbnail in the collection to enlarge it. Hand the iPad to the other person and instruct him or her to swipe from right to left to navigate through your portfolio. Let the person go at his or her own speed and listen to any comments. When the person gets to the end, take the iPad back, tap once on the screen to display the onscreen controls, then tap the Portfolio button in the upper left corner to return to thumbnail view. Cheers and applause (I hope).

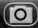

FIGURE 6-7

The Portfolio album among the other albums on an iPad

Showing Your Portfolio on an HDTV

The iPad is great for one-on-one presentations, but for larger groups an HDTV might be more convenient. If you have an Apple TV connected to your HDTV, you can stream the presentation to the big screen. You'll get extra points for the pure coolness factor regardless of what the audience thinks of your shots.

Make sure your Apple TV is on, and that AirPlay is enabled on the Apple TV. To do so, go to the Apple TV's Settings screen, click AirPlay, and make sure it shows AirPlay On; if it shows AirPlay Off, click that label to toggle it to AirPlay On.

On your iPad, tap the first thumbnail in the portfolio, then tap on the enlarged image to reveal the onscreen controls. The second icon from the right in the top navigation is the AirPlay button. It looks like a triangle pointing upward into a rectangle (I'm thinking that it's code for a play button on a TV screen.) Tap the AirPlay button, and in the menu that appears, choose Apple TV, as shown in Figure 6-8. Instantly, the image on the iPad should be mirrored to the TV screen.

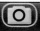
FIGURE 6-8

FIGURE 6-8

Enabling AirPlay in the Photos app on an iPad

Make sure you do this while people are watching so they can be sufficiently impressed.

> **◎ Tip**
>
> If the AirPlay button doesn't appear on your iPad, check to see which Wi-Fi network it's using. Many locations have multiple Wi-Fi networks available, and if the iPad and Apple TV are on different networks, they can't talk with one another. In that case, the iPad won't show the AirPlay button because it sees no AirPlay device to play to.

The iPad becomes your controller for the presentation on the HDTV — you can swipe from image to image at the pace you want. The slideshow function also works with Apple TV. Go to the first image in your presentation and make sure it's displaying on the big screen. Then tap once to reveal the onscreen controls. Tap the Slideshow button, choose your options, and tap Start Slideshow, as

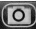

FIGURE 6-9

Setting up a slideshow to play on an Apple TV.

shown in Figure 6-9. You can even choose music from your iTunes library to play through the speakers on the HDTV.

> **Note**
>
> When streamed to the Apple TV, the photos don't display on the iPad itself, just on the TV.

Also, I've discovered that if I adjust the picture settings on the HDTV before starting the presentation, I'm usually more satisfied with the outcome. The settings are usually available via the Menu button on the TV's remote control.

Not all apps have an AirPlay button. But you can still send your photos to an HDTV via AirPlay using the AirPlay Mirroring feature available in every iPad except the original iPad. Keep in mind that AirPlay Mirroring is not limited to portfolio presentations; you can use it to show any screen on your iPad. But it sure comes in handy when you have more than one person in the audience.

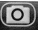

FIGURE 6-10

Enabling AirPlay Mirroring on the iPad

To enable mirroring, make sure that the Apple TV is connected to the HDTV and everything is turned on. On the iPad, press the Home button twice to bring up the multitasking dock. Scroll the icons to the right in the multitasking bar that appears at bottom until you see the playback controls for the iPad, including the AirPlay button, as shown in Figure 6-10. Tap the AirPlay button and choose Apple TV in the pop-over that appears. Make sure the Mirroring switch is set to On. Now, everything you do on the iPad, is also displayed on the HDTV.

When you're done presenting, you can return the display activity back to your iPad by tapping the AirPlay button again and choosing iPad in the pop-over that appears.

Using the Animated Picture Frame Presentation

A fun — and underused — feature on the iPad, is the animated picture frame. With a single tap of the finger, you can display a

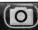

FIGURE 6-11

Setting up the picture frame in the Settings app on the iPad

looping slideshow of your favorite photographs. You don't even have to unlock your iPad.

So you can hand the device to anyone for picture viewing without worrying about them nosing around in the rest of your stuff. Or, you can set your iPad on a stand and just let it do its slideshow thing automatically. And if all that isn't good enough, it's also easy to set up.

In the iPad's Settings app, go to the Picture Frame pane. Choose the options you prefer, such as type of transition and duration of photo on display, and tap the word "Albums" about half way down the preferences list, as shown in Figure 6-11. By doing so you get a list of all albums in the Photos app. Scroll down the list of albums until you reach your portfolio album, and tap it. The iPad indicates that it's selected by adding a check mark to the right of its name. You can select as many albums as you want.

To see the animated picture frame, press the power button to put your iPad to sleep. Press it again to display the lock screen. In

FIGURE 6-12

Tap the Picture Frame button in the lock screen to initiate the animated picture frame.

the lower right corner, is the Picture Frame button (a flower icon), as shown in Figure 6-12. Tap it to start the slideshow.

Once you're finished viewing the animated picture frame, you can either turn off the iPad or put it to sleep, or use Slide to Unlock to work on the iPad as normal.

Preparing Images for Portfolio Display

The short version of this section's advice is this: Save the images you want to copy to your iPad's portfolio with a pixel width of 2,048 on the longest side and with sRGB as the color profile. If you know how, you can jump to the next section.

The reason I recommend 2,048 pixels on the longest side of the image you export is because that's the resolution used by iPads with Retina displays — that is, any iPad but the original iPad, iPad 2, and iPad Mini. But even for those non-Retina iPads, the 2,048-pixel size

is a good setting. At this resolution, your images will look crisp and clean but won't take up any more storage space than necessary on your device.

iPhoto's export settings

To set the pixel size and the color profile in iPhoto on your Mac, select the image you want and choose File ➪ Export. In the Export dialog box, the most important parameters are Kind: JPEG and Size: Custom. Once you've selected Custom, choose Dimension in the Max pop-up menu, and enter **2048** pixels in the field below. Click Export to save the picture with these settings. Figure 6-13 shows the Export dialog box with these settings.

Aperture's export settings

To export from Aperture on your Mac, begin by choosing File ➪ Export ➪ Version. In the settings sheet that appears, choose Edit at

FIGURE 6-13

The export settings for iPhoto on a Mac

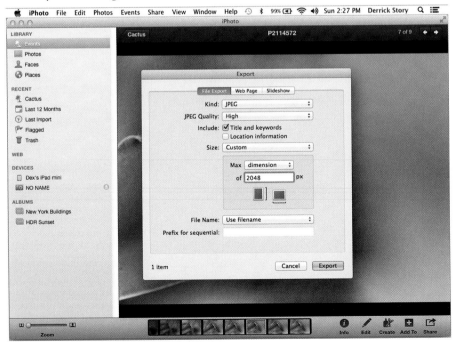

the bottom of the Export Preset pop-up menu. In the Image Export dialog box that appears, shown in Figure 6-14, create a new preset.

First, click the Add button (the + icon) in the lower left corner of the dialog box and give your new preset a logical name, such as "JPEG-2048x2048 for iPad." Then use these settings:

- ◎ Image Format: JPEG
- ◎ Image Quality: 9
- ◎ Size To: Fit Within (Pixels) Width: 2048 Height: 2048
- ◎ DPI: 264
- ◎ Color Profile: sRGB IEC61966-2.1
- ◎ Check the box for Black Point Compensation

Click OK to exit the preset's setup and return to the settings sheet. Make sure your new preset is chosen in the Export Preset pop-up menu. Once you're ready to go, click the Export Versions button in the lower right corner to begin the process. Aperture creates new files based on your specifications that will look beautiful on an iPad.

FIGURE 6-14

The export settings for Aperture

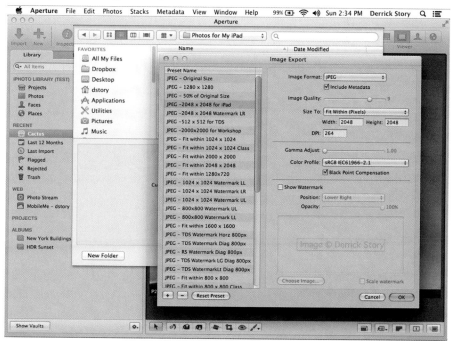

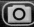

FIGURE 6-15

The export settings for Adobe Lightroom

Adobe Lightroom's export settings

Once you've selected the image in Lightroom, choose File ⇨ Export. In the Export dialog box that appears (shown in Figure 6-15), make the following adjustments:

- In the File Settings section, choose JPEG in the Image Format pop-up menu, choose sRGB in the Color Space pop-up menu, and set the Quality slider to 80.
- In the Image Sizing section, check the Resize to Fit box and choose Long Edge from the adjacent pop-up menu. In the first field below that pop-up menu, enter **2048** and choose Pixels in the adjacent pop-up menu, and in the Resolution field enter **264** and choose Pixels per Inch in the adjacent pop-up menu.

Click the Export button to save copies of the selected images with these settings.

Moving the Pictures from a Computer to an iPad via PhotoSync

You now have a set of images carefully crafted to the iPad's display specifications. My favorite app for moving them to the iPad, also covered in Chapter 4, is the $1.99 PhotoSync. It wirelessly receives images sent from the Mac or Windows PC to the iPad. (There's a free companion app for your computer on its site that you use to send the pictures: www.photosync-app.com/photosync/en/downloads.html.) Your images appear unaltered in iPad's Camera Roll and can now be copied to your portfolio album or used by one of the portfolio apps I cover in the next section.

Moving the Pictures from Computer to iPad via iTunes

If you prefer to copy images to the iPad via iTunes, I recommend setting up an upload folder on your computer. Then all you have to do is save images to that folder, and sync them via iTunes.

Here's how to do it:

1. Create a folder named Photos for My iPad in your Pictures folder on your computer.
2. Save images to the Photos for My iPad folder following the specs outlined earlier in this chapter.
3. Connect your iPad to the computer via its USB cable or Wi-Fi.
4. Open iTunes and select your iPad from the Devices pop-over.
5. Go to the Photos pane in iTunes.
6. Check the Sync Photos From box.
7. In the adjacent pop-up menu, choose Choose Folder.
8. In the Change Photo Folders Location dialog box that appears, navigate to the Photos for My iPad folder in your Pictures folder, as shown in Figure 6-16, select it, and click Open.
9. Click the Apply button in the lower right corner of the iTunes window.
10. Click the blue Done button in the upper right when you're finished.

On the iPad, go to the Photos app's Albums pane. You'll see a new album named Photos for My iPad containing the images

FIGURE 6-16

Syncing with iTunes on a Mac

you transferred from your computer. Open the album and tap a thumbnail to display the full image. Your picture should look terrific, as shown in Figure 6-17. The photos are also available in the Camera Roll album.

📷 Tip

You can set up Wi-Fi syncing between the iPad and iTunes on your computer, rather than plug the iPad in via its USB cable. First, make sure your iPad is connected via the USB cable and open the iPad in iTunes via the Devices pop-over. Then go to the Summary pane. Check the Sync This iPad over Wi-Fi box. In the future, the computer will detect the iPad automatically when they are on the same network.

FIGURE 6-17

A photo from the Photos for My iPad album that is synced with iTunes on your computer

📷 **Note**

When using this method for syncing, you can't remove the synced images from your iPad using the device itself. You need to move them out of the Photos for My iPad folder on your computer, and then click the Sync button in iTunes.

Using Other Portfolio Apps

If you want to expand your horizons a bit, there are many solid portfolio apps in the iTunes Store. You may have selected a favorite already. If not, here are a few apps that I've tested.

FIGURE 6-18

Organizational mode in Minimal Folio

Minimal Folio

The $2.99 Minimal Folio app is particularly useful for Dropbox users. You can sync a folder with Minimal Folio, which allows you to add images to your portfolio from a variety of sources.

Images look very good when displayed in this app. You can organize the images in thumbnail mode, as shown in Figure 6-18, and then view them full screen. Minimal Folio provides external display too via a physical adapter. AirPlay Mirroring also works via the method I described earlier.

You have a variety of options for configuring the app. They are located in the Settings app on the iPad, not in Minimal Folio itself. So if you're feeling that the app's a bit too simple, you know where to look.

Portfolio Pro

Providing more sophistication, but still easy to use, is the $9.99 Portfolio Pro. Its standout feature is that it lets you brand your

FIGURE 6-19

Portfolio Pro allows you to brand your presentation.

portfolio with your logo and type, as shown in Figure 6-19. This is a great option for displaying work to potential clients.

Editing mode is easy to access: Just triple-tap anywhere on the screen. In addition to the standard options you'd expect in editing mode, such as adding and deleting photos, you can also hide images and complete galleries. Portfolio Pro makes it easy to only show the collections that are appropriate for the viewer.

You can add photos via Flickr, Dropbox, and your computer. And once they're in Portfolio Pro, you have many customization options via themes and font choices. If you want to display your images on a big screen, you can use AirPlay Mirroring.

iPhoto for iOS

One portfolio app that you might already have on your iPad is the $4.99 iPhoto for iOS. I recommend it in Chapter 2 for organization and in Chapter 3 for image editing, so why not for display too?

Any album you create in the Photos app is displayed in iPhoto's library with a gray cover. If I tap my Portfolio album, the album

FIGURE 6-20

An image in full display with thumbnails of other available images in iPhoto for iOS

opens to a large image with the thumbnails running down the side, as shown in Figure 6-20.

When you tap the Grid button (a set of nine squares) in the upper toolbar, the thumbnails disappear, letting the selected image occupy the entire display. I can hide the top toolbar by tapping once on the screen. The viewer can navigate through my portfolio by swiping from image to image.

I can show the metadata for any picture displayed by tapping the image again to reveal the toolbar, then tapping the Info button (the *i* icon) to reveal the metadata pop-over, as shown in Figure 6-21. This view is handy when showing images to other photographers who might be interested in the camera type, aperture setting, shutter speed, focal length, and ISO number.

For a closer look at the details, the viewer can, with two fingers, touch and hold the image to reveal the magnifying loupe, as shown in Figure 6-22. The loupe allows enlargement between 1× and 3×. You

can adjust its magnifying power by placing two fingers on the edge of the loupe and rotating them. To hide the loupe, tap anywhere on the image with one finger.

But wait, there's more! You can see the entire image enlarged to 100 percent by tapping twice on the screen with one finger, as shown in Figure 6-23. Once magnified, you can touch and drag the image to

FIGURE 6-21

The metadata display in iPhoto for iOS

FIGURE 6-22

With two fingers, touch and hold on the image to reveal the magnifying loupe in iPhoto for iOS

FIGURE 6-23

Tapping the screen twice with one finger provides an enlarged view
of the image in iPhoto for iOS

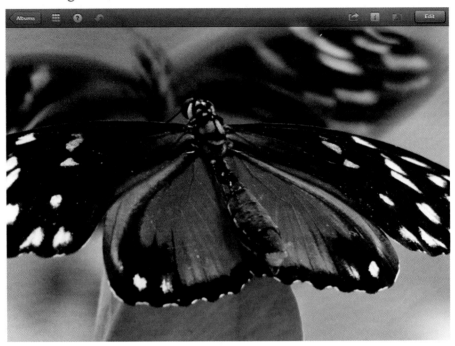

inspect different areas. Tap once on the screen to return to normal
view.

You can view the portfolio slideshow by tapping the Share
button in the top toolbar, then tapping the green Slideshow button in
the Share pop-over that appears.

After making your presentation style selection (there are eight
formats, including Ken Burns and Portfolio), choose your music from
the built-in theme options offered by iPhoto or from your iTunes
library. Then tap the Start Slideshow button as shown in Figure 6-24.
I recommend you explore all iPhoto's slideshow themes and note the
types that resonate best with you.

When you're finished showing off your work, return to the library
by tapping the Albums button in the left side of the upper toolbar.

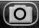
FIGURE 6-24

Tap Start Slideshow to play your presentation

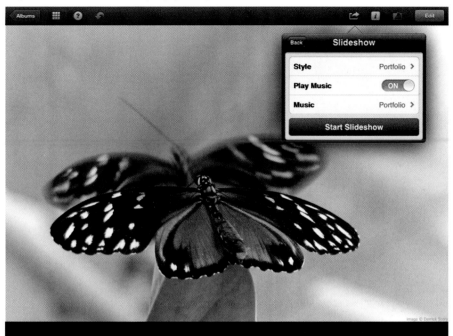

Pulling It All Together

Now that you have a basic blueprint for building a portfolio, I suggest a couple action items.

- First, create a basic portfolio right now. Your next big opportunity could happen tomorrow. Be ready. Then, over time, you can explore the multitude of portfolio app options available in the App Store.

- Second, show your pictures to someone, anyone. It's great practice. And you might be surprised by the feedback.

As I said at the beginning of this chapter, the iPad is a terrific device for displaying your images. Use it to dazzle the world.

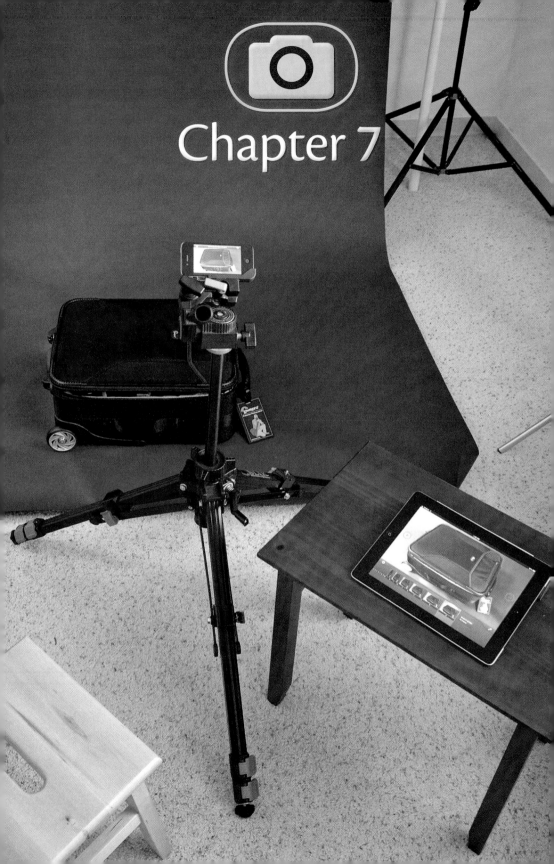

Chapter 7

Shooting, Editing, and Sharing Movies

Movie production on an iPad? Yes, I was skeptical, too. Top of mind, the iPad seems to make more sense for still photography. It's relatively easy to edit and move photos around. But video is an entirely different animal. Editing software seems, well, so complicated. Transferring big video files feels cumbersome. And overall, don't you really need a computer for these tasks?

You don't. In fact, I have more fun playing with video on the iPad than I ever did on a computer. Editing feels like work on my Mac. But on the iPad … well, it's actually fun.

Let me tell you a story of an early movie experience I had with an iPad. I wanted to shoot a time-lapse video of people taking pictures of the Golden Gate Bridge. The movie, titled The Overlook, is published on YouTube at http://youtu.be/sw_vs8Py7ig. I recorded the footage with an iPad 2 clamped to a tripod using an app called iStopMotion (more on that software later).

I set up the iPad in the back of my VW Vanagon so the wind wouldn't blow it away, as shown in Figure 7-1, and recorded from the afternoon to dusk. When I couldn't take the cold anymore, I packed up and drove to a Denny's coffee shop for a bite of dinner and editing on the iPad. I used iMovie for iOS and completed the project before my last bite. I then relocated to a Starbucks for an after-meal coffee while I uploaded the movie to YouTube using its free Wi-Fi. There were already a couple dozen views of my video on YouTube by the time I returned home later that night.

FIGURE 7-1

My DIY rig for shooting a time-lapse movie at the Golden Gate Bridge with an iPad 2

Unlike just about every other movie project I had ever worked on, I enjoyed creating *The Overlook* from start to finish. From that moment on, I was no longer skeptical about creating movies with the iPad.

Granted, the iPad is an awkward device for video recording. The smaller iPad Mini makes it a bit easier, but my favorite way to work is to record the video with my iPhone, then edit the content on the iPad, as shown in Figure 7-2. With a few detours here and there, that's the basic workflow I describe in this chapter.

If you've shied away from tapping your inner Steven Spielberg in the past, this chapter just might change your mind.

What Do I Mean When I Say "Record a Movie"?

Even though I mention Spielberg in the preceding paragraph, I don't make those kinds of movies. The movies I like to produce run between 30 seconds and four minutes. And if it runs four minutes, it had better be darn good.

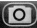

FIGURE 7-2

Shooting a stop-motion video using the iPhone 4S as a remote camera for the iPad

The videos I produce on an iPad are more like poetry than novels, at least in duration. I take a single idea and try to present it as compellingly as possible. These are the types of movies that will garner you praise. They are simple, they are short, and they don't tax the viewer.

If you want to keep your friends, keep your video tight. And fortunately, the iPad is a great tool for accomplishing that goal.

Just because you're not making the next *Argo* doesn't mean you should compromise on your technique. Here are a few quick tips to improve your productions:

- **Don't talk while recording.** Stay quiet and capture the audio around you. Your "oh mys!" will pollute the ambient track and cause you problems later in postproduction.
- **Video loves light.** Generally speaking, the more light the better for movies. When not working outside, look for brightly lit windows or add supplemental lighting.
- **Get the best audio possible.** If you're recording an interview, try plugging an external USB microphone into the iPad via the iPad Camera Connection Kit or Lightning to USB Camera

Adapter, or plug a smaller mic into the headphone jack (it must be designed for this use). Capture environmental sounds, too — they come in handy during postproduction.

- **Focus on the most important element.** Make it easy for the viewer by keeping a sharp focus on what's most important.
- **Record B-roll.** Supplemental scenes such as a long shot of a landmark, signs, daily activity, and so on can give your movies that professional touch.
- **Leave yourself a little extra footage on each end of the scene.** Doing so makes it easier when adding dissolves and other transitions between recorded clips.

Recording video with the iPad's Camera app

Capturing movies with the iPad is a straightforward process. Launch the Camera app, set it to Movie mode via the switch in the lower right corner, and then tap the red Record button. You can capture HD footage with the rear camera, or lower-resolution video with the FaceTime camera in front, on the frame opposite the Home button. Switch between the two cameras by tapping the switch in the lower right corner of the Camera app. (The iPhone's video recording works the same way.)

Recording video with MoviePro for the iPad

I've tested a handful of dedicated apps for the iPad and have enjoyed using the $2.99 MoviePro because of its ease of use, rich feature set, and reliability. If you want to go "simple," just launch the app and tap the red Record button. A handful of options appear on the screen — such as autofocus, auto exposure, auto white balance, and zooming — that you can easily enable. Tap the screen to indicate where you'd like the app to focus and meter.

If you want to explore additional features, tap the Options button (the gear icon) to display options for resolution, frame rate, video quality, audio setting, guides overlay, stabilization, and more, as shown in Figure 7-3.

There's also the Camera button that allows you to capture still images while recording video. Tap the Info button (the *i* icon) to get

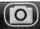
FIGURE 7-3

There are lots of recording options in MoviePro for the iPad.

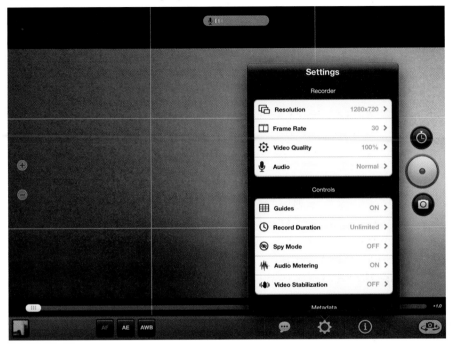

a comprehensive list of help topics that you can refer to without leaving the app. Very nice!

Once you've recorded your video clips, you can save them to your Camera Roll (in the Photos app) or upload them to YouTube. Once they're in the Camera Roll, they're available for editing in iMovie for iOS.

Here's a list of the most notable features for MoviePro:

- Pause/resume while recording.
- Select from a long list of video resolutions from 1920 × 1080 to as low as 320 × 240.
- Set the frame rate (in fps): 30, 25, 24, and down to 1.
- Set the aspect ratio: Widescreen (16:9), NTSC/PAL standard definition (4:3), NTSC (3:2; 720 × 480), and anamorphic widescreen aspect ratios like 2.75:1, 2.55:1, 2.40:1, 2.35:1, 2.25:1, 2.20:1, 2:1, 1.86:1, and 1.85:1.
- Set the video recording quality (bit rate): Choose super (200 percent) quality (for example, double the quality of iPhone's

native video camera), 150 percent, or 100 percent (native quality) for high quality, or choose 75 percent, 50 percent, 40 percent, and 25 percent to conserve storage space.
- Set uncompressed audio.
- Set the external microphone input: This is useful for recording concerts with microphones like the Tascam IM2 for high-quality stereo recording.
- Set the live audio metering option (in the Settings app).
- Upload full-resolution videos to Dropbox, YouTube, and Facebook.
- Set single or separate focus/exposure mode.

Recording video with Filmic Pro

Another movie recording app to explore is the $4.99 Filmic Pro. Its highlights include:
- Real-time, 4× zoom.
- 30 variable capture/output frame rates.
- Three separate shooting modes.
- Four selectable resolutions, including two iFrame modes.
- Audio metering.
- Customizable saved settings.
- Aspect ratio overlays (2.35:1, 4:3, and 16:9).
- iTunes file sharing.
- Six upload destinations.

Filmic has a handful of editor's picks to its credit and a healthy mix of pro and con user reviews. I thought it was capable in my testing. I did, however, prefer MoviePro's user interface.

Recording video with ProCamera HD

Many camera apps also provide video recording. One in particular that I describe in Chapter 1 — ProCamera HD — has pretty good movie modes.

ProCamera HD has terrific recording options: Full-HD Video Recording (1080p 30fps), HD Video Recording (720p, 30fps), and HD Video Recording (480p, 30fps), as shown in Figure 7-4. Plus ProCamera includes a nifty feature called HD Video Preview 16:9.

FIGURE 7-4

The recording options in ProCamera HD

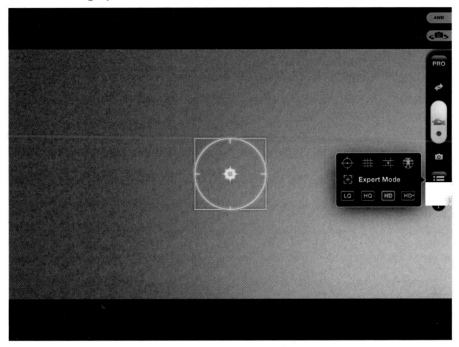

When enabled, the app displays the preview on the iPad in the 16:9 aspect ratio so you can see how it would look on an HDTV.

The app also includes options to turn on or off video stabilization and continuous focusing. And if necessary, there's a 6× zoom option available (however, enabling it increases the video-processing time).

Holding the iPad Steady for a Video Shoot

No matter what app you use to record video, the real challenge is steadying the camera during recording. Unlike a regular camcorder that you can set on a table or mount to a tripod, keeping an iPad upright and steady for recording requires a bit more ingenuity. Generally speaking, holding the iPad in your hand is not the best option for movies. Yes, there are those "slices of life" that you

want to spontaneously capture. But more often than not, your best recordings come from a stabilized iPad.

The following stands and adapters are useful for movie making and for less artistic endeavors, such as reading and watching video.

The Apple Smart Cover

When not protecting the glass screen of your iPad, the $39 Apple Smart Cover can double as a stand. Pros: lightweight and easy to use. Cons: allows only one position.

Makayama Movie Mount

Designed especially for photography and movie recording, the $99 Makayama Movie Mount, shown in Figure 7-5, allows you to

FIGURE 7-5

With the Makayama Movie Mount, you can put your iPad on a tripod.

attach your iPad to a standard tripod via the threaded mount in the bottom of the adapter. (There are separate models for the iPad 2 and for the third- and fourth-gen iPads.) It also includes a shoe mount for LED lighting or for attaching a microphone. Plus, it has an adapter for 37mm conversion lenses, so you can add wide-angle or telephoto perspective to your movies. I've used the Makayama Movie Mount for a few projects, and I love it.

The Brydge Bluetooth keyboard and stand

This general-purpose accessory features a Bluetooth keyboard and sturdy hinged mount that allows for variable positioning of the iPad over a 180-degree arch. You can set the $160 Brydge, shown in Figure 7-6, on any horizontal surface and then adjust it vertically for the desired composition. As a bonus, its Bluetooth keyboard includes a variety of iPad-specific function keys. You can, for example, initiate and stop movie recording using the volume button

FIGURE 7-6

The Brydge Bluetooth keyboard and stand for the iPad

on the keyboard. Using the keyboard helps prevent jarring the iPad at the beginning and ending of your video clips.

I also like using the Brydge during movie editing because I can adjust the iPad at a comfortable angle while working.

DIY solutions

When I recorded *The Overlook*, I hadn't tried any of these accessories yet. So I created my own mount using a spring clamp attached to a tripod. It worked. But I have to say, I feel much better these days using the Makayama Movie Mount or the Brydge.

Making Time-Lapse Movies

Time-lapse photography is used everywhere: TV commercials, sporting events, movies, and on and on. Once you experiment with time lapse, you'll notice how pervasively it's used.

What is it? Time-lapse photography is a movie that consists of hundreds, even thousands, of still photos played in sequence at a high rate, usually 15 or 30 photos per second.

The reason time-lapse movies look different from standard video is because the frames are recorded at a much slower rate. By recording at a very slow rate — say, one photo every two seconds versus 30 images per second in motion video — a time-lapse movie creates the illusion of time passing very quickly.

For example, consider if you made a time-lapse movie of your friend assembling a bookshelf. In real time, it would probably take an hour or more to put it together. But the time-lapse movie of the project would show the assembly from start to finish in less than a minute. If only we could move that fast in real life!

The iPad is a great tool for time-lapse photography, and in some ways better than your digital camera. At the top of the list, the iPad does not have a mechanical shutter like many cameras. So you don't have to worry about burning out the shutter on an iPad after thousands of exposures.

And I'm not exaggerating about the frame count. Take a look at the math: Let's say you're planning to make a movie that lasts 60 seconds. You're going to play that movie at 30 frames per second. If you multiple 30 (the playback back speed) times 60 (movie

duration), you'll need 1,800 photos to make that video that lasts only a minute. You can see how the shutter actuations would pile up if you were using your digital camera to record time-lapse video. Many DSLR shutters are rated for 150,000 exposures. Your iPad, on the other hand, uses an electronic shutter that never wears out.

Ease of composition is another iPad benefit. You can set up the shot and monitor it on a large, bright LCD display. And finally, you have lots of software to choose from for both capturing your time-lapse movies and for processing and sharing them. Virtually everything you need is on one device.

▉ Recording a Time-Lapse Movie with iStopMotion

Using the $9.99 iStopMotion app on an iPad enables you to both record and publish your time-lapse video using only your iPad. Here's how to set it up.

First, you'll need to stabilize the iPad itself so it doesn't move while capturing the hundreds of frames required for a time-lapse. You can use the Makayama Movie Mount, Brydge keyboard and stand, or a DIY solution you concoct.

Next, download and install iStopMotion. You can use any time-lapse app that strikes your fancy, but I recommend iStopMotion. Launch the app and follow these steps:

1. iStopMotion launches in Gallery mode, as shown in Figure 7-7. To start a new project, tap the Add button (the + icon) at the bottom of the screen to take you to recording mode.

2. The app defaults to front-camera mode. So you're greeted with an image of your own face on the screen. Switch to the back camera as quickly as possible: Tap the screen once to reveal the controls, and then tap the Camera button (the movie camera icon) in the upper right area of the screen. You're presented with three options: Back Camera, Front Camera, and Remote Camera. Tap Back Camera.

3. To the right of the Back Camera label is the Settings button. Tap it to reveal the Focus, Exposure, and White Balance adjustments.

 ◙ For Focus, move the target to the area you want sharp.

FIGURE 7-7

Gallery mode in iStopMotion

- 📷 For Exposure, choose Fixed, and drag the icon to an area of the composition that gives you the best exposure, as shown in Figure 7-8.
- 📷 For White Balance, choose the Locked option.
4. Tap the blue Done button when you're finished with the camera settings.
5. Tap the screen again to reveal the controls, and then tap the Time Lapse button (the clock icon) to the right of the Camera button to open the Time Lapse pop-over. Tap Time Lapse and set your interval. Try 2 seconds as a starting point, as shown in Figure 7-9. Tap anywhere on the screen to close the pop-over.
6. iStopMotion provides options to customize the recording experience. Tap the Clip button (the gear icon) to reveal the Clip pop-over's options: Show (for the recording mode; from left to right: Recording, Recording and Live, and Live), Playback Speed, Grid Lines, Play Half Speed, and

FIGURE 7-8

iStopMotion's focus, exposure, and white balance adjustments

Show Navigator, as shown in Figure 7-10. For recording, I recommend setting Show to Live (the camera icon), turn on Grid Lines, and set Speed to 15 frames per second.

7. Now, lightly tap the Start/Stop button (on the right) to begin recording frames. The counter shows how many frames you've recorded and how long the movie will run when played back at 15 fps, as shown in Figure 7-11.

After a few hundred frames, stop the recording. You can watch the movie by tapping the Play button on the left side of the screen. If you want to slow the playback, tap the Clip button and set the Play Half Speed to On (the circle icon). Also, if you want to scrub through frames more quickly, set Show Navigator to On to display a compressed filmstrip that allows you to easily jump around the movie.

Tap any thumbnail frame to reveal the Tools button (the wrench icon). Here, you can delete frames, duplicate a frame, or reverse the

FIGURE 7-9

iStopMotion's time-lapse interval setting

order of your recorded images. If you want to add music or voice-over, tap the Audio button (the music note icon) for those options.

Once you have everything the way you want and are ready to share your time-lapse, return to the Gallery by tapping the Gallery button in the upper left corner. If you don't see it, just tap on the screen to display the onscreen controls.

Notice the Share button (the icon of an arrow emerging from a tray) at the bottom of the screen. Tap it to reveal a dialog box with a playback window and four options: Save to Camera Roll, Mail Video Clip, Upload to YouTube, and Upload to Dropbox. Choose the appropriate Share option, and let the world see your work. If you decide you don't like your first effort, tap the Delete button (the trash can icon) to delete it. Then try again.

For more advanced presentations, you can combine several time-lapse recordings using a movie editor on your computer or using iMovie for iOS on the iPad. The easiest way to move the clips

FIGURE 7-10

iStopMotion's Settings options

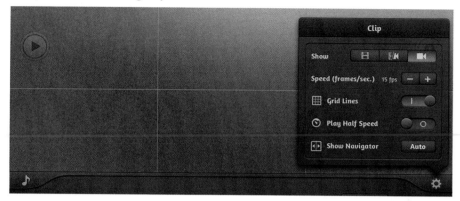

FIGURE 7-11

iStopMotion's counter display

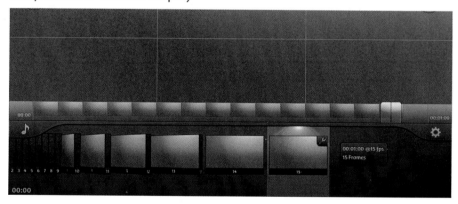

from the iPad to the computer is via the Dropbox upload option in iStopMotion.

Once you've mastered the basics, follow these tips to refine your presentations:

- Reduce flicker from changing light by setting the exposure to Fixed.
- Keep the iPad very steady during the recording session. Movement of the device creates a jarring effect in the movie.
- If you have a mishap, such as jarring the camera, you can use the Tools pop-over to delete the offending frame, then

duplicate the frame next to it to help restore smoothness to your movie.

- Adding a music track livens the presentation immensely. With iStopMotion, you can access music from your library, or record audio.
- Once you've backed up a recording to your computer, you might want to delete it from the iStopMotion gallery to free up space on your iPad.

■ Editing Video in iMovie for iOS

Typically, I don't enjoy video editing. Sitting in front of the computer with complicated movie postproduction software isn't my idea of a good time. But when the iPad with iMovie for iOS came along, everything changed.

I actually like editing video on an iPad. For me, it's a completely different experience from using a computer. And the final outcome is often quite satisfying.

Entire books have been written on video postproduction. That level of detail is not what I'm about here. Once you're finished with this section, my hope is that you'll feel comfortable editing your work — and just might enjoy the process along the way.

If you can, follow along using your own content. Find a video clip on your iPad, or shoot one with its camera. Then get the $4.99 iMovie for iOS. Using nothing more than the video clip and the tools on the iPad, we're going to create a short feature that has opening and closing titles, a soundtrack, and a few professional touches such as fades. So get everything ready to go, and I'll meet you back here.

Locating your video clip in the Photos app

Video captured with your iPad or uploaded to it via the iPad Camera Connection Kit or Lightning to USB Camera Adapter resides with your still pictures on the Camera Roll in the Photos app. So start there.

To find a clip, open the Photos app, go to the Photos pane to display your Camera Roll, and scroll through the images until you find a thumbnail that has widescreen proportions with a movie camera icon on it. To play the video, tap the thumbnail, then tap the

Play button. Look OK? Great. Then it will be a good subject for the project.

Creating opening and closing title artwork

There are two types of opening and closing title screens I use. The first is a frame from the movie itself that I can add text to. The second is a black slide, à la Woody Allen. Create those assets in the Photos app before using them in iMovie.

Start by creating the black slide. Enable the camera in your iPad, turn down the room lights, and take a picture of a dark wall or surface. That image is added to your Camera Roll. We'll return to it shortly.

The second type of title background is a frame from the video clip. In the Photos app, find the video that you're going to use for the project and play it. When you settle on an image that would make a suitable title slide, pause the movie playback. After a few seconds, the onscreen controls disappear, leaving only the paused frame visible on the screen. Now take a screenshot of that paused video by simultaneously pressing the Home and Power buttons on the iPad. You'll hear a camera shutter noise indicating that you've just captured a screenshot. It is added to your Camera Roll and available to iMovie for use as a title slide.

Your work in the Photos app is completed. So launch iMovie for iOS.

Setting up your project in iMovie

iMovie opens to the gallery page. If this is your first project, all you'll see is a brick wall with the message: "Tap + to start a new project or trailer." Do exactly that, tap + — that is, the Add button.

Choose New Project from the menu that appears. iMovie opens a workspace for you, with three main areas. At upper left are the assets you have available in the Media Library. By default, iMovie displays the videos currently in your Camera Roll. You can also access still photos and music here. The preview window occupies the upper right area, and the timeline runs along the bottom, as Figure 7-12 shows.

> ### ⊙ Note
>
> If this is the first time you've opened a workspace, you'll probably see the message "iMovie Would Like to Access your Photos." Worry not, this is the standard iOS permission request. The choices are Don't Allow and OK. Choose OK. This should only happen once.

Content copied from the Media Library to the timeline becomes part of the project. You can add an asset to the timeline by tapping on it the reveal the blue Add arrow, as shown in Figure 7-12, or you can record new content using the iPad's camera by tapping the Record button (the movie camera icon) resides at the right side of the toolbar.

For this project, use existing content stored on your Camera Roll. So the next step is to tap on the desired video clip in the Media Library to add it to the project. When the blue Add arrow appears, tap it, and the content is copied to the timeline.

FIGURE 7-12

The iMovie project window, with a video from the Media Library at upper left being added to the timeline below

 Tip

You can trim the clip before copying it to the timeline. Tap the round yellow handles and drag inward from either or both ends to create the selection you want.

Once the clip is on the timeline, you can scrub through it by pressing your finger to the timeline and dragging it. The preview window displays a larger view of the frame currently selected in the timeline. The vertical red line, called the playhead, serves as your marker. You can also trim the clip here using those same round yellow handles, as shown in Figure 7-13.

You can play the clip by tapping the Play button in the toolbar. If you want to see the waveform for the audio, tap the Waveform button (the squiggly-line icon) to the left of the Play button.

FIGURE 7-13

Working with the video clip in the timeline in iMovie

Building the opening title

I like to make cool little intros to my videos, even the short ones. My favorite technique starts with a black fade-in to a title slide, then to the video itself.

The first step is to add the two title images created earlier in the Photos app to the timeline at the beginning of the movie. Make sure the playhead is at the beginning of your video. Then import the first image — the still photo you captured as a screenshot. To do so, tap the Photos button (the icon of two overlapping rectangles) at the bottom of the Media Library to see the Camera Roll's photos, then tap the desired image to add it to the playhead's location, as shown in Figure 7-14. Move the playhead to the left of the photo you just added, find the black screen you created in the Camera Roll, and add that to the timeline too.

The second step is to add the title text. Double-tap the black slide to bring up the Photo Settings pop-over. Tap Title Style and choose Middle. Tap in the "Title Text Here" overlay that appears onscreen and enter your title text. Next double-tap the second

FIGURE 7-14

Adding a photo to the timeline in iMovie

graphic, and choose Opening for the Title Style, as shown in Figure 7-15. I typed "Surfacing" for that slide. Tap anywhere when finished.

Now tap the Settings button (the gear icon) in the upper right corner of the screen to open the Project Settings pop-over shown in Figure 7-16. Select Simple for the theme. Next, set the Theme Music, Fade In from Black, and Fade Out from Black switches to On. Tap anywhere when finished to dismiss the pop-over.

Direct your attention to the timeline and move the playhead to the beginning of the movie and tap the Play button. You're greeted with two opening graphics, music, and the beginning of the video clip. How does it look?

In my case, I want a few more seconds of black before the first title appears. So I drag the black slide from the Media Library to the front of the movie, then shorten its length to 2 seconds by tapping it and dragging one of the clip handles.

I don't think I need the transition between the two black slides. So I double-tap it to bring up the Transition Settings pop-over, as shown in Figure 7-17, where I can set the parameter to None. I play the intro a few more times to see what I think. I settle on the first

FIGURE 7-15

Adding text to opening graphics in iMovie

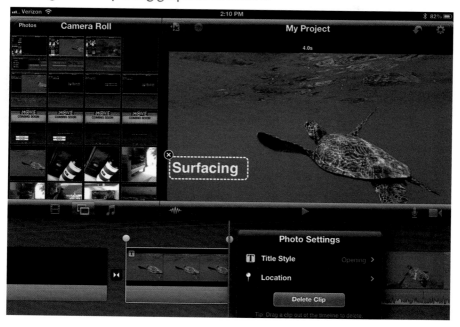

FIGURE 7-16

Setting the project settings in iMovie

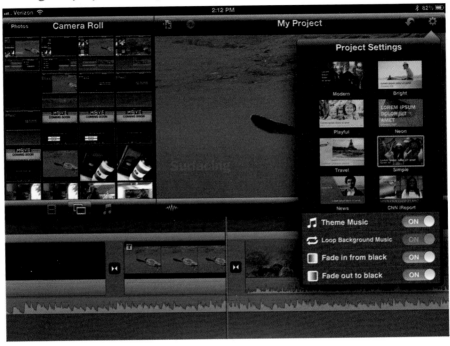

black slide lasting 1.3 seconds. I like the way it works with the music at that duration. I shorten the second black slide to 2.9 seconds to better sync with the soundtrack. Everything is looking pretty good now with the intro. So it's time to work on the main clip.

> **☉ Tip**
>
> Any time you believe you've made a mistake editing your movie, take heart that there's the Undo button on the right side the toolbar, next to the Settings button. Tap it to undo that last action. Tap and hold it to redo that last action.

Balancing music with recorded audio

Because I've added theme music, I have two audio tracks playing at once. The green audio track is the music, and the blue track is the native audio I captured while recording the original footage, as

FIGURE 7-17

The Transition Settings pop-over in iMovie

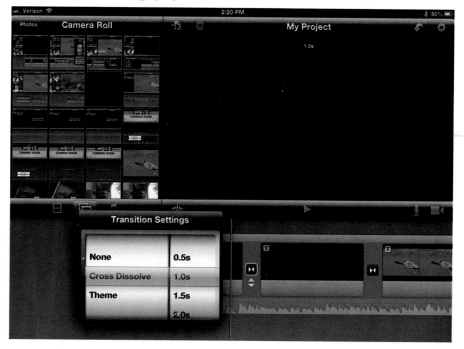

shown in Figure 7-18. I think it sounds a little loud and conflicts with the music track. I don't want to eliminate it all together (at least not yet), but I would like to tone it down.

So I double-tap the blue audio track to bring up the Clip Settings pop-over again. This time, I'm moving the loudness down. I could turn it off all together by sliding the On switch to Off, but I want to retain a little background noise for atmosphere. I can also increase the volume of the music track by double-tapping the green music track and moving the slider to the right.

Once again I play the clip. Ack! Now I don't like the ambient audio at all. It just ends up being distracting no matter what I do. So I double-tap the blue audio track again and slide the volume switch to Off. Sometimes you have to play with things a bit to get the results you want. OK. Good for now. On to the closing image.

Splitting a clip and adding a closing title

I like the last few seconds of the movie where the sea turtle swims off into the distance. That's a good place to add a closing title. And fortunately, it's not hard to do.

I tap the video track in the timeline to select it, position the playhead where I want to make the cut, and slide my finger downward on the red line. iMovie places a cut there, as shown in Figure 7-19. I need to separate that last bit of video so the closing title appears for just a few seconds, and not for the duration of the entire movie.

I tap to the right of the cut to select the newly created clip, and then double-tap to bring up the Clip Settings pop-over. I choose Middle from the pop-up menu for the Title Slide, and type "Hope to see you again!" in the text box.

Visually, it's looking pretty good. But I think I need an audio transition, too. So, in the new short clip, I double-tap the blue audio track to bring up the Clip Settings pop-over again, and turn on the

FIGURE 7-18

Audio tracks in iMovie

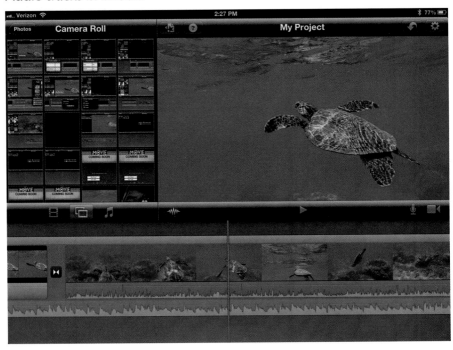

original sound track for just those last few seconds. By doing so, iMovie lowers the volume a bit with the music, thereby creating a more elegant closing.

My finishing touch is to create a cross-dissolve transition to the final clip by double-tapping the transition indicator between the two clips and choosing Cross Dissolve in the Transition Settings pop-over, as shown in Figure 7-20. This is a good visual cue for the viewer, along with the audio, that the movie is ending.

I think I've got it! Time to play from the start for one last look.

Naming the project

Tap the Projects button (the icon of a star in a page) to return to the iMovie home screen. You can name your project by double-tapping the project's temporary "My Project" title and typing in a new project name. Tap Done when finished.

FIGURE 7-19

Making a cut in iMovie

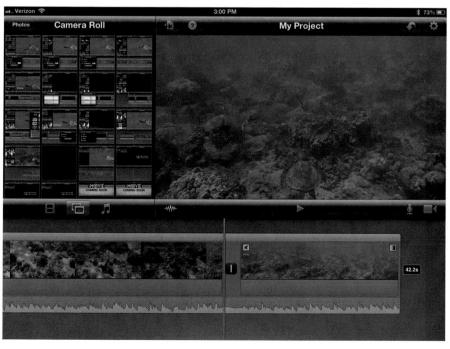

FIGURE 7-20

Adding a cross-dissolve in iMovie

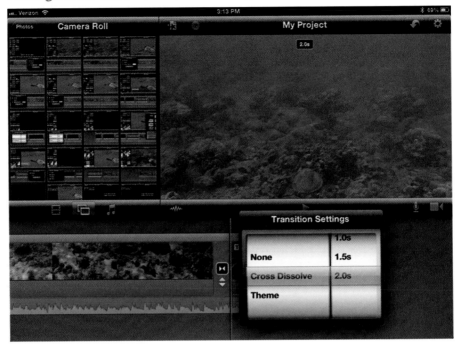

Watching your movie

You can watch the movie full-screen on the iPad by tapping the Play button in iMovie's Project view. It's the arrow icon inside a shaded rectangle. iMovie asks if you want to optimize the playback. Tap Yes. After a minute or two, you're presented with full-screen playback that should look remarkably good.

If you tap the screen once playback begins, onscreen controls appear that give you the option of choosing an Apple TV for viewing.

Saving the movie

At this point, I recommend that you share the movie to your Camera Roll, which provides more universal access to the content. In the Project view, tap the Share button at the bottom of the screen and choose Camera Roll, as shown in Figure 7-21. In the dialog box that appears, select the desired resolution. I recommend going with the largest size (HD-1080p) if it's available. Why? The version you

save to the Camera Roll is like the master print. This is the copy you'll eventually back up.

By way of reminder: The Camera Roll, accessible via the Photos pane in the Photos app, is the best place to share your content with other apps on the iPad and with your computer.

Publishing your movie online

From iMovie, you also have the option to publish online to YouTube, Facebook, Vimeo, and CNN iReport, as Figure 7-21 shows.

If this is the first time you've shared a video to the chosen service from iMovie, you have to log in to your account. You then see a dialog box that allows you to add information about your movie, such as a description, category, and tags. After adding the information, choose the movie size. I like 720p for YouTube because that's the level of HD that plays well on the site. And finally you can choose to have your movie private, unlisted, or public. I choose

FIGURE 7-21

Making a cut in iMovie

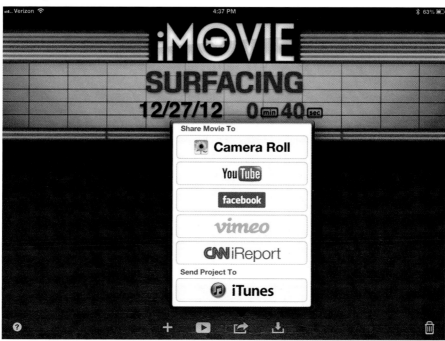

public because, well, that's the point, isn't it? Then tap the blue Share button.

iMovie prepares, exports, and uploads the video to your YouTube or other account. From there, you can easily direct family and friends to the movie. You can see my *Surfacing* movie at YouTube at http://youtu.be/JSkpOUAKdaA.

Transferring Your Movies to a Computer

Unlike the photos you save to the Camera Roll that are automatically backed up using Photo Stream (if you're an iCloud user), video is not backed up automatically. You have to back it up yourself.

I recommend saving a master copy of the movie to your Camera Roll at the highest resolution possible. Then, copy the movie file to your computer. By doing so, not only will you protect the work you've done, but you'll enjoy more viewing options for the videos you create.

You can copy your completed projects to a computer in a couple of ways.

Transferring the movie project to a Mac

One option is to export the entire project package from iMovie for iOS to iTunes, allowing you to open it in iMovie for the Mac for further work.

Start on the iPad by choosing iTunes in the Share pop-over in the Project view. Once the export is complete, connect the iPad to your Mac and launch iTunes. Select your iPad from the Devices pop-over and go to its Apps pane. Scroll down until you see iMovie in the left column. Once you find it, click it; the movie project appears in the right column. Click the Save To button, navigate to the desired folder in the dialog box that opens, and click Open. The movie project is copied to the Mac. After the download is complete, double-click on the file in the Finder to launch your project in iMovie on the Mac.

Once everything looks like it went OK, you can delete the project from the Apps pane in iTunes to recover the file space on your iPad.

Transferring the completed movie to a Mac or PC

If you saved a high-resolution version of the movie to your Camera Roll, you can use PhotoSync to send it to another iOS device or to your computer. Launch PhotoSync on both devices and send a copy of the movie, as described in Chapter 4.

Chapter 8

Taking Care of Business

I've always wanted one device that would do everything. Not just phone calls, photography, or texting, but the whole works. The iPad actually comes close.

In other chapters, I describe its photography prowess. But photographers don't live by pictures alone. We need to organize our week, manage our assets, and communicate with friends and clients just like everyone else. The iPad can help us with those tasks, too.

In the same vein as managing our photo assets, the iPad is not an island unto itself. One of the first decisions you have to make with the business side of the equation is how you're going to integrate the stuff you do on the iPad with your overall workflow that also includes your computer.

I believe that seamless integration is the key to success. The less you have to think about juggling your data, the better you work. When I type a document on the iPad while flying from San Francisco to Phoenix, for example, I want that text available to me that night in the hotel room on my laptop. I don't want to copy it, send it, upload it, or anything else. I just want it there when I'm ready to resume the writing. The same goes for my banking, to-do lists, and spreadsheets.

The good news is, that you can have that effortless integration right now. It takes a little planning upfront but once the pieces are in place, you can pick up your iPhone, iPad, or laptop, and everything you need is waiting for you. And it's up to date.

What fascinates me about this topic is that I once viewed business as a necessary evil for me to be a successful writer and

photographer. But thanks to the iPad, I'm actually enjoying it. The iPad makes work fun.

Using applications such as Numbers, Pages, Listo, iA Writer, ASMP Releases, Invoice ASAP, Pageonce, PayPal Here, and SignNow, my iPad Mini is a business *tour de force* that slides just as easily into my jacket pocket as it does my camera bag.

Wouldn't it be a hoot if this turned out to be one of your favorite chapters in the book? It just might.

Weather

The Number 1 morning question in our household (after "where's my coffee?") is "What's the weather today?" Because I have an iPad nearby, I'm the one who provides the latest information. But as a photographer, weather is important for my work, too.

There are plenty of weather apps, and you're probably using one or two right now. But the one that I like for photographers is Cross-Forward Consulting's $0.99 Check the Weather. It loads fast, is easy

FIGURE 8-1

The Check the Weather app

to read, and provides all the information you need to help plan a shoot.

A graph showing temperature readings for a 12-hour span assists in planning, as shown in Figure 8-1, along with sunrise and sunset times at the bottom. Run your finger along the graph line to have the app display wind speed and the chance of precipitation for that time. Tap and slide your finger upward on the display to see the short-term rain forecast on a Doppler map.

When you need comprehensive weather information quickly, Check the Weather is an excellent choice. It looks good, is easy to read, and provides just the right amount of information.

Mapping

When embarking on a photo assignment, you don't want finding the destination to be the adventure. Mapping software for the iPad makes the navigator's job much easier. Here are the two apps that I use.

> **◯ Note**
>
> Wi-Fi + Cellular iPads include Assisted GPS. Wi-Fi-only iPads do not. You can use either app to plot a route ahead of time, as long as you have an Internet connection. But while traveling, you'll get better results with GPS-equipped iPads that don't depend on finding Wi-Fi access points along the way to determine the current location.

Google Maps

Getting to your destination in a timely manner is an important part of the project. The free Google Maps provides reliable data, turn-by-turn directions, traffic information, public transit routes, and a satellite view.

At press time, only an iPhone version of Google Maps was available, but I anticipate an iPad version soon. Still, it runs just fine on iPads and looks reasonable well in full-screen mode, as shown in Figure 8-2. (You enable full-screen mode by tapping the 2X button in the lower right corner of an iPhone app's screen.)

FIGURE 8-2

Google Maps

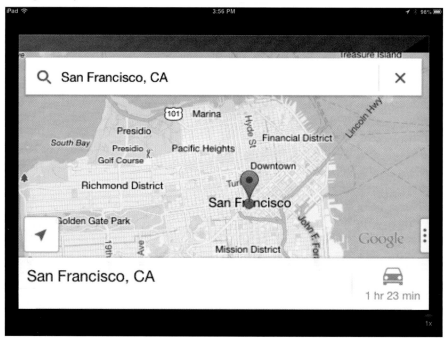

Apple Maps

Apple launched its own mapping software with the release of iOS 6. The debut was less than stellar in terms of total accuracy. But the app has evolved and improved, and I do use it on my iPad because it's so easy to read, as shown in Figure 8-3.

When plotting my route, I still check the data against Google Maps to ensure the best route. But if everything gibes, I use Apple Maps while en route. With its clean graphics and 3D view, it's a mapping treat for the eyes.

📷 Tip

An assistant can provide lots of help during a photo shoot, such as holding reflectors and interacting with subjects while you set up your gear. Having an assistant also serve as navigator during the drive to the assignment makes the trip both safe and sane. You can concentrate on the road while your helper figures out the route.

FIGURE 8-3

Apple Maps

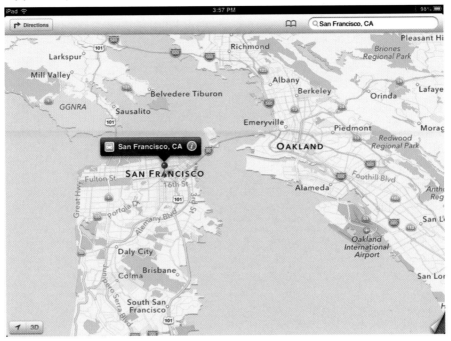

Checklists

I'm a big fan of checklists. They serve as my backup brain to remind me of tasks that I might otherwise forget. The best way to use a checklist is to add items immediately as they come to mind. So it's important that your checklist app is easy to use and syncs across all your iOS devices. That way when you refer to your list, you're always looking at the most current information.

Reminders

A terrific checklist app is included free on the iPad: Apple's Reminders, shown in Figure 8-4. It syncs across all my devices via iCloud, including my OS X Mountain Lion laptop. So regardless of which device I'm holding at the moment, my reminders are current. My typical lists include a photo-shoot checklist, daily tasks, grocery list, and story ideas.

For longer lists, it's easier to enter the data using Reminders for the Mac. I use the Mac for data entry even if I plan to use the information exclusively on the iPad. If you don't have a Mac, you can still speed up entry by dictating items on the iPad. Tap the Dictate button (the microphone icon) next to the spacebar on the iPad's onscreen keyboard.

If you want to rearrange the items in the list, tap the Edit button and drag the list item to the position you want.

When you check the completion box on the list, the list item moves to the "Completed" area that's out of view once you close the app. Don't worry, though: The items are still accessible by tapping Completed in the left column of the app. You can return the tasks to your checklist by unchecking the boxes in this area. It's not an elegant method for restoring your lists, but it does work.

Another challenge with Reminders is that it doesn't have an easy way to save a list to text. So there's no practical way to move a list

FIGURE 8-4

Entering text in Reminders

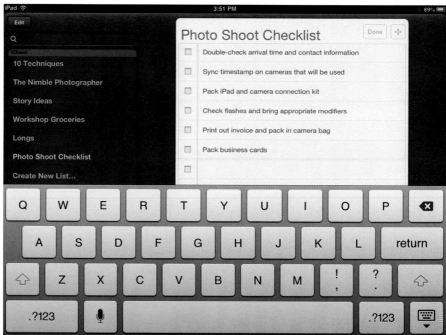

outside the app. Hmmm. Fortunately there are list apps that can do this (read on).

The pluses for Reminders are that it syncs via iCloud to iOS and OS X devices, and it has an attractive interface. On the negative side, there aren't many options for managing your list, and lists cannot be exported.

Listo

A fun alternative to Reminders is SlippySoft's $2.99 Listo that emulates the pen-and-paper experience. You can add items to the list by typing or dictating, then "scratch them off" by simply swiping across the task, as shown in Figure 8-5.

What I like about this approach is that the item isn't relocated after completion (as Reminders does). It simply goes to the bottom of the list. When you're all done, and want to reuse the list, just swipe again on the items to restore them as before.

FIGURE 8-5

Scratching off items in Listo

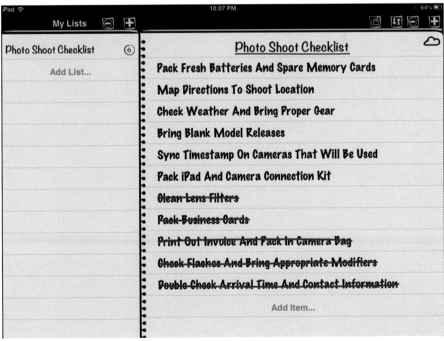

To move items around, tap the Organize button (the icon of arrows pointing up and down), and drag list items to the desired position. Tap the Organize button again when you're finished.

Another feature I like in Listo is its Send as Email function. You can send lists to anyone, including yourself, in a handsomely formatted e-mail. The text can be easily copied and added to other documents.

And finally, Listo is iCloud-compatible, as shown in Figure 8-6. So you can sync lists across iOS devices. Unfortunately, there isn't a Listo app for the Mac. That's really the only feature I'd like added to this otherwise terrific checklist app.

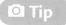 **Tip**

I recommend creating checklists in Listo that help you prepare for travel and photo shoots. By checking what you've packed against the list on your iPad, you're less likely to forget an important item.

FIGURE 8-6

Enabling iCloud sharing in Listo

Errands To-Do List

Another notable app in this category is Yoctoville's $2.99 Errands To-Do List that features iCloud syncing across devices and exporting via e-mail. But I don't like the appearance of the export format in this app as much as I do in Listo.

What Errands To-Do List does bring to the table is a more customizable interface with a built-in monthly calendar view and different types of folders to organize your lists, as shown in Figure 8-7. Completed items remain on the same page but are moved to a section that resides below the working list.

Personally, I prefer the clean, simplicity of Listo for my checklists. But if you need a bit more organization and prefer to tinker with the app's interface, Errands To-Do List is a capable choice.

FIGURE 8-7

Errands To-Do

Documents

I handle text in a variety of ways on the iPad. Short snippets and boilerplates work great on a virtual notepad. Longer documents are better suited for full-fledged text editors. I find each of the following apps valuable for managing all the ideas I want to keep track of.

Notes

Much in the same spirit as Reminders, Apple's Notes is a handy text app that can sync data across iOS devices and Macs with OS X Lion or later.

Unlike Reminders, Notes has the Share button at the bottom of the screen that allows you to e-mail, print, copy, or message a document via the Share pop-over, as shown in Figure 8-8. So your text isn't confined to the application. Because Notes syncs via iCloud, what you type on your iPad is available on all your other iOS and OS X devices, too.

FIGURE 8-8

Using the Share pop-over in Notes to print a document

I like the interface for this app, and I use it primarily as a more powerful "sticky notes." It's good for jotting or dictating ideas about upcoming photo shoots, boilerplate notes, technical information, and so on. It's not a bad app for smaller text projects, either. I personally prefer iA Writer (next on the list) for anything longer than a paragraph or two.

iA Writer

Information Architects' iA Writer ($0.99 for iOS and $4.99 for OS X) is a fantastic text editor for the iPad. Its clean interface and intelligent keyboard let you focus on what you're writing instead of how you're going to operate the app, as shown in Figure 8-9.

Your documents can be synced to iCloud, making them available across your other Apple devices. So you can type a document on the Mac and have it appear on the iPad, or vice versa. iA Writer also features Dropbox connectivity to access text documents stored there in the .txt format.

FIGURE 8-9

iA Writer on an iPad

For iPad documents, I often dictate the notes for faster input. The app keeps track of your character and word count along the way and displays those numbers in the upper right corner.

iA Writer has the Share pop-over that allows you to e-mail, copy, and print your text documents. It also provides the option to open the document in other compatible apps on the iPad, such as Evernote.

The Share pop-over features the Preview function, too, as shown in Figure 8-10. This is handy, for example, if you're writing text or HTML in iA Writer, because you see it unformatted while you compose, as shown in Figure 8-10. The concept is to focus on the words and the code. But by tapping Preview you can see how the text would look published on a web page. Tapping an HTML link in preview mode displays the web page using iA Writer's built-in browser.

iA Writer is an app that gives me confidence leaving the house with an iPad instead of my laptop. It's best for medium to long documents where you want to focus on the text itself.

FIGURE 8-10

The preview mode in iA Writer

iPad 🛜	2:46 PM	86%
Close	TDS Promo Blurbs	

TDS Promo Blurbs

Follow Me on Twitter

Follow me on Twitter

TDS Facebook Page

The Digital Story on Facebook discussion, outstanding images from the TDS community, and inside information. Join our celebration of great photography!

Pinterest

You can find more photo tips and "photography how tos" on my Pinterest page.

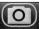

Pages

Apple's Pages ($9.99 for iOS and $19.99 for OS X), on the other hand, is for projects that combine words and other elements. I wrote this entire book in Pages, both on a Mac and on the iPad. And because of its seamless iCloud integration across iOS devices and Macs, you can start a paragraph on the iPad and finish it on your laptop.

I consider this a core app for iPad-toting photographers because of its versatility. You can create everything from resumes to flyers.

When you create a document in Pages, it first takes you to the Template Chooser where you have 16 options, ranging from the simple blank page to a multi-column flyer. If you pick a flyer, for example, Pages opens the template with placeholder pictures and text. All you have to do is tap the placeholders to replace them with your own content.

When you're working on a document, the toolbar at the top of the Pages screen provides several options for working with your documents, as shown in Figure 8-11:

FIGURE 8-11

The toolbar (at top) in Pages for the iPad

Introduction

A gentleman recently cornered me at a social gathering and huffed, "I miss the good old days of photography. All you needed then was a camera and a few rolls of film." He gulped the last of his drink, scowled, then continued (without any encouragement from me): "Now you need computers and memory cards, hard drives, and what the heck is the cloud anyway?"

I sympathize, but I don't agree. I remember the good days too, but differently. I had to keep an eye on expiration dates for film that required refrigerated storage. I either had to process my own black and white images in a jerry-rigged lab at home, or send out my color work to a professional outfit that charged good money for their services. I don't even want to know how much I spent over those years for processing and printing. And once I got it all back, I had to sort it, store it, and figure out how to get the best stuff in front of others.

Honestly, I don't miss those days at all.

- **Documents:** You can create new documents or open ones you've already worked on. Because Pages saves as you write, there's no need to ever worry about losing content.
- **Undo:** You can undo anything you've done by tapping this button. If you want to redo it, just tap and hold it.
- **Document Title:** The documents's name is displayed at the top of the screen. If you want to change it, tap the Documents button to go to the documents list, then tap the title of the thumbnail that you want to alter and enter the new name in the field containing the name.
- **Format:** Tap the Format button (the brush icon) to change the properties of text or an object. This area deserves lots of attention because Apple has added many goodies to spice up the appearance of your work.
- **Insert:** Tap the Add button (the + icon) to add an object to your document. You can add pictures from your Camera Roll and albums, tables, charts, and shapes.
- **Tools:** Tap the Tools button (the wrench icon) to print, turn on tracking, share, check spelling, enable word count, and more.

◎ Note

If you want to work on a copy of a document rather than the original, you need to make the copy in the documents list before you open it. In the documents list, tap Edit, tap the document to be copied, and then tap the Duplicate button (the icon of a + symbol over two rectangles).

For text formatting, tap in a text area and select the text you want to format. Pages displays a ruler at the top of the screen with text-formatting options.

To organize your work after you've created files, return to the documents list, tap a file and drag it on top of another document to have Pages create a folder that you can name. I have document folders for chapters of this book, *Macworld* magazine articles, and Lynda.com projects, as shown in Figure 8-12.

To export a document to your computer, open it, tap the Tools button, tap Share and Print, and choose Copy to iTunes from the menu that appears. You can export your file in one of three formats: Pages, PDF, or as a Microsoft Word document. That's right. Pages is

FIGURE 8-12

An open folder in Pages' documents list

Word-compatible, in both directions. Use the same Share and Print menu to e-mail, print, or open the document in another app.

To retrieve the iTunes-exported document:

1. Open iTunes on your computer.
2. Go to the Devices pop-over.
3. Select your iPad in the pop-over.
4. Go to the Apps pane.
5. In the Apps pane, scroll down the window to where Pages is listed in the column on the left and select Pages.
6. Select the exported document that appears in the adjacent pane.
7. Click the Save To button at the bottom of the pane.

One of the reasons I consider Pages a must-have app for iPad-toting photographers is because it lets you integrate text and pictures in documents that can be widely shared. And, the fact that it opens and allows you to work on Microsoft Word files is a huge plus.

Tip

Mac owners can use Pages instead of Microsoft Word to save a substantial amount of money on software. Pages on the Mac handles all the core functions of Word, including revision tracking and comments, and is compatible with your iOS devices, too. (The iOS version supports tracking but not comments.)

SignNow

Speaking of Word documents, sometimes you just need to add a signature. This is true for contracts, agreements, and invoices that

FIGURE 8-13

Practicing signing with your finger in SignNow

arrive in your inbox. A helpful app is the free SignNow lets you sign Word, PDF, and RTF files with just your finger, as shown in Figure 8-13. Then you can return the signed document via e-mail, and bypass the scanner or fax machine.

The app works in concert with a free SignNow account. As you might have guessed, you can extend the service's capabilities with a Pro account for $14.99 a month or $99.99 a year. The Pro account adds goodies such as customized templates, exporting options, the ability to print, and more. They are helpful features. But if you just need a quick and easy way to sign electronic documents, the free SignNow account and app should serve you well.

Personal Reference

The iPad is a terrific reference device for my documents and technical information such as camera manuals. I use both of the following apps on a regular basis for that purpose.

GoodReader for iPad

One of the reasons I keep an iPad Mini in my camera bag is that it provides a wealth of reference information, yet takes up less space than most books. A good application for managing reference documents is the $4.99 GoodReader for iPad. It connects to a multitude of online servers, including your e-mail account and Dropbox. This flexibility is part of the joy of GoodReader.

For example, in a pinch, I can e-mail a document to myself. Let's say it's a shot list that I want to have with me on a photo shoot. GoodReader can display PDF, text, Office, iWork, HTML, and Safari web archive files, as well as many graphics formats. Plus you can mark up PDF files in GoodReader. For longer-form documents, such as camera manuals, I store them in my Dropbox and access them via GoodReader as needed, as shown in Figure 8-14.

When you first set up the app, spend time connecting it to your e-mail accounts and cloud services. You'll only have to do this once. Then, when you need the information quickly, it's accessible without fuss.

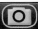

FIGURE 8-14

Accessing files in Dropbox using GoodReader for the iPad

Dropbox

I previously mentioned storing pictures in the free Dropbox app and service, but the fact is that you can also stash your reference documents there, too. In addition to getting 2GB of free space when you sign up, Dropbox provide an attractive, functional iOS app that makes it easy to view the contents in your Dropbox.

You can read PDFs, preview photos, and more. And if Dropbox is your primary cloud service, this free app is probably all you'll need on the iPad for your reference materials.

■ Model Releases

I advise packing a blank model release in your kit. You never know when a great shot will present itself that includes a cooperative subject. I still carry paper model releases. But I've also enabled this capability on my iPad because, to be honest, I'm less likely to forget my iPad at home than a sheet of paper.

FIGURE 8-15

A variety of releases are included in ASMP Release for the iPad

Created by the American Society of Media Photographers, BrickSimple's free ASMP Releases provides templates for a variety of releases, including ASMP Standard Model and ASMP Standard Property, as shown in Figure 8-15.

You start by adding your information to the app that it integrates in any template you use. Then you choose the type of release you want to use by tapping the Create New Releases button. This brings up an incomplete form that has your information, but not the model's data. You can add information by tapping the Customize Release button, then filling in the fields. Once completed, all parties sign the screen on the iPad, and copies of the release can be e-mailed to both subject and photographer.

The application stores your previous releases on the iPad itself. There's no iCloud syncing or Dropbox integration, so be sure to e-mail yourself a copy of each completed release so you have it on file.

Calculators

There are dozens of free calculators available for the iPad. But two are unique and worthy of your attention. I particularly enjoy both applications on the iPad Mini. The generous screen makes calculation easy, yet the device is small enough to hold in one hand.

Digits

For your serious calculator work, take a look at the $0.99 Digits. It is highly customizable and creates a virtual tape that can be edited, labeled, stored, and shared, as shown in Figure 8-16. It's "simple spreadsheet meets cool calculator."

You could, for example, work up a bid on a job using Digits. The application allows you to label all the categories and display the math. You could then e-mail the document directly to the client (and copy yourself) directly from the Digits app.

FIGURE 8-16

The Digits app

Tapes can be saved for future reference. This is easiest if you set up the document first. Tap the Tape icon, and then tap the Browse button. Just tap the Add button (the gray + icon) to create a new document. Give it a name by tapping Untitled and entering the text. Tap the thumbnail to exit browse mode and make your calculations. All your work is saved to that tape.

This application works great for quick estimating and accounting work. Be sure to save your documents, and just to be sure, e-mail a copy to yourself too. Even if you don't need the tape functionality, Digits is an easy-to-use calculator all by itself.

RetroCalc

Now, let's get to the fun calculator app. Futuremedia's $1.99 RetroCalc provides 15 calculators from the past. Each is beautifully detailed and fully functional, as Figure 8-17 shows.

FIGURE 8-17

One of the many beautiful calculators in RetroCalc

So, one day you may choose the Texas International TINT 1250 for your work, and the next switch to the Fujita Sendai BC1010 to tabulate the grocery bill. This is the most fun I've ever had adding numbers!

Invoicing

To get paid, you have to submit an invoice. If you're faced with this task while on the go, you might want to add invoicing functionality to your iPad.

Invoice ASAP

Generally speaking, most billing and invoicing activities are handled on your computer. But it doesn't have to be that way. And there are times when it could be to your advantage to generate an invoice right on the spot. With apps such as the free Invoice ASAP, you can create invoices, estimates, and sales receipts using your iPad, as shown in Figure 8-18.

All your work is synced across your iOS devices via a free account you set up on Invoice ASAP servers. You can upgrade to a Plus account for $7.99 a month or to a Biz account for $14.99 a month. The latter features QuickBooks integration and multiple user access.

But to be honest, for most freelance photographers, the free account provides the basic services you need for creating and sending invoices, sales receipts, and estimates. All these forms are editable and can be printed. You can even copy the contents of one form and create a new form with that information, saving time creating new documents for existing clients.

Even though your forms are saved on the Invoice ASAP servers, I recommend you send them to yourself so you can generate PDFs for your archives.

If you only occasionally create invoices for freelance work, the free Invoice ASAP service could be the only tool you need. Just be sure to keep backup copies of everything you generate. For bigger operations, however, the challenge is integrating your mobile system with what you already have on your computer back at the office. In that case, you should consider upgrading to a Biz account.

FIGURE 8-18

An invoice displayed in Invoice ASAP

Numbers

You can bypass outside services all together to create and store expense reports, invoices, and budgets by using Apple's Numbers ($9.99 for iOS, $19.99 for OS X) and its professionally designed templates, as shown in Figure 8-19. The advantage to the Numbers approach is that the documents are synced via iCloud and readable on both iOS devices and the Mac. Plus, you have complete control over the design and appearance. You can brand your paperwork with your company logo and select from a variety of typefaces. You can e-mail the invoices to the client, or print them out on the spot.

FIGURE 8-19

The invoice template in Numbers on an iPad

The downside is that these documents can take a while to complete on an iPad. If you use Numbers for invoicing, I recommend that you set up client templates ahead of time using Numbers on the Mac, then just complete the invoice with a few specifics on the spot.

This is a good example of leveraging the ecosystem for business work with your iPad, rather than viewing the iPad as purely a standalone device. I like knowing that I can complete just about any task on my iPad. It's a good feeling! But in practice the wiser choice is learning how to balance you computer, iPad, and smartphone to use the best tool for the job at the moment.

All right, back to Numbers. The invoices are standalone documents that are not database-managed, so you don't have end-of-year reporting and analysis as you would with systems such as Invoice ASAP.

Still, if you don't generate a lot of paperwork, the templates in Numbers can serve you well. And the documents themselves are easy to manage because they reside on iCloud. As always, though, I

strongly recommend making backups of everything and storing them on your local hard drives, too.

> **Tip**
>
> A professional looking invoice demonstrates that you're a legitimate businessperson as well as an artist. Invest time creating an invoice template that accounting departments will take seriously when it's time to cut the check.

Finance Management

You're not limited to accepting cash and check payments. Anyone can accept credit cards now too. Many financial services, such as PayPal, offer a free card reader that plugs into the headphone jack on your iPad. There's also new technology emerging that allows you to take a picture of the credit card with the iPad camera and then process the transaction.

But first, the PayPal service. Although there are services that operate in a similar manner, PayPal integrates with the accounts that many of us already have.

Another aspect of finance management is staying on top of your transactions. Most major banks offer their own apps that allow you to review activity, move money among accounts, and sometimes even scan checks with the iPad's camera and remotely deposit them. I've personally tested apps by Wells Fargo and Chase and have been satisfied with their performance.

I also like apps that provide an overview of all my financial activity. That's why I've included my favorite example, Pageonce. It shows me what Chase, Wells Fargo, Paypal, USAA, AT&T, and my other accounts are doing so I can see the big financial picture.

And because these apps are so easy to use and, dare I say, fun, I've done a better job of staying on top of my money.

PayPal Here

Picture a photo shoot in an exotic location. Slash lighting highlights the rugged features of the actor's face. He holds an iPad

FIGURE 8-20

PayPal Here

Mini casually in one hand. There's a brief moment of silence, then he remarks, "I don't accept credit cards often, but when I do, I use PayPal Here on my iPad Mini." Cut!

A credit-card swiper isn't the most exciting thing in the world, despite my attempt to describe it as such. You see them daily in stores and restaurants. But for you, freelance photographer, to have one — well, that is sort of cool.

If you have an existing PayPal account, PayPal Here is an easy way to accept credit card payments on the spot. You sign up for the program at www.paypal.com. Once you're approved, you'll receive their card swiper in the mail. It plugs into the headphone jack of your iPad or iPhone. PayPal has also expanded the program so you can sign up at retail stores such as Staples.

The free PayPal Here app (designed for the iPhone but will run on the iPad) connects the card-swiping capability to your PayPal account. After you sign in, you're greeted with a simple screen where you can enter the transaction amount and purchase name, as shown in Figure 8-20. Once the information is complete, you're prompted to swipe the credit card using the reader. The final step is adding

the signature using a finger or stylus. (Signatures are required for purchases greater than $25.)

PayPal keeps track of everything in your account. But you have the option of e-mailing a receipt, too. If you tap the Setting button (the icon of three lines) in the upper left corner, you can enable options such as sales tax, discount, tips, and even printing. In the Card Reader option, you can practice swiping to get PayPal Here's feedback on your technique without actually charging the card.

Pageonce

Pageonce is a dashboard with all your financial information displayed. It's mission control for your money. The free Pageonce securely keeps track of your bank accounts, credit cards, and investments. And because you have all this data aggregated in one place, the app can display your big financial picture with easy to read charts and summaries, as shown in Figure 8-21.

FIGURE 8-21

Pageonce shows me where my money is going.

Beyond that, you can pay your bills with Pageonce, too. If you draw payments from your bank account, the service is free. Note that bills paid with credits cards do incur a transaction fee.

Pageonce is another example of an app that makes previously mundane tasks fun. As a result, I'm more on top of my money than ever.

Calendars

Apple includes a good calendar app — called Calendar — with iOS that will most likely suffice for all but the most fanatical organizer. If, however, you want a different look, I do have an alternative.

Calendar

As with most of the Apple productivity apps, Calendar's strongest feature is its iCloud integration with your other devices, including a Mac.

FIGURE 8-22

The "year" view in Calendar included with iOS

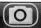

Five views are available: day, week, month, year, and list; the year view is shown in Figure 8-22. Calendar remembers the last view you used and displays that view the next time you open the app. You can adjust options such as turning off and on time zone support and selecting the default calendar (if you manage multiple calendars) in the Settings app's Mail, Contacts, Calendars pane. In individual events, you can set reminder alerts and even e-mail invitations to others; Apple's Mail and Calendar in OS X and Microsoft's Outlook reads these invites and places them in the recipients' calendar.

iCloud syncing is excellent with this app. So, the Calendar data you see on a Mac is the same as on an iPhone or iPad. Calendar is easy to use and has been keeping me on time for years.

Agenda Calendar

If you want something a little different, explore Savvy Apps' $1.99 Agenda Calendar. With its 12 themes, you're not only able to organize upcoming appointments, but you can customize how you view them.

FIGURE 8-23

The week view in Agenda Calendar using the Daring Fireball theme

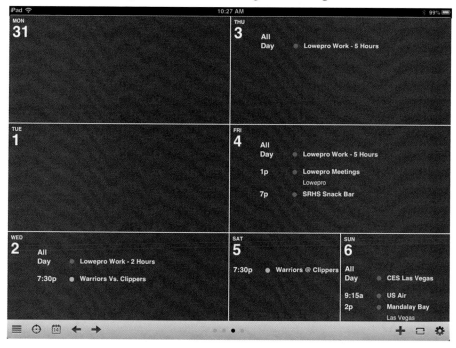

Agenda supports Google Calendar, iCloud, and Microsoft Exchange via the iOS Calendar app. In other words, all calendars created in the iOS Calendar app are available in Agenda Calendar, too.

Agenda Calendar doesn't have a companion app for the Mac. But because it syncs with your Calendar data, that shouldn't be a huge issue. You can just use the OS X Calendar on your Mac. There are four views available: year, month, week, and day. I like the week view on the iPad, and I think the day view looks good on the iPhone.

And in case you're wondering, my favorite theme is Daring Fireball, as shown in Figure 8-23. You can access all the themes by tapping the Settings button (the gear icon) in the lower right corner, then tapping Extras and choosing Themes from the list.

I keep both Calendar and Agenda Calendar on my iPad, with Calendar set to the monthly view and Agenda Calendar to weekly. Both offer alerts and invitations for your appointments, so you should never miss a meeting again.

Printing from the iPad

For situations that demand a hard copy of a document or a photograph, the iPad can go old-school, too. There are two basic printing approaches to explore. The first is AirPrint and the second is using a printer manufacturer's iOS app over a Wi-Fi network.

Using AirPrint

Created by Apple, AirPrint enables you to output documents on your iPad using Apple's driverless printing architecture. Apple's iOS apps and many apps created by other vendors support this technology. The trick is to have a compatible AirPrint printer. Apple maintains a list of these devices on its AirPrint Basics page at http://support.apple.com/kb/HT4356.

Or you can use one of the xPrintServer network boxes from Lantronix that make almost any network-connected printer AirPrint-compatible; some xPrintServer models also let you connect USB printers. xPrintServers range from $100 to $200, depending on USB support and number of network printers supported.

FIGURE 8-24

Printing a Pages document on an iPad using AirPrint

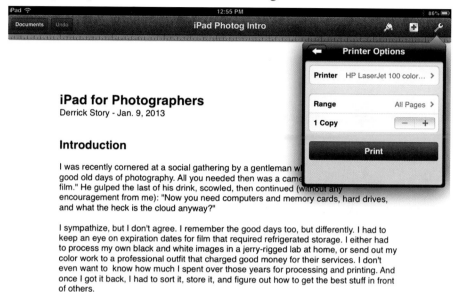

Typically, you print from the Tools pop-over (in Apple's iWork apps) as shown in Figure 8-24, or from the Share pop-over (in most other apps).

In that pop-over, your iPad will display any AirPrint printers found on the local network. Then you select the desired printer, adjust any print settings available, and tap Print to send the print job.

Printing photos via printing apps

Many printer manufacturers have created their own printing apps for iOS that allow direct communication with their devices. I've tested HP ePrint Home & Biz, Epson iPrint, and Lexmark LexPrint. The information page for each app lists its compatible printers. These apps are available (usually free) in the iTunes App Store.

I've been using Epson iPrint with my Epson Stylus Photo R2000 to generate photo-quality prints from 3.5 by 5 inches all the way up to 10 by 12 inches — directly from my iPad. The output is beautiful,

FIGURE 8-25

Checking ink levels on an Epson printer using Epson iPrint for the iPad

iPad 🛜	11:17 AM	⚡ 91% 🔋
Home	**Maintenance**	

Printer	Epson Stylus Photo R2000 🏠 ›

Printer Status

Ready

Ready to print.

Remaining Ink/Toner

Yellow	
Magenta	
Black	
Red	
Orange	
Black	
Gloss Optimizer	
Cyan	

Maintenance

Head Cleaning	›
Nozzle Check	›
Printer Settings	›

plus I have reasonable control for setting up the job. Options include print quality, layout, and even monochrome. If I tap the Maintenance button, as shown in Figure 8-25, I can see my ink levels. Now that's easy.

Even though I don't print often, I appreciate being able to output directly from my iPad. It's a real time-saver.

Chapter 9

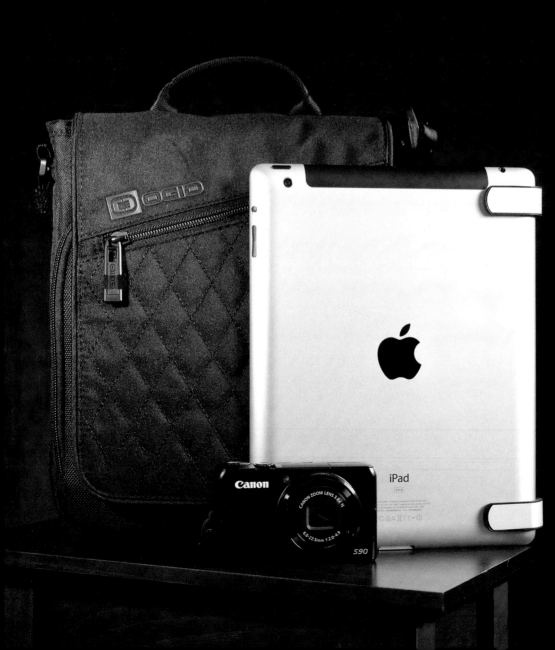

Transporting an iPad and Camera

When it's time to hit the road, or at least the local coffee shop, what are you going to use to carry your stuff?

I must confess that I love solving these kinds of problems. I take great pride in packing light, yet having everything I need at my side. As a result, I have some good suggestions for you. Keep in mind that there are hundreds of different bags and carrying solutions available. I'll share a few of my favorites to get the wheels turning. Then I'll let your creativity take it from there.

Basic Items for Transport

All you really need for most adventures is your camera and an iPad, as shown in Figure 9-1. As long as they have a way to talk to one another, you're set. In my typical "bang around" kit, I like to add a few accessories, too:

- The iPad Camera Connection Kit's SD card reader and the Lightning SD Card Reader.
- A stylus (pen).
- An extra battery and an extra memory card for the camera.
- A USB-to-Dock cable, a USB-to-Lightning cable, and a travel charger.
- A lens cloth.

That's not a lot of stuff — and I carry both Dock and Lightning adapters and cables because I have both a third-gen iPad and an iPad

FIGURE 9-1

The basic components: a camera and an iPad.

Mini, which have different connectors —but it's more than enough to get most jobs done. So how do I decide which carrying solution I'll use? That depends on three things:

- The type of iPad (full-size, Mini, or both).
- The type of camera (compact, mirrorless, or DSLR).
- The type of activity (work or play).

I like having a variety of options available. That's right. One bag is not enough. Here's my rationale: I have different cameras for the variety of assignments I cover, and heck, I even have two different iPads. To work as efficiently as possible in the field, I can't expect one bag to meet all those different situations.

Now I won't go as far as confessing to how many bags I own. Every man should be allowed a few secrets. But I will say that when I'm preparing to walk out the door, I want exactly the right bag for the tasks that lie ahead.

Most of my working kits are protected by Lowepro bags, which I've been using since 1995. In those days, I was toting SLR film cameras around in Lowepro's rugged shoulder bags. Now I carry both my electronics and photo gear in its backpacks and messenger bags.

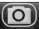
There are many other good brands available, including Tamrac, Timbuk2, STM, Fossil, Ogio, Victorinox, and Samsonite. The challenge is finding a carrying solution that works for both your camera gear and the iPad. Many of the other bags I researched were terrific just for the iPad. But we are photographers. We carry more. So let's explore the options.

Midsize messenger bags

My typical work kit includes a full-size iPad with the Olympus OM-D mirrorless camera and a handful of lenses: 12-35mm f/2.8, 45mm f/1.8, and 60mm f/2.8. Because I shoot primarily with existing light, I lean toward fast-aperture lenses. I prefer a nimble shoulder bag for these occasions, such as the $69 Lowepro Event Messenger 150, shown in Figure 9-2.

The Event Messenger includes a dedicated, padded iPad sleeve in the camera compartment, as shown in Figure 9-3.

FIGURE 9-2

An open Lowepro Event Messenger 150 with full-size iPad, Olympus OM-D camera, 12-35mm Panasonic zoom lens, and Olympus 60mm macro/portrait lens

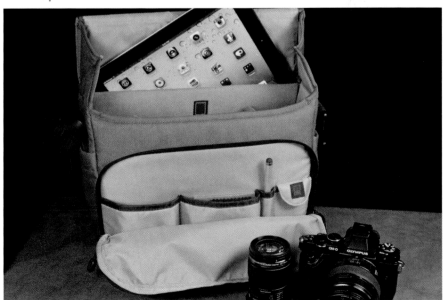

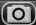
FIGURE 9-3

The dedicate iPad sleeve inside the Lowepro Event Messenger

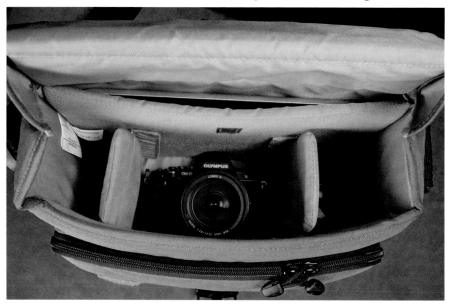

FIGURE 9-4

The Event Messenger closed and ready for transport

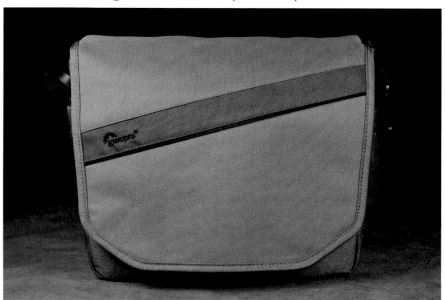

This allows me to carry the iPad without any cover if I want to. It is fully protected in the padded compartment. Yet there is enough room to accommodate a case or keyboard attached to the iPad. The camera and lenses can be secured using positionable panels with Velcro-lined edges.

If I want to carry my iPad Mini too, it fits in the front compartment. You can see inside this compartment in Figure 9-2. Because that area isn't protected, I want the Mini in its own case. Just in case.

Once the Event Messenger is closed, as shown in Figure 9-4, it looks stylish but doesn't scream "camera bag." This is perfect for urban environments. I can carry the bag over one shoulder and have it hang down my side. Or I can carry it cross-shoulder, messenger style. I tend to keep it on one shoulder when working out of the bag, then switch to messenger style when I'm ready to hit the pavement.

The outer dimensions are 13.5 inches wide by 6.2 inches deep by 10.5 inches high. So it's easy to go with the Event Messenger on public transit and in restaurants and coffee shops.

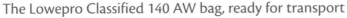

FIGURE 9-5

The Lowepro Classified 140 AW bag, ready for transport

Lightweight shoulder bag

For spectator sports, street fairs, and other crowded venues, I tend to pack a little lighter than my midsize working kit. I usually slim down to just an iPad Mini and mirrorless camera body with a couple lenses. For these situations, I want a shoulder bag that is small and light enough for me to wear constantly without being in the way.

Other than size and weight, the critical element is a protective sleeve for the iPad Mini. Fortunately, there are quite a few bags available that can accommodate this requirement. I've been using a $69 Lowepro Classified 140 AW, shown in Figure 9-5.

The Classified has ample room for my mirrorless camera kit, plus it has an easily accessible protected sleeve for the iPad Mini, as shown in Figure 9-6.

When I take this kit to a basketball or baseball game as a spectator, it's easy to navigate through the crowds at the event. (The bag's dimensions are 8.7 inches deep, 11.8 inches high, and 9.8 inches wide.) When I take my seat, I swing the bag around to sit on

FIGURE 9-6

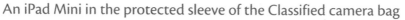

An iPad Mini in the protected sleeve of the Classified camera bag

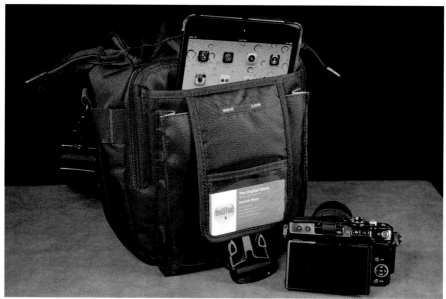

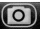

my lap, with the strap still across my shoulder. My camera and iPad are easily accessible, yet secure.

The Classified camera bag is harder to find these days because it isn't in production any more. But I did a quick search and found it for sale on eBay, Amazon.com, and other online retailers.

And as mentioned before, there are plenty of alternatives on the market. If you think this is a type of bag you need, there are plenty of similar options out there for you.

Backpacks for bigger jobs

The advantage of backpacks compared to shoulder bags is that the weight is distributed across both shoulders instead of just one. Here are two backpacks that can accommodate both iPads and cameras.

FIGURE 9-7

A full-size iPad located in the tablet compartment of the Photo Hatchback 16L. Also shown is a Canon 5D Mark II with a Sigma 50mm f/1.4 prime lens, and a Joby Gorillapod Focus with Ballhead X.

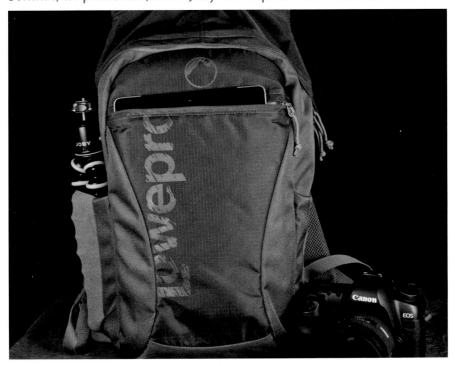

Lowepro Photo Hatchback 16L AW

For shoots where I want to use a DSLR for photography but stick with the iPad for everything else, I bump up in size to a backpack. One of my favorites for iPad photography is the $99 Lowepro Photo Hatchback 16L AW, shown in Figure 9-7. It has a dedicated tablet sleeve in the front with a center divider. You can store a full-size iPad and an iPad Mini, too. Each has its own place. The front part of the tablet sleeve has less padding than the back so if you put an iPad Mini in the front, make sure it has a cover or a slim case.

The camera compartment is in the back of the Photo Hatchback. It can protect a midsize DSLR up to the height of a Canon 5D Mark II with a 24-105mm f/4 L zoom lens attached. The camera compartment is removable too. So, if you want a full-size backpack for day tripping, you can convert it in just seconds.

When on the road, I've actually pulled the fully loaded camera compartment out of the Photo Hatchback and locked it in the hotel safe. This is a lot easier than juggling separate items.

A third area in the top of the backpack is perfect for personal items, or, if you need, an extra lens or two.

The Photo Hatchback is a good vacation bag. Its dimensions make it airplane friendly (10.83 inches wide by 7.28 inches deep by 18.5 inches high). It holds enough gear for a week long trip and it can easily be transformed from a camera bag to a regular backpack. I also like that it can accommodate both an iPad and an iPad Mini at the same time.

Lowepro CompuDay Photo 250

For business trips, where I need to transport a laptop, an iPad, and a camera, I often choose the $109 Lowepro CompuDay Photo 250. This midsize backpack measures 12.6 inches wide by 7.9 inches deep by 17.1 inches high and can accommodate laptops with screens as large as 15.6 inches in its padded compartment. Plus this bag has an additional interior sleeve that works great for a full-size iPad. You can add an iPad Mini in the zippered front pocket, as shown in Figure 9-8.

The side-access camera compartment is big enough to hold a midsize DSLR with zoom lens attached. Other handy features include a padded carrying handle on top and a trolley sleeve in the back that

allows you to attach the backpack to your rolling luggage — very handy when racing through airport terminals.

The CompuDay Photo 250 also has interior pockets to stow portable hard drives, small accessories, pens, and documents. It's an excellent workhorse backpack.

FIGURE 9-8

The Lowepro CompuDay Photo 250 with an Apple MacBook Pro 15-inch Retina Display laptop, iPad Mini (in the front pocket), and a Pentax K-5 DSLR with an 18-55mm zoom lens

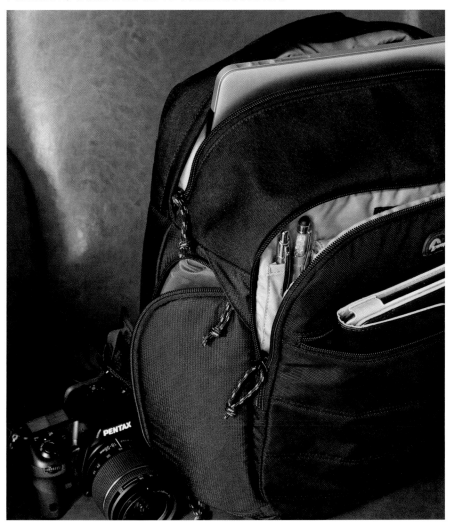

Supercompact transport with the iPad Mini

For times I'm heading out the front door for errands, I like to travel superlight with just an iPad Mini and a compact camera. There are a number of small shoulder bags that can accommodate 7- to 10-inch tablets.

I've had an OutPack Padded Travel Documents Shoulder Bag for years that I've repurposed for this task, as shown in Figure 9-9. The iPad Mini slides in to the main compartment. The Canon S90 compact camera fits in the front pocket. I bring along the Lightning to SD Card Camera Reader, and I'm set for just about anything.

Unfortunately, this particular OutPack isn't readily available any more. The good news is that this is a popular category with many options. So I explored a few modern upgrades. Here are two in particular that I like.

Samsonite Classic Notebook/iPad Shuttle

This $29 dedicated iPad shoulder bag has a clean look and is easy on the shoulders. It weighs just one pound and measures

FIGURE 9-9

An iPad Mini in an OutPack shoulder bag

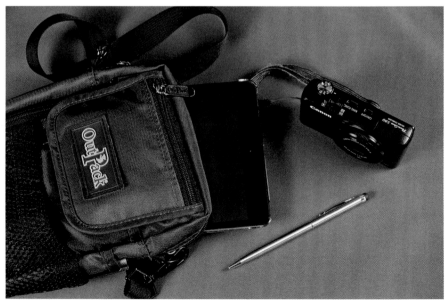

11.5 inches wide by 9.5 inches high by 2 inches deep. The padded main compartment with top access provides protection for your iPad or iPad Mini, with room for a few documents, too. You can stash a handful of accessories, including a small compact camera, in the exterior zippered pockets — two in the front and one in the back. I also like that the Samsonite has comfortable top handles in addition to its shoulder strap that is a nice finishing touch for a well-appointed bag.

Ogio Module Vertical iPad/Tablet Messenger

The $29 Ogio shoulder bag features urban styling and a fleece-lined iPad compartment. It hugs the body during transport, measuring only 11 inches by 8 inches wide by 2 inches deep. There's not much room for a camera in the Ogio, although my slim Canon S90 fits comfortably in the front pocket. If your smartphone is your camera while on the go, the Ogio is a stylish way to protect and carry your iPad.

FIGURE 9-10

The Apple Smart Cover folded into a keyboard stand for an iPad

Slim iPad protection

Alternatives to dedicated tablet bags are cases for the iPad itself, allowing you to stash your tablet in any type of bag without worrying about scratches and dings.

The $39 Apple Smart Cover for the iPad and the separate $39 iPad Mini version protect the glass surface of your tablets. They also fold neatly into a triangle, creating a slightly elevated keyboard stand, as shown in Figure 9-10.

For more protection, consider the $49 iPad Smart Case that protects both the front and back of your tablet, as shown in Figure 9-11.

Another option that takes up a minimum amount of space but provides excellent all around protection is the $19 Acme Made Skinny Sleeve, shown in Figure 9-12. With your iPad in a Skinny Sleeve, you can stash it anywhere in a standard messenger bag or backpack.

Another of my favorite solutions for the full size iPad is the Brydge Keyboard/Cover that I describe in Chapter 7. The polycarbonate model sells for $150 and does a good job protecting

FIGURE 9-11

The Apple Smart Case protects both sides of your tablet.

FIGURE 9-12

The Acme Made Skinny Sleeve with an iPad and standard messenger bag

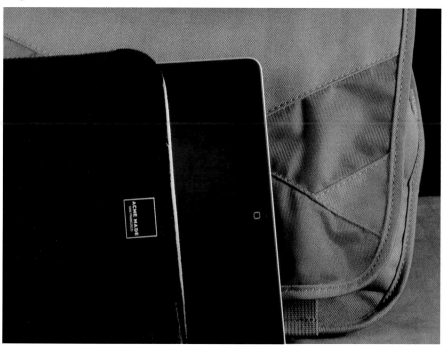

the glass surface of a full-size iPad. When you open it, you have a handy Bluetooth keyboard with function keys, as shown in Figure 9-13.

These days, I keep the Brydge on my iPad most of the time. When secured to the iPad, the duo fits in the Lowepro Event Messenger 150, Lowepro Photo Hatchback 16L, Samsonite iPad Shuttle, and the Ogio Tablet Messenger. And, having a keyboard for the iPad is a luxury that I've grown quite accustomed to.

Designing Your Carrying Solution

When I'm trying to figure out the right bag for the job, I take all the contents I need and spread them out on the table. This gives me a chance to make sure I have the essential tools, but not lugging around stuff I don't really need.

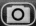

FIGURE 9-13

The Brydge Polycarbonate Keyboard/Cover with a full-size iPad

I also consider where I'll be working or hanging out. On a beach, I'm more comfortable with an all-weather backpack such as the Lowepro Photo Hatchback 16L AW. While passing the time in a local coffee shop, I'm just fine with the Ogio shoulder bag.

The iPad is such a powerful, nimble device. Do it justice by finding the right carrying solutions for you.

Chapter 10

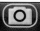

Tips for the Road Warrior

As I described throughout the book, the iPad is suited for the photographer on the go. And you can enhance your experience even more by practicing a few road-warrior tips that I've learned during my travels.

Staying Charged

The iPad battery life is excellent. But heavy use for extended periods of time eventually exhausts your power. Photo work creates additional stress on the battery. Here are a few ways to extend that battery life.

Adjust screen brightness to the task at hand. When editing images, you need to set the brightness between 85 and 90 percent so you can properly judge the exposure of your photos on the screen — even though this high setting uses more power. To adjust the brightness, go to the Settings app's Brightness & Wallpaper pane, shown in Figure 10-1. Turn off Auto-Brightness. (You want to be in control of this setting.) Then move the brightness slider over, as shown in Figure 10-1.

But when you're not editing photos, you can help conserve battery life by dimming the screen to 50 percent or so, depending on your personal preference.

I like to have quick access to my frequently used controls such as Brightness, Wi-Fi, and Airplane Mode, so I keep the Settings app on the Dock, as shown in Figure 10-2. To move the Settings app's

FIGURE 10-1

Adjusting screen brightness in the Settings app

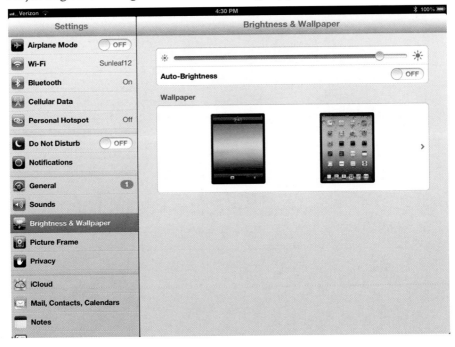

icon there, tap and hold it until all the apps begin to wiggle. Drag the Settings icon into the Dock, then release your finger. Then press the Home button once to lock everything in place. You can store as many as six icons in the Dock on an iPad.

Image editing can be processor-intensive, especially when adding filters, sharpening, or retouching. If you know that you're going to be on a long flight with no in-seat power port, for example, or have an extended period of time before you can recharge your iPad, you may want to stick with tasks that are less processor-intensive. Activities that are less of a strain on battery life include library organization, adding star ratings, entering metadata, and so on. These are chores that still need to be done, right?

Another energy-savings tip involves turning off Wi-Fi, cellular, GPS, and Bluetooth radios if you don't need the connectivity. All these options can be disabled at once by switching to Airplane Mode in the Settings app.

For extended road trips, you can explore 12-volt power adapters for the car so you can keep your iPad plugged into power, bypassing

FIGURE 10-2

Placing the Settings app's icon in the Dock

the battery. These are particularly handy if you plan on using the iPad for navigation. That amazing GPS system *does* tax the battery.

And finally, make sure you charge all your mobile devices the night before you depart. There's nothing worse than firing up the iPad on the plane only to realize that it has 28 percent battery left.

Using the Best Connection

I prefer iPads that have both cellular and Wi-Fi connectivity, despite the extra $130 they cost. With both types of Internet connections available, you are less likely to be out of touch or unable to access information or resources — such as iCloud syncing — you need in the field. And iPad data plans are month-to-month so you can turn it off when you don't need it.

Many businesses do offer free Wi-Fi. If you're simply reading online news, browsing social networks, and web surfing, take advantage of the free connectivity and spare your cellular data plan.

FIGURE 10-3

The Personal Hotspot screen on an iPhone

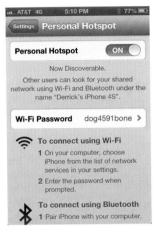

On the other hand, free networks do bog down, possibly bringing your productivity to a standstill. That's a good time to switch to your cellular network, which will probably yield better performance.

Wi-Fi-only iPad owners can use the cellular option by enabling the personal hotspot service on their smartphone (if their carriers allow it) or by buying a personal hotspot device (the MiFi is the best known). Either way, you'll pay extra for the data plan. I have this plan for my iPhone, and it has saved me in countless situations when the Wi-Fi network became useless.

To become your own access point, enable Personal Hotspot on your smartphone, as shown in Figure 10-3. Then connect your iPad to the Internet connection broadcast by the phone via Wi-Fi or Bluetooth. Interestingly enough, I've had better luck connecting my iPads to the iPhone using Bluetooth. Test both and see what works best for you.

The first time you establish this connection, you have to enter a password in your iPad that is generated on your smartphone; on an iPhone, you do this in the Settings app's Personal Hotspot screen. After that, the connection should be made automatically.

Tip

A cellular-equipped iPad can also act as a hotspot if you have an LTE-capable (4G) model and your carrier supports personal hotspots. Many carriers don't charge extra for this service on the iPad, even though most do on smartphones.

I've had to rely on this system for my iPad Mini because it doesn't have cellular. At first, I thought it would be a big hassle. I guess I was spoiled by having Wi-Fi and cellular on my full-size iPad. But to tell the truth, Personal Hotspot has worked well for me. And there have been times when it was a lifesaver for my laptop, too. I just turn it on, set the smartphone on the table, and go about my work.

Tip

If you decide to activate the personal hotspot on your smartphone and also purchase a Wi-Fi + Cellular iPad, consider having a different carrier for each device. In my case, I have AT&T for my iPhone and Verizon for the iPad. This increases my odds of establishing a good connection in just about any environment: If AT&T fizzles out, I can try Verizon.

Backing Up as You Go

The iPad is a powerful productivity tool enabling you to create and maintain to-do lists, calendar appointments, text documents, spreadsheets, Keynote presentations, and more. The best working scenario allows you to create freely on the iPad knowing that your work will be automatically backed up.

That's why I recommend taking advantage of an iCloud account and applications that automatically save to it. These apps include Pages, Numbers, Keynote, iA Writer, Calendar, Notes, Reminders, and Listo. Many of these apps, such as iA Writer (shown in Figure 10-4), have software counterparts for the Mac so you can use the most convenient device for your work, knowing it all gets saved to one place.

Automatic backup is also great for your photography. If you work for 20 minutes on an image in iPhoto or Snapseed, then save it to

An iA Writer document saved to my iCloud account

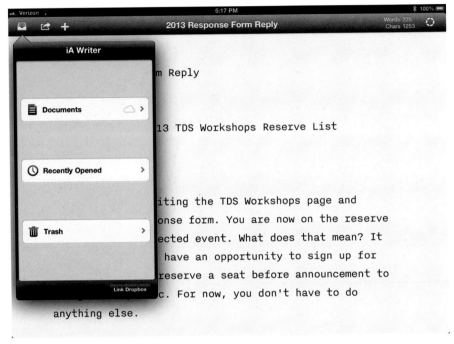

your Camera Roll, the photo is automatically copied to Photo Stream (if you have it activated). For those who prefer Dropbox, direct the photo applications to upload directly to that service.

The more automated your backup system, the better served you'll be by it. It's worth investing time up front to establish a worry-free backup workflow that integrates with your favorite apps.

Entering Data with Dexterity

Even though I'm comfortable typing on the onscreen keyboard on the iPad, my input speed improves substantially when I use a physical keyboard. In Chapter 7, I mention the Brydge keyboard for the full-size iPad. I really do like it and leave it attached 95 percent of the time, as shown in Figure 10-5.

My larger iPad has become my workhorse mobile device. I write book chapters on it, edit photos, and answer e-mail. Even though the Bluetooth keyboard adds a little thickness to the package, it's worth the gain in productivity.

FIGURE 10-5

The Brydge Bluetooth keyboard for a full-size iPad

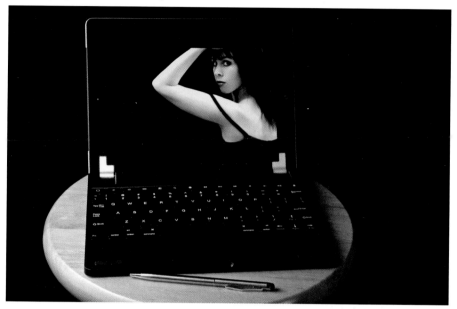

With the iPad Mini, on the other hand, I don't use an external keyboard. I consider the Mini my supernimble iPad, and I want to keep it as thin and light as possible. I primarily consume content on the Mini, as opposed to creating it as I do on the full-size tablet, so I wouldn't get much advantage if I used the physical keyboard with it. (Of course, if you have a Bluetooth keyboard for a full-size iPad, it will also work with the iPad Mini — just not simultaneously, of course.)

Whether you consider a keyboard depends on the demands you have for your mobile devices. I tend to work mine to death. Your mileage may vary.

Reference Documents

Storing camera manuals and other reference documents in the cloud can save you time searching for them via Google when you need to look up something quickly. I like to keep my PDFs in Dropbox, as shown in Figure 10-6.

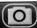
FIGURE 10-6

My reference documents stored in Dropbox and displayed on my iPad

One of the benefits of the Dropbox for iOS is that you can read your stored documents right in the app without switching to other software. Text usually doesn't use that much bandwidth, so even if you're on a cellular connection, the documents should load quickly, enabling you to get the information you need.

Choosing the Right Device for the Job

A question that comes up occasionally sounds something like: "Can I replace my computer with an iPad?" In short, the answer is no. The iPad fills a gap between full-fledged computing and smartphone connectivity.

Before the iPad, I didn't want to take my laptop everywhere. But I had to. That's changed. When I'm working on assignment all day, I can take a break, grab a cup of coffee, and get some work done — with my iPad that weighs less than a camera. On vacation, I can enjoy my photos from the day's activities without lugging my

entire work world with me on a computer. And when I'm relaxing on the couch after a long day's work, I can see what my friends are publishing with an iPad Mini sitting lightly on my lap.

But there are still times when I need serious computing power. I have terabytes of data stored on RAID hard drives connected to my studio computer running Photoshop, Lightroom, and Aperture. Big jobs with lots of data are easier to manage on a traditional computer with big storage. The trick is to choose the right tool for the job. On an airplane, I reach for my iPad. When I shoot with my full-frame Canon DSLR, I fire up a computer to process the images.

My working life has never been more enjoyable. I use a smartphone, an iPad, and a computer to help me accomplish my goals. And I like deciding which tool to use for the job.

The bottom line is: The iPad might not replace your computer. But it sure makes computing a lot more fun.

Appendix

Choosing the Best iPad

When considering a new iPad, is it possible to choose the wrong one? Well, "wrong" is such a strong word. Maybe a better way to approach this question is: How do I choose the best iPad for me?

There are four major considerations to making a good selection:

- **Size:** iPad Mini (7.87 inches by 5.3 inches) versus a full-size iPad (9.5 inches by 7.31 inches).
- **Connectivity:** Wi-Fi only versus Wi-Fi + Cellular.
- **Storage:** 16GB, 32GB, 64GB, or 128GB.
- **Price:** $329 to $929.

Size Considerations

Let's start with the physical dimensions of your tablet. This is a tough one for me. I have both a Mini and a full-size iPad. I like them both, but I use them differently.

The iPad Mini is my go-to tablet for consuming content. I read newspaper articles, blog posts, and books on the smaller iPad. It's easier to hold with one hand and more comfortable to use when reclined on the couch or in bed. The Mini is perfect for watching TV shows and viewing pictures on Flickr and other photo sites. It fits practically everywhere and weighs next to nothing.

The Mini fits great in a small messenger bag with just a compact camera and a few accessories. It also fits in many of my assignment camera bags, meaning that it's convenient to pack for just about any situation.

It's easy to fall in love with the iPad Mini. But its smaller screen isn't ideal when I need to get a lot of work done.

That's when I pick up the full-size iPad. The larger screen is hard to beat for creating content. I use it to answer e-mail, write articles, and post online. The big, high-resolution Retina display is perfect for image editing and managing my photos. It's much easier for me to edit video on the big screen compared to the iPad Mini. When working in the field, I can use the big iPad instead of a laptop for the bulk of my tasks. I find that impressive.

So when you're thinking about size, the real question might be, "Which iPad do I get first?" I almost hate to say this, but I can't imagine giving up either of mine. Start with the size that best fits your needs. Then, start saving.

Connectivity Considerations

The iPad is a mobile device, so it needs to communicate with the world. You can choose Wi-Fi-only, or opt for a Wi-Fi + Cellular model. Think this through.

Realistically speaking, the iPad will be your computer when you're on the go. Pictures will be uploaded, stored, edited, organized, and shared from it. You'll also answer e-mail, browse web pages, shop for new gear, manage your banking, and even generate invoices and balance the books. And, you'll want to engage in these activities whenever you have the time to do so, whether you're near a Wi-Fi network or not. That's why I lean toward Wi-Fi + Cellular. It's more versatile. It also costs about $130 more than the Wi-Fi-only model.

This leads to a confession. When the iPad debuted, I was excited about its potential. I wanted to start testing and writing about it immediately. But Apple only released the Wi-Fi version at first. I told myself that "Wi-Fi only" would be fine. "I'm always around some sort of network." But inside, I knew I wanted the Wi-Fi + Cellular model. I ignored my little voice and made the Wi-Fi-only purchase.

About a month later, the Wi-Fi + Cellular model was released. I had already been experiencing the "no, there aren't Wi-Fi networks everywhere I want to work" syndrome. I realized I had made a mistake. I soon bought the Wi-Fi + Cellular model and was much happier. I could have saved myself both grief and money had I listened to my little voice in the first place.

So, here's my less anecdotal reasoning for opting for Wi-Fi + Cellular:

- You don't have to sign up for a lengthy contract for cellular access. You can enable and disable it on a monthly basis. And even when you use it, most carriers offer affordable options if you're not a heavy user.
- The cellular model includes GPS. I've found this to be as important as the data network itself. With GPS, you can use your iPad to navigate to locations and discover and mark where you are at any given moment.
- There are not Wi-Fi networks everywhere. It seems like there are until you want to check your e-mail in the parking lot outside your kid's school.

The other option is to enable your smartphone as a personal hotspot and share its Internet connection with the iPad, as I describe in Chapter 10. I've tested this, too. It's not bad. But with AT&T, this option costs me $25 a month. And quite honestly, having the cellular radio built in to the iPad is more convenient. Going forward, I'm probably going to pony up for only Wi-Fi + Cellular models.

Storage Considerations

I've tested iPads with 16GB, 32GB, and 64GB of storage. I haven't tried the new 128GB model of the forth-generation, full-size iPad yet, but I certainly would if one fell into my lap.

This is an area where I might have a minority opinion. My belief is that as cloud services improve, the need for internal memory decreases. My music lives on iTunes Match (part of Apple's iCloud offering) and the bulk of my photos stay on the camera's memory cards except for the images I plan on using immediately on the iPad. As a result, I've had a very good experience with a 32GB iPad.

But if you plan on storing more images on the iPad, such as during business trips and vacations, you'll appreciate the convenience of 64GB or even 128GB of storage. Maybe this is an area where your budget will dictate the final decision — each step in storage capacity costs $100. If you can afford lots of memory, you probably won't regret getting it.

Price Considerations

Which leads to the ultimate consideration: price. Heavy iPad users will probably get two to three years use from their device before contemplating an upgrade. Can you afford $500, $700, even $900? This is your personal decision.

After you decide which size is best for you, I recommend pricing the Wi-Fi + Cellular models, then purchasing as much storage as you can afford. I'd rather have a 32GB Wi-Fi + Cellular than a 64GB Wi-Fi-only model, for example. But I've thought a lot about this … and learned the hard way. So I know it's the right call for me.

Deciding when to buy a new iPad

Many people have asked me the best time to buy an iPad. Well, right after a new model has been released jumps to mind. But we can't always synchronize our lives with Apple's product cycles. So the real answer is to buy an iPad when you need it, and when you can afford the purchase.

There will always be new models. That's technology. Establish a pattern that works for you and stick to it. My moderate approach (for a tech guy and photographer) is to buy every other release for iPhones and iPads. And, to be honest, I do just fine in the "off years."

But just between you and me: I'm happier in the "on years."

Should you consider a used iPad?

This is a great question. I've sold two iPads, and the buyers were thrilled. They were able to begin their exploration into tablet computing with a smaller investment.

In my opinion, the original iPad is too slow for photography work, so I don't recommend it. But the iPad 2 is a viable machine. And the third-generation iPad with Retina display is terrific.

If you can get a good deal from a reputable seller on a third-gen or newer iPad, you'll likely have a positive computing experience.

Factoring in the cost of accessories

When working with your budget, remember to factor in the cost of a good case, adapters, and other accessories you might want.

I use the iPad Camera Connection Kit a lot, and I like having the Toshiba FlashAir card in my camera for sending images to the iPad, for example.

You'll most likely want to invest in software right away. Fortunately this isn't a huge expense, but it can add up if you're on a tight budget.

Try to get everything you think you'll need on paper, then proceed accordingly. Whatever you do, however, don't skimp on getting a case for your iPad. You want to protect your investment.

Feeling Comfortable with the Investment

Once you've decided which iPad you want, you want to feel comfortable with your investment and be able to explain your reasons to others affected by the expenditure. Here are some of the common factors why iPads appeal to photographers.

- You want to carry less weight, yet improve efficiency.
- You have a love/hate relationship with your computer.
- Portable devices appeal to you and fit with your style of work.
- Tablets inspire you to be creative.
- You enjoy sharing pictures with others, and it's just easier with an iPad.
- When working with your photos, the simpler the better.
- You like the idea of a device that handles many of your communication needs.
- If you could carry everything you needed in a medium sized camera bag or backpack, you'd be thrilled.

And there are probably others you could add to the list. The best way to get comfortable is to build a pro/con list. Under the Pros header, add all the reasons why you think an iPad is a good investment. Under Cons, add the downsides to buying one. Which column is more compelling?

Index